A. Legros

MODELLING AND SCULPTING THE HUMAN FIGURE

by

Edouard Lanteri

With an Introduction by
Nathan Cabot Hale

DOVER PUBLICATIONS, INC.
NEW YORK

Published in Canada by General Publishing Company, Ltd., 30 Lesmill Road, Don Mills, Toronto, Ontario.

Published in the United Kingdom by Constable and Company, Ltd., 10 Orange Street, London WC2H 7EG.

This Dover edition, first published in 1985, is an unabridged, slightly revised republication of Volumes I and II of the three-volume work originally published by Chapman & Hall, Ltd., London, under the title *Modelling*. Volume I, represented by Section One of this edition, was originally published in 1902, and Volume II, represented by Section Two of this edition, was originally published in 1904. (Volume III of the original set appears as a Dover reprint edition under the title *Modelling and Sculpting Animals*, 25007-5.)

The present edition incorporates the Introduction written by Nathan Cabot Hale specially for the original Dover edition, as first published in 1965 under the title *Modelling and Sculpture: A Guide for Artists and Students*. A new Publisher's Note appearing on page viii, the footnote on page vi and the explanatory note preceding the Contents for Section One on page xi were written specially for this edition.

Manufactured in the United States of America
Dover Publications, Inc., 31 East 2nd Street, Mineola, N.Y. 11501

Library of Congress Cataloging in Publication Data

Lanteri, Edouard.

Modelling and sculpting the human figure.

Originally published as v. 1–2 of Modelling: London : Chapman & Hall, 1902–1904.
1. Human figure in art. 2. Modeling. 3. Sculpture—Technique. I. Title.
NB1930.L36 1985 731'.82 85-10372
ISBN 0-486-25006-7

Introduction To Dover Edition

Figurative art in America suffered a gradual decline after the Armory Show of 1913. At that time art expressions reflecting the mechanical rhythms and geometrical patterns of our industrial pathology began to supersede the forms and rhythms of the natural organic matrix of life. Now, more than fifty years later, men are coming to understand more about their dependence on the natural environment and the damaging encroachment on nature that is possible through misused technology. Today there is a growing interest in and urge toward art forms which represent mankind and value nature. With this interest a whole new generation of artists is faced with the need for gaining skills and insights that were rejected after the advent of what has been called "modern art."

The task of learning these skills is difficult enough in itself, but the modern figurative artist must bear the additional onus of those words "conservative" or "academic" which have been attached to the realist tradition. Yet most serious artists of today would probably agree that such hard-won aspects of this tradition as the technical skills of sculpture and painting, the anatomical knowledge given us by such men of genius as Leonardo and Michelangelo, and the great psychological insights of Rembrandt, Goya, or Daumier should not be denigrated by being thus labeled. It would be far better for artists and art writers finally to acknowledge that the meaning of these words has been partially obscured by their application to persons or

groups with rigid, dense, arrogant, or pretentious character struc-
tures—persons or groups who use the professional organization, the
press, the museum, or personal political power to repress valid art
expressions.

At the turn of the century this was often the behavior of the old
academicians and their supporters. Today, and for the past three
decades, the power and manipulation have been in the hands of the
abstract schools. Neither situation is desirable, but there is some dif-
ference in that these latter-day academicians have benefited by the
amazing developments of mass propaganda techniques and the tax-
free institutions devoted to the furtherance of the aesthetic mystiques
of abstraction in the public mind, however specious or silly these
mystiques might prove to be on careful examination. Unfortunately
the public and the art student often tend to memorize rather than
analyze in the light of their personal feelings. So they end up accept-
ing out of trust and innocence things they may at heart not really
care for. It will be up to the artists themselves gradually to make it
understood that excellence and inspired achievement can proceed
only from artists who have mastered the skills of their trade.

In this regard the republication of Lanteri's *Modelling and
Sculpture* is an important event for American sculpture, for this
set of three volumes is *the* classic treatise on the techniques of
figurative sculpture.* The material presented is the product of the
thirty-thousand-year evolution of the Western figurative concept, and
it represents at least three thousand years of accumulated studio lore.
There are few books on sculpture that can compare to this. The
material included covers a large part of what should be the content
of a four-year sculpture curriculum. The book is a gold mine of
technical information, the kind of reference work that should be
a lifelong studio companion to the figure sculptor.

*Volumes I and II of the original three-volume work are both contained in this Dover
edition. Volume III is available as a Dover reprint edition under the title *Modelling and
Sculpting Animals* (25007-5).

This work shows how one develops the sculptor's logic of organic form, a logic that deals not with words but with organic shapes and anatomical functions of movement, expression, and relationship. It shows the step-by-step handling of most of the problems that arise in figurative sculpture without ever encroaching on the artist's aesthetic prerogatives. It instructs with a total awareness of the time and labor required to gain mastery of sculpture technique. This is not the sort of work that purports to make sculpture easy, in the manner of all too many books for the hobby artist; but it is at the same time so clearly and soundly conceived that the intelligent amateur may gain from it as well as the professional for whom it is expressly intended.

There are, however, some difficulties that young sculpture students will encounter that are beyond the province of these volumes; since 1911, when the last volume of this text was published, the role of the professional figure sculptor in society has so declined that the basic skills required in teaching this kind of sculpture have all but died out. The professional teacher of artistic anatomy (a rigorous subject) has almost totally disappeared. Competent portrait sculptors, as well as men capable of teaching the methods of monumental work, are hard to find or are too old to teach. As a consequence, few schools can offer in a full four-year program the sound curriculum outlined in Professor Lanteri's volumes. I know of no school in the United States that can provide this kind of professional instruction at this time. This is indeed unfortunate, since learning sculpture technique often involves the wordless communication of processes of form construction and handling of media by a teacher experienced and tempered by professional practice. In view of the shortcomings inherent in the art schools of today, therefore, these books will serve the young sculpture student as a trustworthy authority and guide by which he may regulate his own study and development.

It is, thus, with the most serious and fervent hope that I commend

these volumes to the aspiring art student, the professional sculptor, and the art educator, that they may make the best use of this fine work: the art student to demand these valuable technical subjects of the teachers of his chosen trade; the professional sculptor to maintain the highest level of understanding and practice; and the educator to understand the full factual extent of his teaching obligation. It is my hope that the republication of these fine volumes will do much to reinstate the teaching of figure sculpture of the highest order in the United States.

NATHAN CABOT HALE

New York, 1965

Publisher's Note

Reprinted here in the present Dover edition are Volumes I and II of Edouard Lanteri's classic three-volume text on figurative sculpting and modelling. Volume I, represented by Section One of this edition, offers a detailed study of sculpting and modelling in the round. The author describes in depth the procedures for sculpting the human head and the bust, and for modelling the entire figure. Each discussion is accompanied by instructive illustrations of the appropriate anatomical features. The Contents for this section appears on page xi of Section One. Volume II, represented by Section Two of this edition, covers in detail modelling in relief, modelling drapery, sculpting medals and the principles of composition in relief and in the round. A separate Contents for this section of the book appears on page ix of Section Two.

Volume III of the original set is also published by Dover, under the title *Modelling and Sculpting Animals* (25007-5). In it Lanteri covers the step-by-step process of sculpting various animals, giving detailed anatomy for the horse, lion and bull. It also includes a thorough description of the method of casting in plaster.

PREFACE

IT would be difficult to overrate the value and excellence of this work.

Had such a book been obtainable when I was in the twenties, I would not have rested a moment until I possessed a copy, and when possessed of it, it would have been my constant companion.

Professor Lanteri has put in very comprehensive language everything that is needful for the young sculptor to know.

The result of the careful thought and observation of years is here set forth in a manner so clear that it may appear to some readers that after learning Professor Lanteri's book by heart, they will then know how to model. A careful study of this work will show that the author does not hold out any such vain hope.

The object of this work is to teach the student how to begin. Many things are clearly shown in the illustrations and

Preface

described in the text that would take some people many years to find out for themselves. The young student is plainly told how to begin, the more advanced student will find many doubts here cleared up, and the feelings, after reading the book, of all who make sculpture their life study, will be those of gratitude.

E. ONSLOW FORD.

CONTENTS

Contents

PART III

MODELLING AND SCULPTING THE HUMAN FIGURE

INTRODUCTION

I HAVE repeatedly been asked to publish the notes of which I made use for my demonstration-classes at the Royal College of Art.

I fancy that by somewhat developing them they will be found useful by those who intend to devote themselves to this art, as well as by those who undertake the task of instructing beginners in the subject.

I do not pretend to think that my method is the only right one—there is no such thing as an infallible method. Every intelligent teacher must be free to form his own, on condition that he bases it on true principles. Thus, instead of exclusively setting forth one method,—even if it be the very best,—it is better to state broadly the great essential principles of teaching, in which every method ought to be included, and to allow the teacher a certain latitude.

It is important that every one should bring to the adopted method such modifications as will allow him to consider it his very own personal method. It is only thus, that he will find the impulse and devotion necessary for the accomplishment of his arduous task.

The auxiliary means of teaching have not an absolute value in themselves,—they may prove useful or dangerous, according to the moment and measure of their application. In order to prove efficacious, they must be presented in methodical order. This order can only be settled after precisely ascertaining the object in view, and the principles on which the means for obtaining this object should be based.

Art is essentially *individual*, in fact "*Individuality*" makes the artist.

All teaching, to be true and rational, must aim at preserving, developing and perfecting the individual sentiment of the artist.

Therefore the end at which every teacher should aim, whose task it is to teach the Fine Arts, is the development of the artistic aptitude of each pupil. The best means and exercises are those which tend most surely to attain this end.

In thoroughly teaching each pupil the *craft*, not to say trade, of a sculptor, there is no fear of destroying his individuality ; on the contrary, having conscientiously learnt the craft, he will gain confidence and the necessary power to express truthfully the personal sentiment with which Nature has

endowed him. Whilst, if the teacher wants to go further than this, he risks imposing on the student his own way of looking at things, and destroying the pupil's individuality.

This short attempt of mine has no other object than to place before the student some practical hints, based entirely on the anatomical construction of the human body, which construction is invariable in its principles. When he has mastered this method, he will come to apply it without thinking of it,—instinctively as it were, and without effort. The application of this method will have caused him to fix the points of construction precisely; he will have made a complete analysis of the human figure; all the causes and reasons of its various forms will be clear to him, and he will avoid that groping in the dark, those unreasoning alterations, which are always tried, when this branch of the instruction has been neglected.

This book contains in short limits the essence of the subject; it is, so to speak, the summary of a method, a sort of guide which gives the primary indications of the way.

I must insist again and again on this point, that the aim of Art-teaching should be to put within the pupil's grasp all that is necessary to help him to express his thoughts by the simplest, surest and quickest means. It should in particular sharpen his observation, without too much influencing his own judgment; and when the student's judgment goes astray, he should be corrected by model or example, placed before him without his

perceiving the intention,—for fear of making him lose his own power of judging.

And as *Drawing* is the principal foundation of *Sculpture*, and a good sculptural work depends largely on good drawing, the student should draw as much as, if not more than, a student of painting,—(which unfortunately is not always done). No student ought to be admitted to modelling in a school, unless he has first done some serious drawing; and on this understanding I begin this guide,—always addressing myself to a student who is capable of *seeing a line* and *executing it properly*.

Another important point on which I must insist, is the thorough study of *Artistic Anatomy*. You must begin your work with some knowledge of the form of the bones and muscles, and go on with the study of it while at work. I shall point out to you in the following pages what is necessary for you to study, but I can of course only slightly indicate it to you, leaving you to complete your knowledge from the actual *skeleton*, the *anatomical* figure, and the excellent books written on the subject of Artistic Anatomy by the late Professor Marshall, Professor A. Thompson, Mr. J. Sparkes, and others.

I beg you to observe that the knowledge of the bones is even more important than that of the muscular system; and do not lose sight of the fact, that "*Anatomy teaches you the general laws of the human form, whilst the living model shows you the same laws applied, and modified by individual characteristics.*"

PART I

PART I

TOOLS

(1) Provide yourself with two turntables,—one for the work, the other for the model, the height from the ground about 3 feet 4 inches to 3 feet 6 inches. See Fig. 1.

(2) Provide two wooden boards, about 18 inches square or larger, according to the size of your work. To avoid warping through the moist clay, have the boards clamped at the back with two battens nailed or screwed on crossways. See Fig. 2.

(3) A few wooden tools are enough to begin with, the preference to be given to those of simple form ; avoid tools which are heavy in your hand, as well as the small and thin ones, unless your work is to be in very small proportions. One tool with strong wire curves at the extremities will be found helpful. For shapes see Fig. 3.

(4) Provide a pair of large iron compasses or callipers, with their legs slightly curved, and about 10 to 12 inches long. These are best ordered from a local blacksmith. Fig. 4.

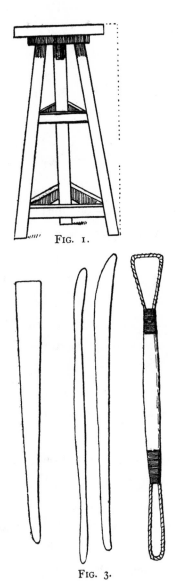

FIG. 1.

FIG. 2.

FIG. 3.

FIG. 4.

(5) Have at hand a small sponge to keep your fingers clean during modelling, and some soft old linen to cover up the work after leaving off for the day. Occasionally you will also require a fine syringe or a big brush to splash the clay, when it begins to harden. As we go on, I shall describe whatever tools become necessary ; at first no more than the above-mentioned are required.

FIRST STUDIES.—THE FEATURES

The Mouth

THE best models for the details of the face I consider to be those taken from the mask of Michel-Angelo's " David." They are executed with such precision, so much knowledge of form and anatomy, that in copying them the student is seized with the desire to know the reason for these forms, and he is thus urged on to the study of ANATOMY, so necessary for sculpture.

After having fixed your plaster cast on a board like the one you are going to work on, and having placed it on the turntable, fix both boards at the same angle by means of a wooden support, nailed to the board and turntable, (or by an iron support, screwed on to both), see Fig. 5, so that your work, as well as the plaster model, is in a vertical position. Then drive

a nail into your board, at about the level of your eyes. To
this nail, by means of some wire (galvanised iron-wire will do,

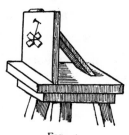

though copper-wire is preferable) fix a
small wooden cross ("butterfly" in
studio parlance—see Fig. 5), which will
help to bear the weight of the clay.
Then with your sponge wet the board
and immediately rub some clay on the
wetted part, so as to form a thickish
paste to which your clay will adhere.

Fig. 5.

If you neglect this, your clay will soon get loose from the
board and drop down, but this paste and the butterfly will
keep it in its place.

Let me just mention by the way, that the more you work the
clay through with your hands, the more pliable and conse-
quently the better it will be.

To begin work, lay a certain quantity of clay on your board,
pressing it well in with the thumb, so as to give about the
general shape and mass of your model, always taking care to
keep a little below the actual amount, so that there will be no
need to scrape off, but rather to add on, in order to arrive at
the true form of the model.

Before beginning each study, you must try to understand
what you wish to reproduce, and I shall, therefore, introduce
each feature by a sketch of its characteristics and its anatomy.

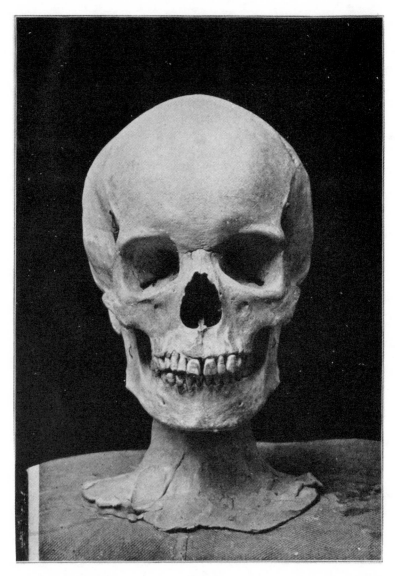

FIG. 6.

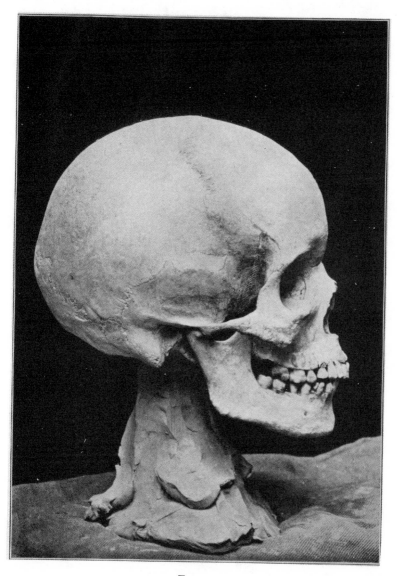

FIG. 7.

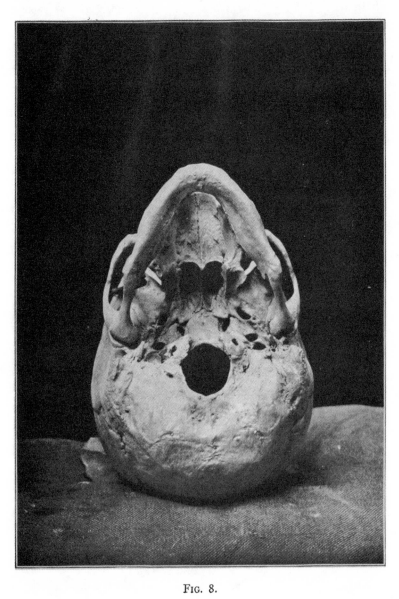

FIG. 8.

The mouth is formed by the Upper and Lower Jaw ; the upper jaw consists of the two *Superior Maxillary Bones* ; they are two large bones, joined in the middle line and placed almost vertically beneath the Frontal Bone. By means of four processes —the *Malar, Alveolar, Palatine* and *Nasal Processes*, which extend in different directions, these bones are joined to the other bones of the face. The Malar processes connect them with the cheekbones. The Alveolar process forms the Superior Dental Arch, which contains the sockets for the Upper Teeth. The Palatine Process passes inwards to form the anterior part of the hard palate, and the Nasal Process extends upwards to the orbits and the Internal Angular Process of the Frontal Bone ; it forms the sides of the nose and is connected with the Nasal Bone in front, its outer border forming the deep notch which constitutes the anterior opening of the nose.

The *Lower Jaw Bone* or *Mandible* is originally composed of two halves which very early become a single bone, *i.e.*, the *Inferior Maxillary*. It consists of a solid, horseshoe-shaped body, and upturned, flattened ends, the *Rami* or *Branches*. See Photograph of Skull, Figs. 6, 7 and 8.

The posterior border of each ramus expands into an oblong condyle which fits into the *Glenoid Cavity* of the *Temporal* bone and forms the *Temporo-maxillary Articulation*, a very secure double-hinged joint, which allows backward and forward, as well as lateral movement of the lower jaw. The junction of the

body of the bone and the Rami forms a rounded angle, which really decides the width and shape of the cheek. Apart from individual varieties, the angle is more acute in the fully developed individual than in the child, or again in an old man, where it is obtuse. See Figs. 9, 10 and 11.

FIG. 9. FIG. 10. FIG. 11.

In the same way the Alveolar Processes are not so prominent in a child as in a full-grown person; and in old age, when the teeth fall out, these processes become absorbed and disappear.

There are various processes and ridges on this bone, which serve as attachment to powerful muscles; most important for our purpose is the triangular *Mental Eminence*, or Chin, which is subcutaneous, and therefore of great service for taking measures from, besides its being a very characteristic feature in the human face. Above it is the *Symphysis*, a vertical line which marks the union of the two Maxillary bones.

The transverse line which we specially designate by the name of Mouth is surrounded by the lips, which in their

turn are surrounded by the *Labial* group of muscles. These are :—

(*a*) The *Levator of the Upper Lip*, which raises it and draws it forwards ;

(*b*) The *Levator of the Angle*, which raises the outer part of the Upper Lip ;

(*c*) The *Zygomaticus Major*, which draws the corner backwards and upwards, and is a laughing muscle ;

(*a*) The *Zygomaticus Minor*, which draws the outer part of the upper lip in an upward, outward, and backward direction ;

(*e*) The *Depressor of the Angle*, which draws the corner of the mouth downwards and backwards and assists in producing a sad expression ;

(*f*) The *Depressor of the Lower Lip*, which draws the lower Lip down ;

(*g*) The *Levator of the Lower Lip*, used in raising it and protruding it ; and last—not least

(*h*) The *Orbicularis Oris*, which surrounds the mouth and which forms the Lips. On the upper lip it forms a vertical *Median Furrow*, the ridges of which form the inner borders of two long triangular spaces, the other two sides of these being formed by the free border of the upper lip and the naso-labial line descending from the wings of the nose to the corner of the mouth. Figs. 12 and 13.

The Median Furrow ends in the prominent *Median Lobe* of

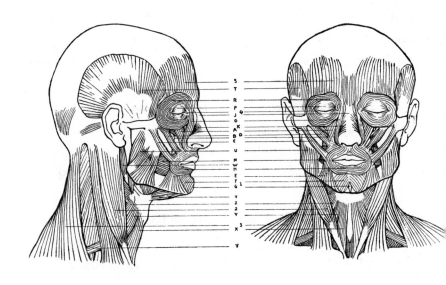

FIGS. 12 AND 13.—MUSCLES OF THE FACE AND NECK.

A. The Levator of the Upper Lip.
B. The Levator of the Angle.
C. The Zygomaticus Major.
D. The Zygomaticus Minor.
E. The Depressor of the Angle.
F. The Depressor of the Lower Lip.
G. The Levator of the Lower Lip.
H. The Orbicularis Oris.
I. The Pyramidalis Nasi.
K. The Compressor of the Wings.
N. The Buccinator.
O. The Common Levator of the Upper Lip and Nose.
P. The Levator of the Upper Lip.
Q. The Tensor of the Lids.

R. The Orbicularis Palpebrarum.
S. The Occipito Frontalis.
T. The Temporalis.
U. The Masseter.
V. The Digastricus.
W. The Digastricus.
X. The Sterno-hyoideus.
Y. The Omo-hyoideus.
Z. The Thyro-hyoideus.
1. The Stylo-hyoideus.
2. The Sterno-cleido Mastoideus.
3. The Trapezius.
4.
5.
6.

the upper lip ; at its sides are slight depressions beyond which the lips are carried on by a convex form to the corners. The lower lip has no median projection, but there is a *median depression* from which two convex forms start towards the angle of the mouth, where the upper and lower lips join. The skin which covers this red border of the lips is closely adherent. From the fact of there being no cartilaginous framework in the lips, they are very flexible and lend themselves to the most varied expressions.

There is another small surface-muscle, called specially *Risorius* or *Laughing* Muscle, which acts together with the *Zygomaticus Major*, to produce a laughing expression. See Figs. 12 and 13.

After having well mastered the anatomical characteristics, and having laid on your board a certain quantity of clay, draw on this mass a horizontal line to represent the division of the lips ; then with your callipers measure the distance from corner to corner of the mouth, and set this distance off on your horizontal line. Turn your board and the plaster model sideways, and work in profile—with small balls of clay—the outline of the middle with its projections and depressions ; do the same from the opposite side-view ; then stand in front of the work, and with the work executed from the profile as your guide, fill in the rest,—always keeping slightly below the volume.

You may then at once apply your anatomical knowledge, and lay the superficial muscles on in separate, well-defined strips, rather exaggerating their form than drawing them with indecision. See *Photograph* of mouth in three stages, Figs. 14, 15 and 16.

And now you ought to proceed by section,—that is, by studying your work from below and above,—taking good care that you look at your model and your work from the same point of view, from below and above, so as to compare them and try to obtain the same contours from these points of view. Thus you will correct what you have done so far.

Then look at your work and the model from a three-quarter view, and correct it from that point of view.

Having worked your masses well together from these different points, you proceed to work by light and shade and the numerous half-shades: this I call *Colour*, and I shall use the expression "colour" in this work entirely in the sense of *light and shade*. You must be careful to place your work in the same effect of light as the model, and in a strongly projected light from the side, which will give you a greater variety of shades than a light from the front,—in the latter, numerous small depressions pass unobserved, so that the result would be a surface without life and movement.

With the help of this working by colour, and by frequently turning the work and model so as to gain different effects, and

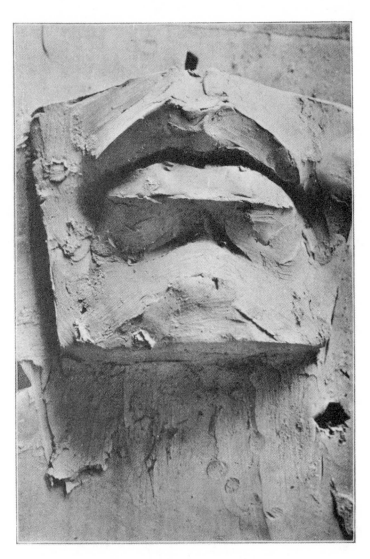

Fig. 14.

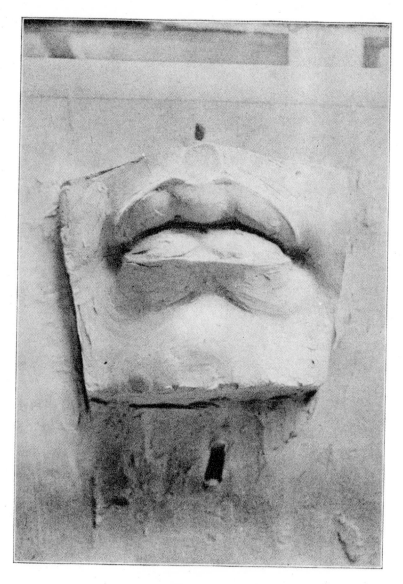

FIG. 15.

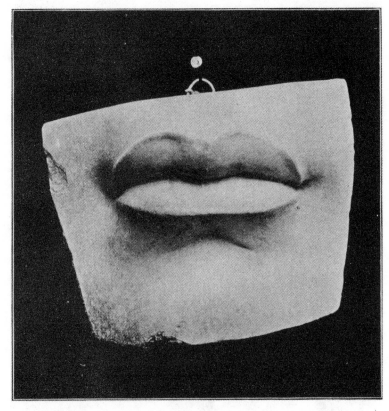

Fig. 16.

different points of view for your drawing, you will at last arrive at the simple form of your model. In short, you must always correct your work by drawing, and must try to obtain simplicity by colour, and expression by your knowledge of the form. Observe that work done in a side-light will always look well when turned to the front; whilst, on the other hand, work done in full light will from a side-view look uneven and undecided in its planes.

Take care not to use the tool too much; it will prevent you from acquiring suppleness of the hand and from developing a fine touch. The human finger, more firm and sure than the wooden tool, will best transmit the intentions of the artist, and express them in varied degrees; the finger is an intelligent, energetic, I might almost say an intellectual, instrument, and you must always use it wherever you can get it in, and only use the wooden tool in places where the finger cannot get in.

SECOND FEATURE.—THE NOSE

The nose is formed partly by *bone* and partly by *cartilage*. The two elongated *Nasal Bones*, joined to the Cranium just below the *Glabella*, form the bridge of the nose, and are supported at the sides by the ascending processes of the Superior Maxillary; to their anterior border are attached the *Lateral Cartilages* of the nose. There are five principal cartilages, an

upper and a lower Lateral cartilage on each side, and a median
one between the two halves of the nose. See Figs. 6 and 7,
page 11, and Fig. 12, page 14.

The lower lateral cartilages support the wings of the nose.
There is a vast difference in the shape of the nose in races and
in individuals, owing to variety of form in the arch, as well as
in the cartilage. The muscles but slightly conceal the shape of
the bone. The principal muscles from the artist's point of
view are:

(*i*) The *Pyramidalis Nasi*, which is really only a con-
tinuation of the big Frontal muscle;

(*k*) The *Compressor of the Wings*, which envelops the sides
of the nose below the previous muscle;

(*l* and *m*) The very diminutive *Anterior* and *Posterior
Dilators of the Nose*, at the side of the nose, and hardly visible;

(*n*) The *Depressors of the Wings of the Nose;* and

(*o*) The *common Levator of the Upper Lip and Nose*. Refer
to Figs. 12 and 13, page 14.

When you have well studied the position and characteristics
of these bones and muscles, erect your board in the same way
(vertically) by the side of your model. To give the better
support to your work, make a *small* butterfly, which ought to be
inside the most projecting part of the nose, taking care to make
it sufficiently small, so as not to allow the ends to show or stick
out of your finished work.

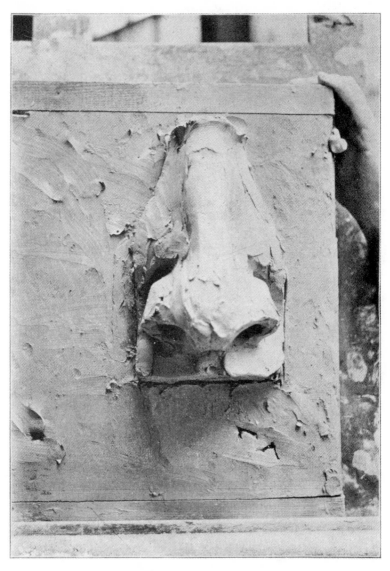

FIG. 17.

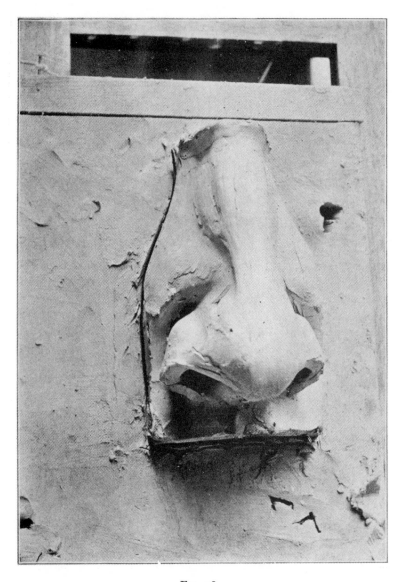

FIG. 18.

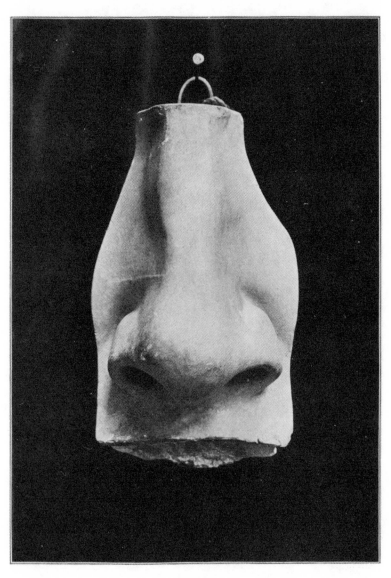

Fig. 19.

Proceed then in the same way as for the beginning of the previous feature, *i.e.* moisten your board, make a clay paste on it, and let me say, once for all, that this has *always* to be done on starting modelling on a background. Having put on a sufficient mass of clay to cover the cross and give the size of your model, you measure with callipers the length of the nose, and at once start to work the profile, first from one side, then from the other, then from below and above, to get the outlines of wings and nostrils sharply indicated ; then you take the three-quarter views, and at last the colour, in a side-light, thus modelling and drawing alternately from every point of view, to correct your work wherever you see a mistake, until it is satisfactory. I would particularly warn you not to round off too much the tip of the nose, but well show the planes. See Figs. 17, 18, and 19.

Third Feature.—The Ear

For our purpose the outer ear, or *Auricle*, is all that is needful, whilst the Anatomist proper has to study carefully also the parts of the ear hidden from view.

We have to examine in the Auricle the external and the internal face, and observe that the *depressions* of one side are the *protuberances* of the other.

The framework of this feature consists not of bone, but of

cartilage, much turned and twisted, which descends right into
the Ear-Passage, where it is attached to the bony structure of
the skull; the cartilage does not descend into the lobe of the
ear, which is made up of areolar and fatty tissue.

The outer curved rim of the ear is called the "*Helix*"; it is
generally more or less folded over at the upper part; within
this curve, and parallel to it, is the shorter curve of the *Anti-
helix*, a ridge which surrounds the deep *Shell* or *Concha*, that
leads into the Ear-Passage or *Auditory Meatus*. Its upper
part branches off into two ridges between which lies a small
Fossa, which loses itself under the overlapping part of the
Helix.

In front of the Concha, protecting, as it were, the opening
into the ear, is the *Tragus*, presenting a convex form to the
outside. Immediately behind its lower part is a deep notch
(—the point from which we take our measures for the face—),
behind which rises another protuberance, called the *Antitragus*,
and below it extends the *Lobule* or *Lobe* of the ear. The
muscles which lie on the Tragus and Helix are very insignificant,
even the three Auricular muscles, which fix the ear to the skull,
are so small and thin, that they hardly influence the surface-
form. The ear is covered with a fine and smooth skin, which
closely follows all the depressions and projections of the
cartilaginous framework. (Fig. 20.)

The process of working will be the same as indicated for the

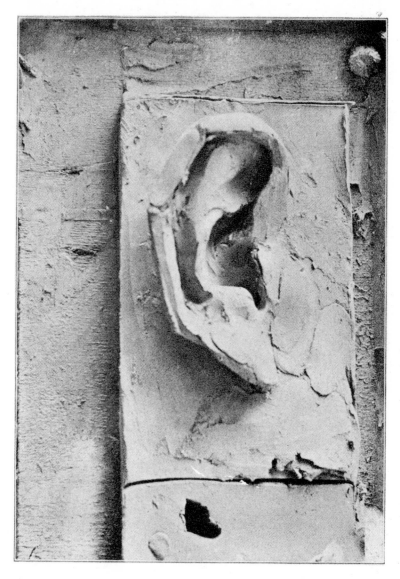

FIG. 21.

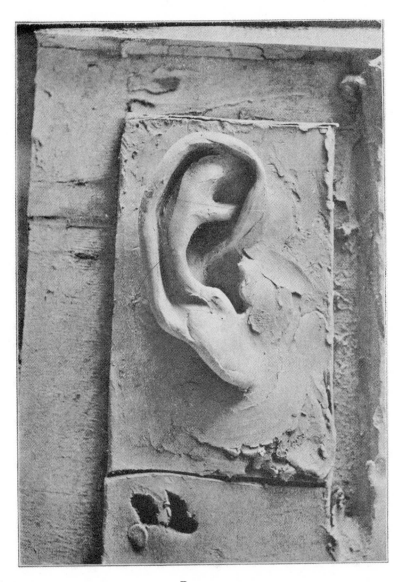

Fig. 22

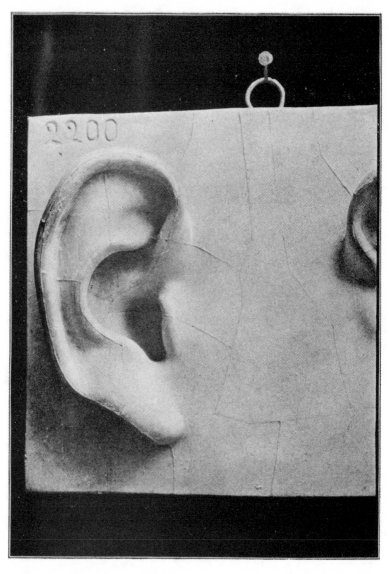

Fig. 23.

previous studies; only let me repeat that the principle of drawing and working by colour-effect is the only principle I shall insist upon for all our studies, whether they be from the cast or from nature. That is why a modelling-student must above all be a good draughtsman, for drawing will give him not only precision in the form, but it is also the only means of making his work graceful and telling,—a quality of work which can never be obtained by him who cannot draw, and whose work will always remain heavy and common-place. Therefore when you have under-

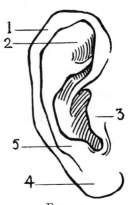

Fig. 20.

1. Helix. 4. Lobe.
2. Concha. 5. Antitragus.
3. Tragus.

stood the why and wherefore of each form, and know it by heart, drawing will remain the most important part of your work. See Figs. 21, 22, and 23.

Fourth Feature.—The Eye

The eye lies in the socket, called *Orbit*, which is formed by various bones.

The Frontal Bone forms the roof of the cavity itself, its upper border, on which the *Supra-Orbital Ridge* and the *Superciliary Eminence* are well defined. Where the Supra-

Orbital Ridge terminates, in the *External Angular Processes*, the Malar Bone continues the outer wall and part of the lower border of the Orbit, which is completed by the Nasal Process of the Upper Jaw-bone. See Figs. 6 and 7, page 11.

The shape which the orbit presents in the skull is a somewhat irregular rectangle, within which rests the Eye-Ball or *Globe* of the Eye, held in its place by the four straight and the two oblique muscles of the eye-ball, which are entirely hidden from view; they surround the Optic Nerve, and only interest us on account of the influence they exercise on the movements of the eye-ball. They *rotate* the eye-ball, moving it respectively outwards, inwards, upwards, or downwards.

The Globe of the Eye consists of a large sphere, the opaque white *Sclerotic*, and the segment of a smaller sphere in front of it, corresponding with the round, transparent, and prominent *Cornea*.

Through the Cornea we see the *Iris*, having in its centre the round opening of the *Pupil*, which shows as a black spot and admits the light into the interior of the eye. I dare say you have all observed its faculty of contracting in a strong light and dilating in a diffused light; and that occasionally the size varies on the right and left of the same person.

The eye-ball lies with the greatest ease in the ample socket, being surrounded by a larger or lesser quantity of fatty tissue, on which it rests, and which fills the empty spaces and corners

of the hole. The connection with the eye-lids is managed in front under their surface by a very loose *mucous membrane*, which allows the lid to move easily over the eye-ball. The muscles of the eye, which to some extent affect the surface, and therefore our work, form—

The *Palpebral* Group ; these consist of—

The *Levator of the Upper Lid*,

The *Tensor of the Lid*, and

The *Orbicularis Palpebrarum*.

The *Eye-lids, Palpebræ*, or *Tarsi*, are supported by thin fibro-cartilage ; its outer border constitutes the margin of the lid, and causes the comparatively flattened, thick edge of the lids. At the *outer corner* the junction of upper and lower lids forms an *acute* angle ; not so at the *inner corner*, where the small *Lacrymal Fossa* interrupts them. This *Lacrymal Fossa*, into which the *Lacrymal canals*, coming from the tear-bag, empty themselves, and which slants towards the nose, contains a small pink elevation, the *Caruncle*. The skin covering the eye-lids is very thin and contains no fat.

The *Levator of the Upper Lid* is rather deep-lying within the orbit, and is hidden by the *Orbicularis* muscle.

The *Tensor of the Lid* draws it inwards, and appears almost to be a deep-lying part of the *Orbicularis*. This latter, a thin, broad, elliptical sheet of muscular fasciculi, by its *palpebral* portion covers the lids, and by its *orbital* portion covers the

margin of the orbits ; it is slightly attached to the Malar Bone at one point, and its fibres blend with those of the surrounding muscles of the forehead, cheek, and occasionally with those of a nasal muscle.

Its action is to close the eye for sleep as well as in various emotions, and in closing the lid it moves the outer angle of the opening towards the inner. The inner angle, being held in place by the *Tendo Oculi*, does not move appreciably ; it is therefore a useful point for us to measure from. See Figs. 12 and 13.

The Orbital part of this muscle has a great effect on the skin of the surrounding parts of the face, and its contracting action causes the wrinkles and folds of the skin at the outer corner of the eye. You will have to study its action very carefully from your Anatomy-books, and from your own face with the help of the looking-glass. I can here do no more than give you a hint what to look for. The late Dr. Bellamy, in his lectures at South Kensington, used always to impress on his Anatomy students that they carried their own skeleton about with them. I beg to repeat this, and to point out to you that study before the looking-glass will reveal and make clear to you anatomical details, such as your unaided eye can hardly see in the model. See Figs. 24, 25, and 26.

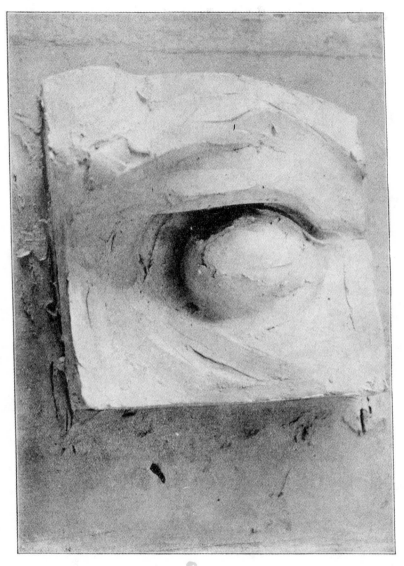

FIG. 24.

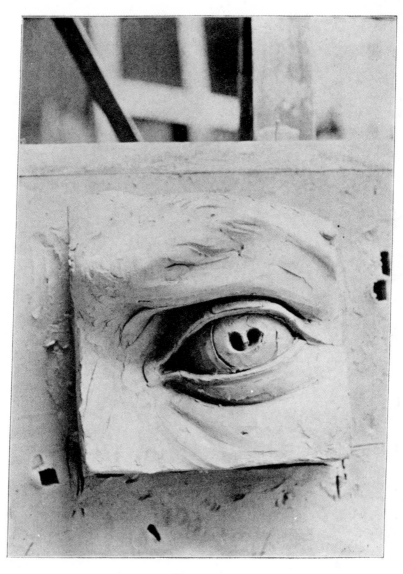

FIG. 25.

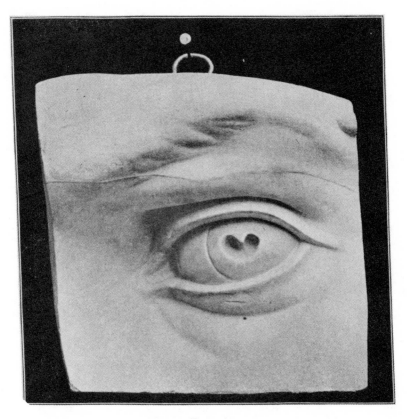

Fig. 26.

THE HEAD

The Skull, or bony part of the Head, consists of two distinct parts, the *Cranium* and the *Face*, each part being again composed of several bones. On comparing several skulls with each other, we notice great variety in their development; some are more developed in front and above, others more at the back, others, have their development in breadth. If you take the oval-shaped "Foramen Magnum" as a point of centre, and compare the extension of the skull in front and at the back of it (see Figs. 27, 28, and 29, you may take it as a general rule, that, (—in races and in individuals), where the back portion of the cranium is of larger extent, the instincts predominate over mental capacities; and, *vice versâ*, where the forehead and upper part of the skull are more developed, mental faculties predominate over instincts. In the African, *e.g.*, you see the forehead receding and the Occiput largely projecting, as if it must balance the projecting chin; in the European, on the contrary, you see the Facial Line almost vertical, and but little projection at the Occiput. When you have a chance of observing the skulls of different nations,

races, and individuals, I would advise you to compare carefully
and to take notes of their diversity, as I have not time to do
more than direct your attention to the great variety in the
subject.

The skull consists of several bones articulated by the

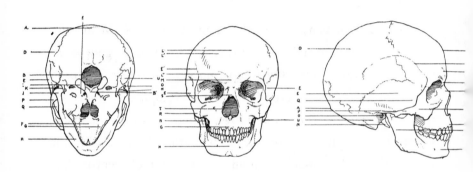

FIGS. 27, 28, AND 29.—BONES OF THE FACE.

A. Occipital.
B. Foramen Magnum. B'. Basilar process.
C. Occipital Condyle.
D. Parietal.
E. {E. Temporal. E'. Temporal Ridge. E''. Squamous Portion. E'''. Petrous.
F. Palatine.
G. Alveolar. Upper Jaw-bone.
H. Lower Jaw-bone. H'. Ramus of Jaw-bone.
J. Glenoid Cavity.

L. {L. Frontal. L'. Frontal Eminence. L''. Superciliary Eminence.
M. Glabella.
N. Styloid Process.
O. Auditory Foramen.
P. Zygoma.
Q. Sphenoid.
R. Malar.
S. Nasal.
T. Ethmoid.
U. Mastoid.

Sutures which belong to the *immovable joints*. In some of
these Sutures the edges of the bones are *serrated*, in others
they are *bevelled* and *overlapping*, others are deeply *indented;*
in short, there is a great variety in their articulations, and

no movement can occur at these joints; yet they allow of continuous growth of the bones, for a thin layer of fibrous membrane intervenes between bone and bone. The sutures become *osseous* in old age. When they unfortunately become so in young children, the brain can no longer expand, and the result is *idiotcy*.

The bones forming the outer surface of the Cranium are :—

The *Occipital*,
The two *Parietal*,
The *Frontal*,
The two *Temporal*,
The *Sphenoid*, and
The *Ethmoid* bones.

The four first-mentioned are the larger ones.

The *Occipital* bone, or *Occiput*, is the lowest and hindmost bone of the Cranium, by which the head is joined to the neck. It is convex to the exterior; its lower part contains the opening, called *Foramen Magnum*, through which the *Spinal Cord* passes down from the brain; on the right and left of this opening are the *Occipital Condyles*, which fit into the articulation of the *Atlas vertebra*, and are so arranged as to allow facility of movement with great security. The part anterior to the Foramen Magnum, called the *Basilar Process*, is joined to the *Sphenoid Bone*; the part posterior to it forms the *Occipital Protuberance* (see Fig. of skull) which gives attachment to the *Ligamentum Nuchæ*,

the *Trapezius* muscle and to the *Occipito-Frontalis* muscle. This is the most projecting part of the back, and also the thickest part of the bone.

As the Occiput forms the back and base of the Cranium, the *Parietal Bones* form its sides and summit; the wall being continued forward by the *Frontal Bone*, which constitutes the upper part of the face, the *Forehead;* it forms the root of the nose and the upper border and inner roof of the Orbits, and part of the base of the Cranium, which is completed by the Sphenoid and Ethmoid bones; but as these latter hardly come to the surface, with which our work is concerned, I only mention them.

The *Frontal Bone* shows various eminences, ridges, and processes, which you must study on the dried skull as well as on the living model. On each side of the forehead you see above the Temples the *Temporal Ridges*, which limit the Temporal Fossæ and lose themselves at the back behind the ear, and in front terminate at the *External Angular Processes* (which join the Malar bones below). From these external angular processes start in an inward direction the *Supra-Orbital Ridges*, which form the upper margin of the orbits, and are continued to the root of the nose, which produces more or less the indentation that you observe in the profile. The smooth, broad part of the frontal bone above this indentation is called the *Glabella;* on

each side of it you observe the *Nasal Eminence,* from which the *Superciliary Eminence* starts in a slightly curved ridge. The space between the Superciliary Eminence and the Supra-Orbital Ridge contains the *Frontal Sinus.* This Sinus consists of an air-space between the outer and inner layers or *tables* of the bone, and, by means of a corresponding sinus in the Ethmoid bone, this air-space communicates with the nose. These sinuses evidently serve to increase the anterior part of the base of the Cranium ; they do not exist in childhood, are smaller in women than in men, and diminish in old age. They do not, as is often supposed, indicate an extra development of the cerebrum, but probably give resonance to the voice.

Above the superciliary ridges, and separated from them by a depression or furrow, we find the *Frontal Eminences,* and between them in the Median Line a vertical ridge, indicating that in early life the Frontal Bone consisted of two halves.

The two Temporal Bones occupy a semicircular space on the sides of the Cranium, between the Occipital, Parietal, and Sphenoid bones. They are somewhat complicated in shape, consisting of four portions, the *Petrous, Squamous, Mastoid,* and *Zygomatic* portions, which meet round the ear-passage. The wedge-shaped *Petrous* portion, containing the organ of hearing, fits into the base of the skull ; from the side of the *Auditory Meatus* the *Styloid Process* projects into the neck, there to serve as attachment to several muscles and ligaments.

The *Squamous* portion of the Temporal Bone occupies the space above the ear and most of the Temporal Fossæ. The space behind the ear is taken by the *Mastoid* portion with its large *Mastoid Process*. This latter is filled with air-cells, which assist the organ of hearing. To the surface of the process various muscles are attached. It is small in children and largest in the male sex. In front of the ear there extends in a forward direction the fourth portion of the *Temporal Bone*, the *Zygomatic Arch*, which is joined in front to the posterior part of the *Malar Bone;* beneath it and protected by it, the *Temporal Muscle* and the great blood-vessels pass freely ; to its lower border the *Masseter Muscle* is attached. The *Zygoma* at its base is attached to the *Squamous Portion* of the bone by three ridges, two of which pass inwards, and form the *Glenoid* cavity, into which the condyle of the lower *Maxillary* is articulated.

The *Sphenoid Bone*, a single bone which is wedged in and touches all the other bones of the Cranium, is hidden from view. Its body completes the base of the skull, supports the *Septum*, completes the *Orbital Sockets*, and by two extended processes fills in the space in the *Temporal Fossæ* between the Frontal, Temporal, and Parietal bones.

The *Ethmoid Bone*, also a single bone, completes the base of the Cranium between the Sphenoid and Frontal bones. It is like the former bone, more interesting to the anatomist than to the artist, as it nowhere comes to the surface in the living form.

Of the bones of the face, only the *Malar* bones, the superior *Maxillary*, the *Nasal* bones, and the *Lower Jaw-bones* show on the outer surface. The *Malar* bones are the two thick quadrangular bones clearly discernible in the face. The body of the bone sends out three processes, the longest of which, the superior or *Frontal* process, joins the *External Angular* process of the frontal bone, and completes the outer border of the orbit; the *Posterior* or *Zygomatic* process completes the *Zygomatic Arch*, the *Anterior* or *Maxillary* process lies on the upper jaw-bone and helps to form the lower margin of the orbit; the deeper parts of the *Malar* join the superior *Maxillary*, *Sphenoid*, and *Frontal* bones.

As for the Jaw-bones and Nasal bones, I beg to refer you to pages 11 and 12, where I have already given you a sketch of them, for the features of mouth and nose.

MUSCLES OF THE HEAD

Refer to Figs. 12 and 13, page 14. We may divide these muscles in groups under two heads:—Muscles with *Osseous attachments*, *i.e.*, which are attached to the skeleton both at their origin and insertion, and *Cutaneous Muscles*, one end of which is attached to the *Fascia* under the skin; or more conveniently into seven groups: *Masticatory*, *Epicranial*, *Auricular*, *Orbital*, *Palpebral*, *Nasal*, and *Labial*.

To these belong—

The *Temporal,*

The *Masseter,*

The *External Pterygoid,*

The *Internal Pterygoid,* and

The *Buccinator Muscles.* (Refer to Figs. 12 and 13.)

The *Temporal* is a fan-shaped muscle, originating above the *Temporal Fossa* and the surface of the *Temporal Fascia ;* it narrows as it passes underneath the *Zygomatic Arch* into a broad, strong tendon, and is inserted at the *Coronoid* process of the lower *Maxillary.*

The *Temporal* is the strongest of the Masticatories.

Function :—It draws the lower jaw upwards to close the teeth, and also backwards when it protrudes. It is superficial above, but deep-seated lower down. The direction of the *Muscular Fibres* is converging to the tendon.

The *Masseter* is a thick, quadrangular muscle on the lower part of the face. It is attached at its origin to the lower border of the *Zygomatic Arch,* and below to the *Ramus* and *angle* of the lower jaw and the *Coronoid* process. The direction of the fibres is oblique downwards and forwards for the lower layer, and oblique backwards for the upper layer.

Function :—It elevates the lower jaw, draws it forwards and sideways.

The *Pterygoids*. Both the external and internal *Pterygoids* come nowhere to the surface ; they are deep-seated. The internal *Pterygoid* passes from the *palate* and *sphenoid* bones to the inner surface of the *Ramus* of the lower Maxillary ; the external *Pterygoid*, overlying the former, passes from the Sphenoid to the front of the *neck of the lower jaw.*

Function :—The internal *Pterygoid* assists the action of the *Masseter ;* the external *Pterygoid* protrudes the jaw and chin.

The *Buccinator*, or trumpeter's muscle, is a flat, quadrilateral muscle, covered behind by the *Masseter*, but coming to the surface, and filling up the hollow between the *Masseter* and the *Depressor of the angles* of the mouth and below the *Zygomatic Major.*

Function :—It retains the food between the teeth during mastication ; it serves, when the cheeks are inflated with air, to expel the air through the lips, and thus justifies its name of trumpeter's muscle.

The EPICRANIAL *Group.*

This consists of the *two Scalp Muscles and the Corrugator of the Eyebrow.* The two *Scalp Muscles*, the *Occipital* and *Frontal*, are joined into one muscle by the *Epicranial Aponeurosis*, and named the *Occipito-Frontalis* muscle. (Muscles joined like that

—or should I say separated ?—by a transverse *Aponeurosis* are called *Digastric* muscles.)

The *Occipital Portion* is attached to the outer two-thirds of the superior curved line of the *Occiput* and to the *Mastoid Process*.

The *Frontal Portion* is attached to the external angular process of the frontal bone, and to the nasal bone (I have already pointed out on page 18 that the *Pyramidalis nasi* appears to be a continuation of the frontal muscle). Between these two bony points of attachment, the *Fasciculi* of the *Frontalis* mingle with those of the *Orbicularis* and the *Corrugator* muscles. Both portions of the scalp muscle are broad and thin ; of the same breadth, but longer than either is the connecting *Aponeurosis*, which covers the summit of the Cranium.

Function :—The occipital portion draws the scalp backwards; the frontal portion elevates the eyebrows and causes the transverse wrinkles on the forehead.

The *Corrugator Supercilis* is a small deep muscle covered by the *Orbicularis Palpebrarum*. It exercises considerable control over the frontal muscle by drawing the middle of the eyebrow downwards and inwards, and thus *corrugating* the forehead, as its name implies—that is, causing the vertical folds in the middle, which express suffering or frowning.

The *Eyebrow* itself consists of fatty tissue mixed with muscular fibres, and it contains the roots of the hairs. Observe

the directions in which these grow and the arch they form.

I need not again indicate the muscles of the *Auricular, Ocular, Palpebral*, and *Labial* Groups, as I have drawn your attention to them in describing the different features; and besides—let me say it again—in mentioning anatomical features, my aim is not to write an anatomical work proper, but to prepare you for the anatomical lectures you ought to attend; or, failing that, if lectures are not available, the special books on Artistic Anatomy. You ought to work particularly with the bones in hand, as, for sculpture, *Osteology*, or the science of bones, is of still greater importance than *Myology*, or the science of muscles.

Thus in giving you later on an outline of the skeleton, I shall do so in order to point out to you those places where the *movement* takes place, *i.e.* where you have to look for it when you are face to face with the model.

PART II

PART II

THE BUST

BEFORE beginning the study of a head from Nature, it is necessary that the student should copy at least two busts from the plaster-cast, such as the head of Lucius Verus (Græco-Roman) and The Lawyer (see photograph of bust in three stages, published by Chapman and Hall) by Donatello, or the Laughing Faun (bust from the antique). In the same way as the features taken from Michel-Angelo's David, these three busts possess all the qualities desirable for the study of form. The anatomy in them is so clear, the division of masses so plain, that with a little reflection the student easily understands what each form is meant to express. As far as construction goes, they are perfect ; in short, they are splendid busts, the study of which can only elevate the taste of the student. No doubt, in choosing these models for the first studies from the round, I differ from a great many teachers, but in my opinion one should not give beginners examples to copy, the qualities of which consist in the beauty of style, qualities which a beginner cannot understand, or at

least cannot appreciate at their full value. Our taste is only formed in the course of time, and only after a succession of serious studies do we arrive at the true appreciation of those master-pieces, and can learn from them. The great apparent simplicity of antique statues has suggested the idea of giving them as copies to beginners. But these at first sight simple contours are in reality refined to such delicacy and so exactly correct, that the least deviation by the student who copies them utterly spoils them.

And as to the admirable modelling of these antique statues, why, there is nothing in the world so difficult as to render these learned simplifications and this exquisite delicacy. We should leave to these inimitable works their true and superior task of instructing by example. Let us have them reproduced by casts taken from them direct, and place these casts to be studied and admired before young artists, when they are capable of understanding the lesson they teach!

If we put before a beginner a head, the beauty of which consists only in style, where the construction is slightly neglected, where the anatomy and mechanism are not evident, he will only see the surface, and try to reproduce a polished surface, without seeing the beauty which may be in the model, but which he cannot understand. (It would be just as senseless to expect a child who does not know his scales to play a sonata of Beethoven's.) The greatest harm resulting from such a

proceeding will be that, when the student comes to model from Nature, he will not understand what is before him, and will model as he did from his antique copies a round and polished form, without heed of anatomical construction. He may go on working all his life without making any real progress. We ought from the beginning of our studies to understand what is before us, to find the reason for each depression and each projection, regardless of the time it takes us to analyze them.

When we have learnt the reason, our studies will proceed fast enough ; and when we have mastered the principles and laws of Nature, we can give free scope to our personal sentiment. Then there will be no more need of a teacher ; for, to impose a style on a student, without knowing whither his bent, his temperament, tends, is a crime. For is it not killing in him the artistic germ by imposing on him one's own way of looking at Nature ? He may only become an imitator of his master's style, and never a good imitator, unless he happens to be of absolutely the same temperament.

I have said before : " Individuality makes the artist." Mind you do not misunderstand the word ! Do not strive to be original, for the result of such an effort is often deplorable, as many people have confused eccentricity with originality ; the word " personality " will perhaps better convey my meaning.

Unfortunately it is not given to every one to have a distinct

personality or individuality; few have this supreme gift; and
for the others, my advice is to seek in the branches of Indus-
trial Art employment for which their studies have well qualified
them. It is a well-known fact that sculptors who have begun
by studying from the human figure can easily adapt themselves
to other branches of the art, and, after short apprenticeship,
soon excel in them, which is not generally the case with those
who have begun with another branch,—say, flowers, ornaments,
animals, &c.

After having modelled two or three heads from plaster-
casts, the student may pass on to the study of the living model,
the head from Nature. I need hardly say
that this study of a head must be repeated
and con inued for a long time.

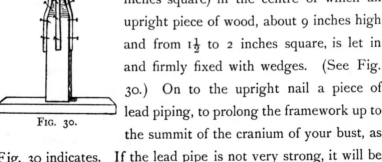

Provide yourself with a wooden model-
ling-stand—that is, a board (about 18
inches square) in the centre of which an
upright piece of wood, about 9 inches high
and from $1\frac{1}{2}$ to 2 inches square, is let in
and firmly fixed with wedges. (See Fig.
30.) On to the upright nail a piece of
lead piping, to prolong the framework up to
the summit of the cranium of your bust, as

FIG. 30.

Fig. 30 indicates. If the lead pipe is not very strong, it will be
advisable to have two butterflies suspended from the top, one

for the front, one for the back of the head. The advantage of using lead piping consists in its movability, if one wants to change the action of the head during work, without destroying what one has already done. A framework, for whatever study, should always be strong, and at the same time malleable, after being covered with clay. It is therefore very important that the student from the beginning should make his frameworks very carefully, as by that he will save time in the end.

When the framework is finished and placed on the turntable, you proceed to wet the board and pipe and make a good clay paste over them. Begin by covering your framework at the neck, at the level of the collar-bone ; *i.e.* put a ball of clay, about 1 or 2 inches projecting, in front of the lead pipe, and the same at the sides and back of the pipe, so as to make sure of having the latter well in the centre of the neck. Taking this mass of clay as your guide, you raise a column of clay right up to the top of the head, and then complete your column in a downward direction to the board on which your frame rests. I lay stress on your placing your pipe well *in the centre* of the bust ; if you do not, you are sure to have it come out at an inconvenient place, where you cannot push it in without destroying some of your modelling. (See Fig. 31.)

After having built up this column of clay, turn your work so as to face the profile ; calculate or measure (from the place where you fixed the articulation of sternum and collar-bone) the

height of the chin, and mark this place by a horizontally projecting, small peg, of about the thinness of a match ; place at once a sufficient amount of clay from the neck to the projection of the chin,—always pressing each fresh ball of clay well on to the preceding layer, so as to make it adhere and avoid air-holes. Pay attention to getting the right projection

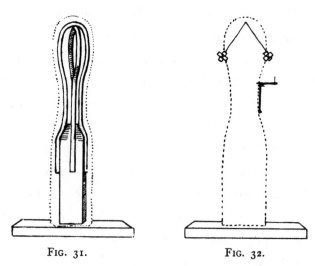

Fig. 31. Fig. 32.

from neck to chin *at once* (by measuring and using the plumb-line), else it might happen afterwards that you had to cut into the neck, which would expose your pipe. This happens nine times out of ten to pupils, who, in their hurry to get expression into their work, or even to build up the hair, consider these instructions as insignificant details. It would be better to increase the projection than to make it too short. (Fig. 32.)

Then continue in an upward direction to put in the projection of the face up to the top of the cranium, so that you get a general line of the profile (see Fig. 33), and go on continuing this outline to the back of the head, all the while keeping slightly *under* the actual dimension.

When you have thus set up the profile, front and back, face your work, and add—with the projection of the profile as your

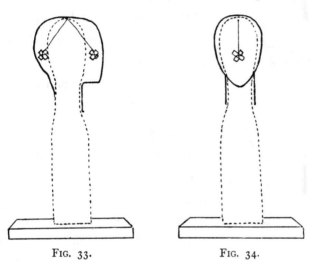

FIG. 33. FIG. 34.

guide—sufficient clay at the sides to make an oval, on which to work the detailed features of the face (Fig. 34), always putting on less clay than the actual volume finally required.

Turn again to the profile, and from the previously fixed point at the top of the sternum—the *supra-sternal notch*—add the profile of the sternum, which you will find to consist of

three planes, mostly in an outward and downward direction. Then place the collar-bones starting from the *manubrium*, or upper part of the sternum, to the shoulders ; fill in the angle between sternum and collar-bone by placing the great *pectoral* muscle ; then at the back find the approximate place of the last *cervical* vertebra, *i.e.* the *nape of the neck*, and fill in the place

from there to the shoulders with part of the *trapezius* muscle. All these pre-liminaries carefully executed will save you a great deal of difficulty later on. I have already mentioned that you should roll the clay in your hands before putting it on, as this will prevent your work from being too rough, and will assist precision in the superstructure. (Fig. 35.)

Fig. 35.

It is well at the beginning to make your model *stand* by your modelling table, or *sit* on the throne, so that his head should be at the level of your work ; and make him hold his head quite straight and upright at the beginning,—without regard of the pose you wish to give him afterwards,—as this will greatly assist you in getting the proportions and measurements well established.

Having thus prepared the foundation for your work, you

begin very carefully to take the following measurements with a steady pair of callipers :—

1st. The distance from *ear to ear*, taken from the deep notch between *Tragus* and *Antitragus* (see Fig. 36A and B). Set this measurement off on the two sides of your oval, and mark the points by two pegs of wood or matches (I advise you to take matches, and I shall just call them " matches " in future, as these are firm, without being too thick), pushing the wood in so far that

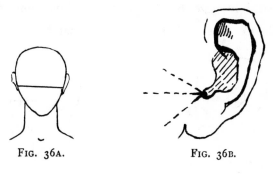

FIG. 36A. FIG. 36B.

the extreme projection will just be the exact measure. Of course, before settling the place for these notches, you must make a fairly accurate calculation how high above the sternum and how far back with regard to the chin they will be. The preliminary use of the plumb-line is therefore much recommended, and do not shrink from taking a little extra trouble, for these two points are the starting-points for all your measurements of projection. Note also from the front whether the two points are horizontally on the same level. When you feel

pretty sure of having got your matches at the right points, put some clay round them to keep them in place.

2nd. Then turn your model and your work to the profile, and by means of a ruler or any other straight-edge, held at arm's length, in a horizontal position, ascertain the relative position which the tip of the nose bears to the notch of the ear, *i.e.* whether it is just in line with it, or above or below. Try to carry the difference, if there is any, well in your eye when you hold the straight-edge before your own bust, and mark the point for the tip of the nose by another match. Compare this

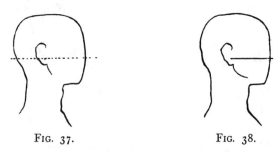

FIG. 37. FIG. 38.

well from the other profile, so that you get the nose well in the centre line of the face. (Fig. 37.)

3rd. Measure on your model the distance from the notch of the ear to the most projecting part of the nose-tip (Fig. 38) (take this measure on both sides, for you will frequently find that the distance on right and left side varies), and set off the measurement on your bust ; and when you have arrived at the true projection from both sides, push your match in until

its projection will accurately mark the point. Thus you will have obtained not only the distance from ear to nose, but also the central part of the face. Build the nose up, so as to make your measure firm.

4th. From the tip of the nose measure the distance to the most projecting part of the chin, *i.e.* the subcutaneous *mental eminence*, and then put one leg of your callipers gently but firmly on the measure for the nose, and strike an arc on the chin. Hold the callipers with one hand, and with the other place the indispensable match in the centre of your arc, letting it project sufficiently. (Fig. 39.)

Fig. 39.

5th. To make sure of the correctness of the previous measure, you now take the distance from the ear to the mental eminence (see Fig. 40) in your callipers, and if this measure, taken from both ears of course, coincides with the previously fixed point on the chin, your measure runs a fair chance of being correct. If it is not, you have to alter the place of your match—pull it out, or push it in—and retake both measures, until they agree.

6th. Measure the distance *from the chin to the beginning of the hair*, by placing one leg of your callipers on the match marking the mental eminence, and striking a small arc above the forehead. (Fig. 41.)

Fig. 40.

7th. Take from the profile the distance *from the ear to the beginning of the hair,* and intersect on your bust the last described arc. Take the measure from both sides, and when your intersections agree, insert your match. (Fig. 42.)

I need hardly repeat that these seven measurements must be taken with the greatest care and precision, and should not be changed during the progress of your work, unless you have doubts of their being correct. In that case, you have to take

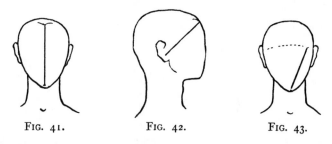

FIG. 41. FIG. 42. FIG. 43.

them *all* again, for by altering one, you throw the others out of proportion, and the fault is often not where you believe it to be. Take care also to keep their extremity uncovered with clay, and do not push them in before your bust is quite finished.

There remains another measure to be taken, which, although not as important as the previous seven, may be very useful. It is the distance from the chin to the eyebrows. You take this measure by describing an arc on the model, in order to find out if the eyebrows are of the same height on either side, and

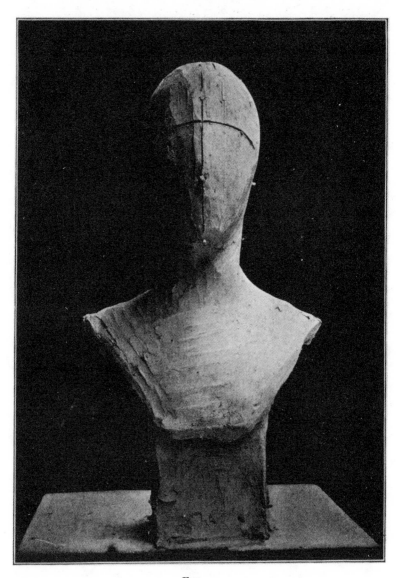

FIG. 44.

set it off in the same fashion on your bust. (Fig. 43, and photograph, Fig. 44.)

In order not to worry the model by repeated measuring, it is a good plan to take your measures down in writing at the beginning. It is best to take a board (or a substantial sheet of paper) on which you draw a straight line. At the extremity of the line mark a point, on which you plant one leg of your callipers, and with the other leg describe an arc intersecting the line, and on this arc write distinctly which measure it is; for instance, "ear to nose," "chin to brow," &c. Having your measurements thus safely on paper, you have the advantage of being always able to verify them after the model is gone, so as to make sure the points have not been moved accidentally.

Now that you have your framework properly made, a certain mass of clay to work on, and the exact proportions of the face, or at least of the principal points, you must set to work at the bony construction of the head in its great lines, its principal projections and depressions. The bones form the framework of the human body, and support the muscles; it is on their proportion and relations to each other that the principal character of a head depends. If the bony construction and projections are not correct, you will never obtain a striking likeness, however good some of the details of your work may be; but, if the anatomical part is well set up, the details will fall into their proper place and help on the resem-

blance. Besides, the taking of these measurements has also
the advantage of accustoming the pupil's eye to *see* correctly ;
for, having fixed points from which he may not depart, he is
compelled to put the intermediate proportions in their right
size and place. After having done such a study a few times,
his eye will be corrected of its bad tendencies, and he will
naturally acquire a true conception of masses, and feel that he
must make sure of some principal points first, instead of piling
up a confused mass without order and intelligence.

Most sculptors nowadays build up their work in the way
I have sketched, although there are many who do not render
themselves a clear account of it, because they have only arrived
at it after much groping in the dark and loss of time. It is,
therefore, not a question of inculcating new and arbitrary ideas
in the mind of the student, but of initiating him at once into
a method and practice at which he needs must arrive in the
end, but would often only arrive by slow and uncertain
ways. To arrive at it quickly, you must proceed with order,
knowledge of the reason why,—in fact, substitute method for
empiricism.

Once the student has grasped that the first study consists
in appreciating the positions of certain fixed points, he will
be able to select others that appear to him noteworthy and
favourable to his work.

The teacher, on the other hand, must carefully watch over

the pupil whose work he directs ; he must make sure that the pupil makes a good and careful start for his work, and get him into the habit of working carefully, so that he may learn to do it in the end instinctively.

Having then regularly followed the course of study that I have sketched, and acquired a certain correct judgment of the eye and a certain skill of hand, he has further in the use of horizontal and vertical lines a steady and positive auxiliary, and will be able to work with order and method.

He will now begin with the orbits (taking as his guide the arc he struck for the eyebrow), by hollowing out two deep spaces at the side of the nose, and indicating the shape of the brow above them, and the form of the cheek-bone at the side and beneath them, so as to have the orbit ready for receiving the eyeball. Then sketch in the forehead, with regard to the formation of the bones ; further add the nose, which you join to the brow ; at the extremity of the nose at once indicate the bean-shaped nostril ; then the lower jaw-bones. Start them from the ears, well observing the angle they form below, and by them join the ear to the previously fixed point of the chin ; indicate the depression between chin and lower lip ; then model the upper jaw, marking at once the two corners of the mouth, well observing their relation to the size of the nostrils. Having indicated the large lines and places,—rather sparsely,—you turn your model as well as your study to the profile, and set the ears

up, regulating their projection again from the front view; then draw the outline of the crown of the head and the back of the head, going on to the outline of the neck (to below the nape of the neck); come back to the front view, and do the side of the neck by laying on the *sterno-cleido-mastoid* muscles from the *sternum* to the *mastoid process* behind the ears, and the *trapezius muscle*. Then, looking from below and from the front, draw the shape of the collar-bone, and from the profile re-draw the oblique line of the sternum, and connect these bones by the *great pectoral muscle*. Go once or twice again over the same ground, by looking at model and study from other points of view, which will give you the projections of the bones; and then from the front give symmetry to the two sides. The *bones* should have their *true* projection as early as possible, for their proportions serve as guides to find the other points, whilst the muscular parts should, up to the last, be left rather below their actual volume.

The more care you spend on this preparatory labour, the less you will feel that uncertainty which is so apt to discourage one, and to destroy one's interest in the model. Need I say that, after this preparatory laying on, you resume your work by starting from the profile view, and *drawing*, as correctly as possible, as if you had a pencil in your hand and the clay were your paper, not only the profile of the face, but also of the back, of ears, neck, chest—in fact, of the entire structure,—comparing

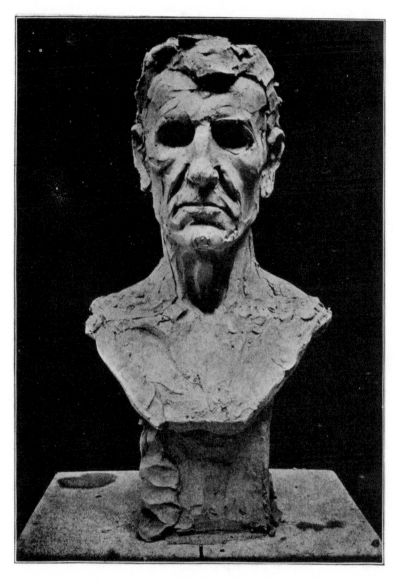

FIG. 45.

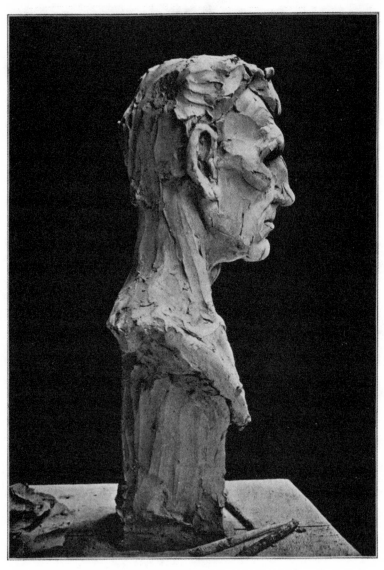

FIG. 46.

the proportions as to length and width, applying mentally hori-
zontal, vertical, and oblique lines from one point to another,
just as you would do in drawing a head. The same process is
to be repeated from the other side, then the outlines of the sides
of the head, looked at from the back as well as from the front.
After this, the three-quarter views must be drawn in the same
way, always taking care that you look at your model and your
study from the same point of view. (See photographs 45 and
46 of bust in clay.)

Having proceeded so far, you may now give a pose or
movement to your bust, if you wish it. If it is a portrait bust,
you should only do so after having attentively observed the
habitual pose of the person you are modelling. Everybody
carries his head on his shoulders in a slightly different way, the
very action of the shoulders has an individual character, so has
the direction of the eye, &c. In short, you must well observe
the characteristic attitude of your model, which in a bust goes a
long way towards the likeness. It would be ridiculous to give
to a timid and simple man the action of a fighting man (a
gladiator) ; a thinker, a philosopher, does not carry himself like
a shop-walker or like a tragedian. In short, no man resembles
another man, either in every feature or in attitude and bearing.

Such observation takes time. You cannot properly execute
the bust of a man who might come to your studio, saying he
wanted his portrait done, and begun then and there,—as

would say to a photographer. You ought to know him first; you ought to see him in his private life, to know what he is really like. Having found out what pose is most natural to him and corresponds most with his character, then you may start work on your portrait; for a bust is not merely the photographic presentment of an instant,—it should be that of a collection of instants, a sort of biography. That is what makes many busts of the old masters so admirable, and that is what you find in many of Holbein's portraits. There are portraits of which you have never known or seen the original, of which you know neither name nor origin, and yet—in their features and bearing— you can retrace their character, their way of living and thinking, the race from which they have sprung; and therein consists a great part of the attraction, of the unconscious admiration, we feel before them.

For a pupil who only makes a study from the professional model, the difficulty is not quite so great, although it will be excellent and desirable that he should also observe in this sense as soon as possible; but what he has to learn first is to proceed carefully and methodically in his work.

He must first give to his model the action which suits his purpose best. The lead framework inside his work will allow him to take a firm hold of the head with both hands, and turn it right or left or slightly inclined, so as to make it like the action of the model. In taking hold of the head, he should

place his hands behind the ears, so as not to touch the latter, and with gentle pressure he will be able to manage the turn in whichever direction he wishes.

Having accomplished this much, you must turn your observation to the *lines of contrast* produced by the action of the model—for, if you turn the head on one side, it follows that the shoulder, in the direction in which you turn, comes forward, and, generally speaking, it will also be higher than the other shoulder whence the action starts. That gives you *four contrasts, two contrasts of line, and two of projection.* (See Fig. 47.) To obtain these on the study, you proceed in the same way as for the head : you take hold of the

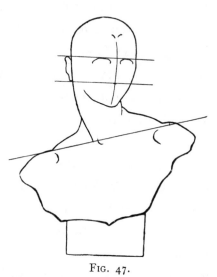

FIG. 47.

shoulders with both hands,—one hand behind the shoulder to be thrust forward, the other in front of the shoulder that is to go back, pulling the former and pushing the latter to obtain the desired action, and on the same principle raising the one and lowering the other.

Now, having settled the pose, the proportions, and to some

extent the construction, the drawing is the *one thing needful* to occupy your hands and eyes.

You may now indicate the eye, or rather the globe of the eye, by placing a round ball of clay in the orbit, trying from the profile view to get the same projection as in Nature with regard to brow and cheek-bone. Lay over this, first the upper eyelid, by means of a rather flattened ball of clay, and here I draw your most careful attention to the two corners of the eyes—-the inner and outer corner ; on them depends the place of eye and cheek, &c. They are, so to speak, *central points*, which give the key to the outlines of the face. If you place them *too deep*, the outlines of the cheek will recede too far, and the nose will stand out too much. If you place them *too low* with regard to the mouth and brow, the nose will appear too short, as they descend too far down upon it, and thus cause the distance between the root of the nose and the nostrils to appear too short. If they are *too far apart* from each other, they will be too far from the centre-line of the nose ; and not only will they make the nose look too big at the root, but will bring the outer corner too far to the side of the face, which will incline you to enlarge the temporal part, and thus make the whole head too wide. Thus you will understand how important it is to fix these points correctly by eye and measurement. A careful measurement from inner corner to inner corner, rectified by another measurement from, say, the centre of the mouth or

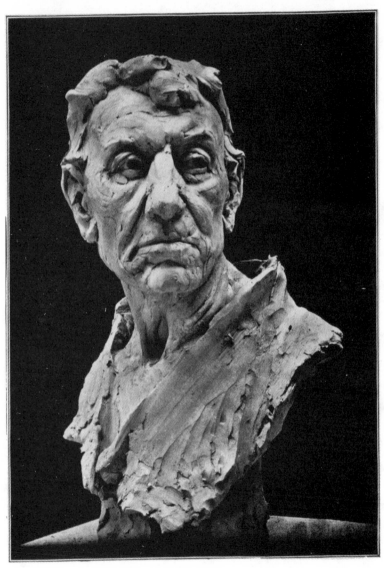

FIG. 48.

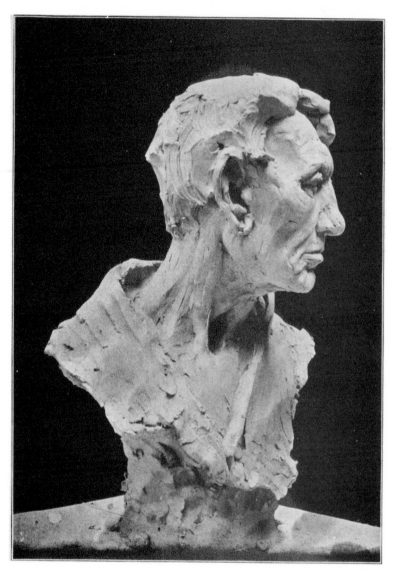

FIG. 49.

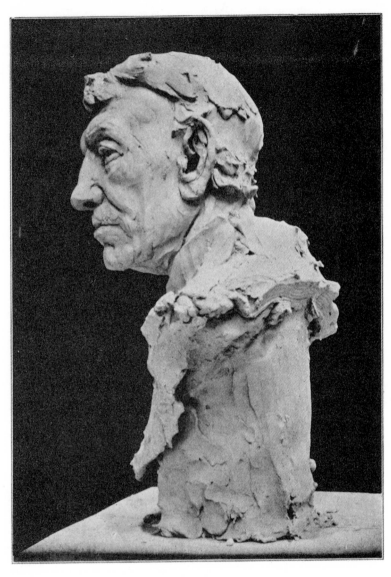

FIG. 50.

the extremity of the nostril, will assist the eye to fix the place. For the outer corners, measure similarly, and observe that the outer corner is *always* higher than the inner corner—a fact to which I have continually to draw the attention of my students ! A smile will further raise these outer corners, whilst a sad expression slightly lowers them. It may assist you to measure their distance from the ear, *i.e.* the notch between Tragus and Antitragus, from which we have taken our other face measurements, and from any other point that strikes you as being an assistance, for the outer corners are as important for the true outlines of the cheek as the inner ones. (See photographs 48, 49, and 50 of head in clay.)

Arrived at this stage, the student ought to turn the model and his own study as often as possible, both to afford him always the same point of view. When I say " turn," I do not mean that the throne should be turned far round, but rather a small distance, say two inches at a time, so as to give you not only direct profiles, but three-quarter profiles and profiles seen from the back, &c. If you carefully work round the model in this fashion, by the time you come back to the front view, you will be able to correct by means of your anatomical knowledge, and to give expression and intelligence to the mechanism of your work.

You should put the hair on with regard to its principal masses, which ought to be laid on in varied planes, for

the suppleness of hair is never obtained by detail, but by numerous planes or surfaces, which give variety of light and shade. Once these surfaces are put in, a few intelligently made touches with the tool (or the jagged end of a broken piece of wood), and a few small balls of clay put in very decidedly, will give much more life and suppleness to the hair than a number of detailed scratches, which will only impart a hard, metallic air to it.

Here I would also advise you to study *how* the hair grows round the face, and that it is paler in colour at its roots. As a painter mixes a little flesh-colour with the local colour of the hair round the face and on the neck, so you must blend its origin in these places with the fleshy parts, so that it does not look *stuck on*, but *growing on*.

After having thus indicated the hair, and drawn and re-drawn the bust from every point of view, and modelled the whole together by an intelligent understanding of the anatomical form, and having corrected every possible mistake from different points of view, you ought to put yourself in a lower position than before, and look up to study the section of every feature on the model, and correct your work from the same point. This has, of course, to be done all round the head, and afterwards you have to mount on a stool and look down on the model and your work, to study the sections of the head and features from above, and correct wherever you find the slightest deviation from the

right outline. Remember that you must particularly study and work up *those parts which are not seen* from the front view ; it is those same points which make the face by showing you the projections, which you could not possibly see if you looked at the model from the front only—(a daily occurrence at the art schools, however much the teacher may try to prevent the students from doing it), the face becomes flat, and is naturally without colour and construction. Therefore, I say again : turn and turn, draw and re-draw, from below and above, as well as all round. Neglect not a single point ;—under these conditions only will your bust be well set up and constructed as a work deserving the name of sculpture.

To *finish*, put your model in a side-light : a strong effect of light and shade is the best to show up the direction of form. It is well understood that you try to put your work in the same light, not only as regards outline, but also with regard to the value of light and shade.

In working from this point of view, be guided not only by drawing, but also by anatomical form for expression, and by colour for simplifying. If you find a shadow too dark, you may be sure that the space is too hollow ; if, on the other hand, it is too light, you may be sure it is too flat, and so on for the half-tints as well. Do not forget that now you must modify your effects as often as possible, and always have model and work in the same effect of light—side-light, of course—for the light from

the front must serve you only to see the result of your work and re-view it, so to speak ; to work in, it is the most dangerous light, as it shows you very little of form, and leads the pupil to polish and fill up without rhyme or reason, so that the result is a heavy, expressionless piece of work. See photographs 51, 52, and 53 of head in clay.

When you are at the finishing stage, it is well to model a little across the form, to obtain a richer substance ; and with very soft clay cover the whole surface with a continuous layer of skin, which will blend the depressions and convexities together. Such details as wrinkles on the forehead, or crow's feet below the eyes, should not be obtained by cutting into the clay, but rather—for the sake of suppleness—by superposing clay which the finger ought to shape into the right form on the work, and which should be very much effaced again, so as not to show too much.

DIAGRAM OF CONSTRUCTION OF THE FEATURES

In the elementary part I have already described the divisions in the *form* of the mouth ; now I wish to draw your attention to the movement of the *planes* at the corner of the mouth. These movements are produced by the *Orbicularis Oris*.

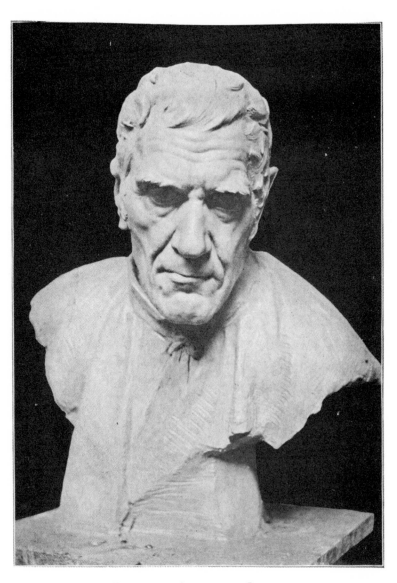

Example of Study from Life.

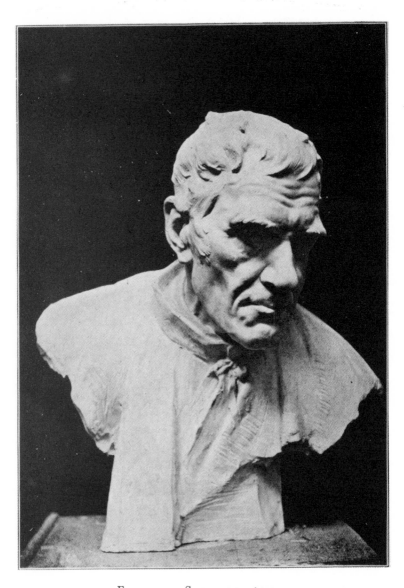

EXAMPLE OF STUDY FROM LIFE

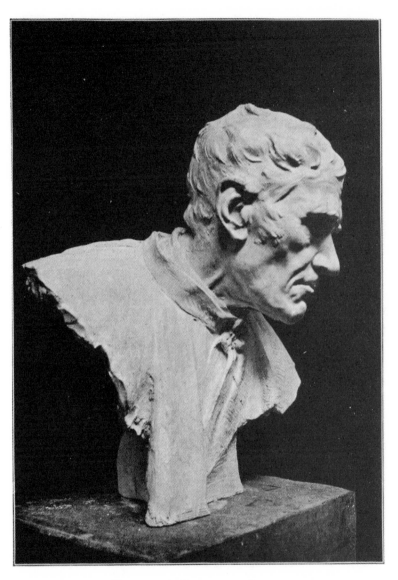

EXAMPLE OF STUDY FROM LIFE.

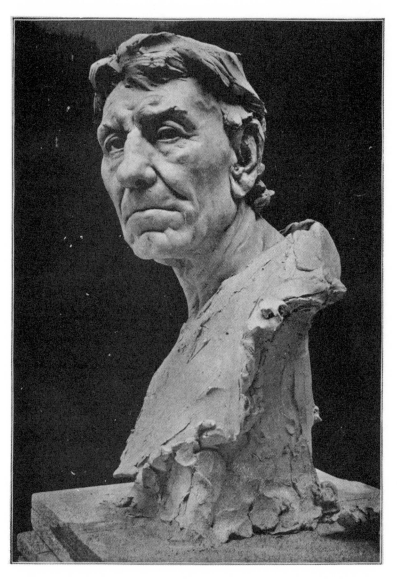

FIG. 51.

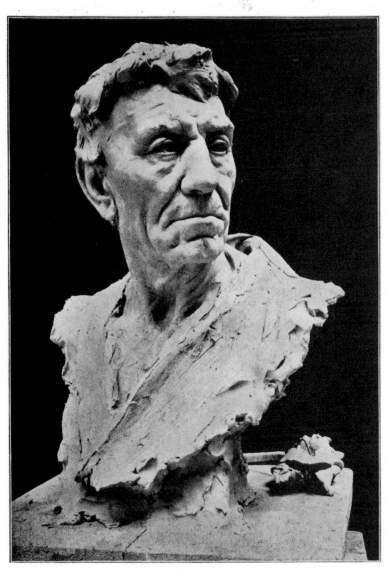

FIG. 52.

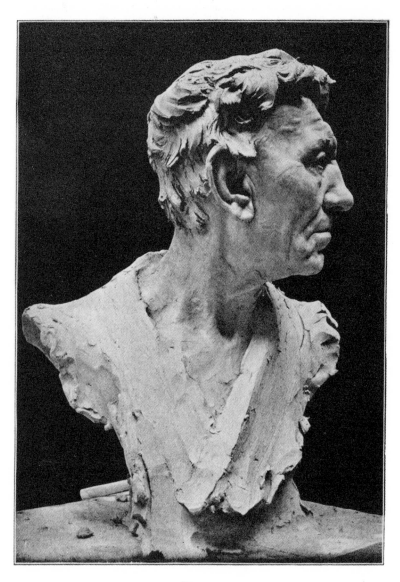

FIG. 53.

You notice on the top of the upper lip a large, slightly curved plane, which, diminishing in size, and twisting as it were, round itself, extends to the corner of the mouth. (Fig. 54.)

This effect is produced on both sides of the upper lip, and in the same way on the lower lip. (Fig. 55.)

These movements form a *radiation*, the centres of which are the two corners of the mouth. It is almost like a hinge-joint,

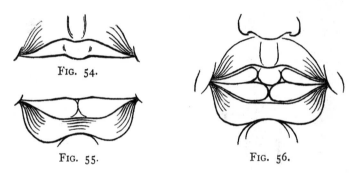

Fig. 54.

Fig. 55.

Fig. 56.

which suggests the impression that the mouth can open and shut when and as it likes.

The upper lip presents three masses, the lower lip two masses, and two other large masses stand well out underneath the lower lip—all of these accounted for by the Orbicularis Oris. (Fig. 56.)

Nose

The shape of the nose is decided by bone and cartilages.

When the drawing of the nose, both from the profile and

front, is pretty well correct, you must first study the shape of the nostrils, looked at well from below, and particularly note the

ridge which separates them from each other. (Fig. 57.)

If this central ridge (Columna Nasi) is made too thick, the nostrils will be too far from the centre and the lower part of the

FIG. 57.

nose will appear too thick. Try to indicate it correctly, and then draw the nostrils; by these inner contours you will get the outer contours correct.

The nose is often modelled too thin, and will consequently appear too long. I have often noticed that this mistake is

FIG. 58A, Wrong. FIG. 58B, Right

owing to a misplacement of the *Lacrymal Fossa* at the inner corner of the eye. If this is placed too low, and if the line which starts from it forms a too acute angle, the nose is not allowed its proper thickness. Great attention ought therefore to be paid to the correctness of these lines. (Figs. 58A and B and 59.)

The division of forms in the nose is shown in Fig. 60. These forms are always existing there—even in the roundest of noses, where they are only less accentuated than in others. A strong side-light on the model will always show them up.

FIG. 59.

Another plane which is very important in order to obtain suppleness round the nostrils, starts at the outer, lower part of the nostril, follows its upper outline entirely up to the tip of the nose, where it forms a slightly-curved plane. (Fig. 61.)

I often see students make the outline of the nose in profile meet the upper lip at a *sharp angle,* as shown in Fig. 62. This never happens in Nature. There is always a small plane which

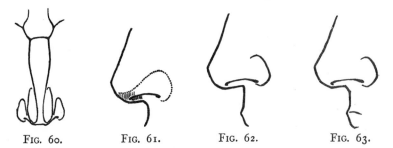

FIG. 60. FIG. 61. FIG. 62. FIG. 63.

separates the two, as seen in Fig. 63; and this gives both distinction and mobility to the outline. Of course it is more pronounced in some persons than in others.

Ear

More than any other feature, the ear varies infinitely, its outer framework being entirely *cartilaginous*. Its drawing is generally vigorous in character. Its position with regard to all the other features is of the greatest importance. In the profile it is the *central point* from which you ascertain the distance to forehead, nose, mouth, and chin. (Fig. 64.)

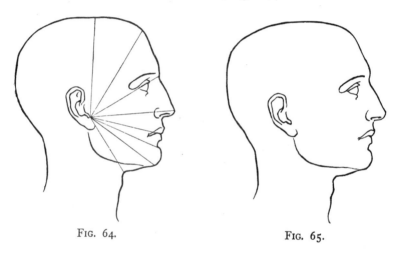

FIG. 64. FIG. 65.

If the ear is placed at too great a distance from the nose, the head will appear too thin from the front-view. (Fig. 65.) And from the side-view the back of the head will appear too small.

If the ear is placed too far forward, the opposite will happen, and the head will appear flat from the front-view. (Fig. 66.)

If the ear is placed too high, the lower part of the face will appear too long, and the upper part of the head will seem insufficiently developed. (Fig. 67.)

If its place is too low, the opposite effect will appear.

As a general rule, the direction of the ear is parallel to the direction of the nose (see Fig. 68), but there are numerous

FIG. 66. FIG. 67.

exceptions, which the student will observe all the more for knowing the general rule.

Another general rule is that the top line of the ear falls horizontally in line with the highest point of the eyebrows, and that its lower border is generally level with a horizontal line drawn from the nostrils. Refer to Fig. 68.

The length of the ear varies enormously, but a well-propor-

tioned ear fills about the space between the two horizontal lines
indicated on Fig. 68.

The outline of the ear, looked at from the front of the head,
is a matter which demands all our attention. If the ear were
too flat, *i.e.* not standing out from the head like that of the
model, the face will appear too thin. This is a mistake which

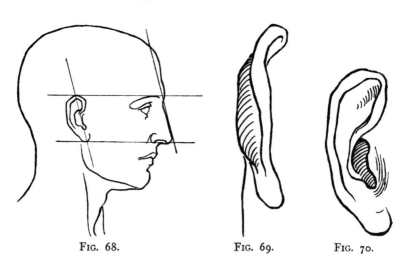

FIG. 68.　　　　　FIG. 69.　　　　FIG. 70.

nine out of ten beginners will commit; as a rule, they will
make the ear almost stick to the skull. It is therefore most
essential to study the outline of the ear, not only from the front,
but also from the back, and carefully to note the distance which
separates the border of the *Helix* from the *skull*, as well as the
depth and drawing of the *Concha*, or shell. (Fig. 69.)

There is another point to which I must draw special.

attention. It is the way in which the *Tragus* follows the perfectly round opening of the *Auditory Meatus*. Consequently it should not be made flat. (Fig. 70.)

EYE

I repeat myself, and remind you that the globe of the eye lies in the socket, called *Orbit*. (Fig. 71.)

The eyebrow forms an elongated mass, starting from the inner and upper border of the orbit, and following it as far as its

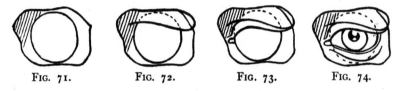

FIG. 71. FIG. 72. FIG. 73. FIG. 74.

external border. Its form is larger at the outer end than near the nose. (Fig. 72.)

The upper eyelid starts from the corner of the *Lacrymal Fossa*, and overlies the eyeball. It is larger in the centre than at its extremities. (Fig. 73.)

The lower eyelid starts in the same way from the Lacrymal Fossa, and, closely overlying part of the eyeball, it joins the upper eyelid from below at its outer corner. (Fig. 74.)

In beginning the eye, the bony construction must be the first consideration ; having obtained that as correctly as possible, you proceed as the diagrams show—first, by putting in the

globe, and trying to make its projection correct by studying the eye of the model from the profile as well as from below. Proceed in the same way and at the same time with the other eye. You should never finish one side of the face without having established the construction of the other side, or you will not obtain the effect of *unity* in the face.

The eyeball having been placed in the right projection, the eyebrow must be laid on and studied *from the profile for projection from the front for drawing, from below for its section.*

Settle the distance between the Lacrymal Fossæ, from the full-face view, and their depth with regard to the nose, well bearing in mind the difficulties I have already indicated in the earlier portion of this guide. (Fig. 75.)

Starting from the Lacrymal Fossa, you put in the upper eyelid, noting in the same way as for the eyebrow the projection from the profile view, and the section from looking up to it.

FIG. 75.

For the lower eyelid you proceed in the same way.

If, instead of beginning the eye with its anatomical construction, you were to put a lump of clay of any shape and anyhow, and tried to dig in it and scrape it about in order to obtain the drawing of eyeball, brow, and lid, the result would probably be an inert and weak feature that could never suggest the movability of the eye.

Another point to be attended to is, that the black spot of the pupil is in the most projecting part of the eyeball. Thence it follows, that directly above it is the highest point of projection of the upper eyelid as seen from below.

If the model looks towards the side, the outline of the upper eyelid from the Lacrymal Fossa forms more or less a straight line up to the central point of the pupil, and from there makes a rapid curve to the outer corner, *i.e.*, where the upper and lower lids meet (Fig. 76); whilst in the other eye you observe the

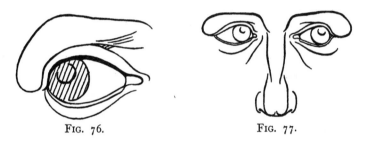

FIG. 76. FIG. 77.

contrary—the long straight line starting from the outer corner, and the rapid curve of the lid being from the highest point towards the Lacrymal Fossa.

It follows from this, that the two *Caruncles*, that lie in the Lacrymal Fossæ, will present different shapes, when the look is directed to the side : the Caruncle of the eye which looks outward will be stretched and look longer than the Caruncle of the other eye, which is following the direction of this one and approaching the nose. (Fig. 77.)

I have already mentioned on page 59 that the outer corner must never be placed lower than the inner corner, and a horizontal line through the corners will assist the student to find its correct place. (See Fig. 78.)

If, in impressing these details of observation on you, I have repeated myself, you will readily excuse it when you realise how

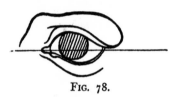

FIG. 78.

much they contribute to render the expression and direction of the eye strong and vigorous, and how feeble and even faulty the result is, when they are neglected. What can be more objectionable in a bust, than the two eyes looking at different points ? Therefore, instead of experimenting and pushing the pupil a little to the right, or a little to the left, use every effort to verify the points I have indicated.

HAIR

I have often been struck, when looking at busts, by the fact that the hair has the appearance of a wig put on the head.

This unfortunate effect is the result of ignoring the points from which the hair starts or is attached round the face.

Looked at from the front and profile, the attachment of the hair takes place in three masses : one goes round the frontal bone (coming generally to a point above the centre of the face),

the second mass is attached to the temporal bone, and the third, smaller, mass below the temples. (See Fig. 79.)

On the top of the head the hair is attached or grows round a central point, the Crown of the Cranium, from which the hair grows in all directions, like rays emanating from a centre. (Fig. 80.)

In black hair you accentuate the details, *i.e.* make deeper cuts to obtain the effect of a dark mass ; in white hair details

FIG. 79. FIG. 80.

must almost disappear, and they must be massed instead of being broken up. The details should not be treated as ornament. To avoid ornamental treatment, it is necessary to take first the outer contours, and draw them in straight lines, well observing the angles which they make, for it is these angles and their distance from each other which decide the character of

the hair in individuals. After that, each mass must be divided by drawing it in firm, almost straight lines. Here it is very

necessary to observe the variety of proportions in one mass, as compared to the other. And finally indicate the variety of planes which receive light and shade in various directions, and add a few touches

FIG. 81.

here and there—some details, in other words—to indicate the fineness of hair. By these means you will avoid its looking heavy, monotonous, and ornamental.

MOUSTACHE AND BEARD

The moustache grows on each side of the face in three absolutely distinct masses.

The first is attached below the nostrils. ⎫
The second is attached on the upper lip. ⎬ (See Fig. 81.)
The third is attached on the cheek. ⎭

The beard is also divided into three large masses, which have their points of origin or attachment in different places.

The first mass grows underneath the lower lip. ⎫
The second mass is attached to the chin. ⎬ (See Fig. 82.)
The third grows on the cheek. ⎭

The treatment of the beard in modelling is pretty much the same as that of the hair, but its execution is extremely difficult,

and it is necessary to make special and frequent studies of it or for it, for the treatment varies according to the effect of colour one wishes to give.

Badly executed hair and beard will spoil an otherwise good bust. It needs great taste —I might almost say *tact* —to know how much detail to introduce in order to preserve its colour without detracting from the value of the face.

Hair and beard must, so to speak, disappear— that is, they must not be the first thing which strikes an observer of the bust, yet they must be interesting.

Fig. 82.

Modelled tastefully, harmonious in colour and shape, they will complete a head and give character to it.

DIAGRAM OF FACE

This diagram represents the division of the forms of the face. (Fig. 83.)

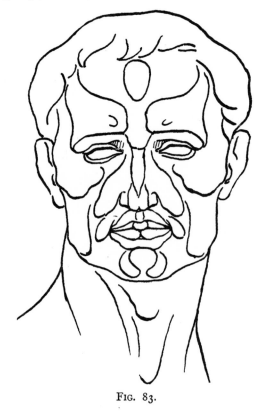

Fig. 83.

The masses which are indicated by outline are produced not only by the bones and the groups of muscles of the face, but

also by the skin, which covers them in following their undulations.

They exist, with a certain variety of drawing, and in a more or less accentuated manner, in the female as well as in the male.

In the child they seem to disappear altogether, but knowing that they are there, we find them indicated by extremely delicate planes.

In the face of an old person we see them quite clearly.

When in a face of very simple appearance the existence of these masses does not strike us, we must work continually with a strong side-light in order to obtain on the face of the model a variety of half-tints which will be produced by the planes or depressions that divide these forms, and which will show them more clearly to us.

If you ignore this rule, you will, without any doubt, produce a polished surface with no variety of modelling, and the result will be a face without suppleness or expression.

One of the most characteristic points in the works of Michel-Angelo, particularly in the statues of David and The Slave, is the neatness and purity with which each of these forms is drawn without anything being lost of the simplicity of the whole.

When these divisions of form have been obtained in their proper drawing by studying each separately, the work may appear a little hard. Then it becomes necessary to work by

colour—that is to say, by the comparative values of the half-tints, in simplifying or accentuating the surfaces or planes which divide these forms.

The simplicity of the model may be obtained thus, by leaving under this almost flat surface a mechanism, which not only gives expression to it, but enables the work to be exposed to every light without losing its value.

Take, for instance, a cast of the head of Michel-Angelo's David; let it be placed in any light whatever,—this head always retains its resemblance, and nothing seems to have been left to chance, the whole remains neat and clear; the planes retain the required direction, and, modelled well together, they give movement to the whole surface.

On the other hand, if a sculptor has merely sought to render the impression of the model by effect of shadows, more or less mysterious, by tricks of texture or of tooling—in fact, simply by means of " seasoning,"—these works, to preserve their quality, must be allowed to remain exactly in the same light in which they were done, under penalty of no longer being recognised, or of finding that which was expressive become insignificant,—in fact, all resemblance will be gone, simply because the light has been changed, and the work is thus reduced to a mere piece of plaster, having none of those ideal qualities of which that artist had so fondly dreamt.

Beyond the artistic expression of the work, which is the

direct result of our sentiment and individual taste, Sculpture exacts *positive knowledge of the laws of Nature.*

Michel-Angelo has proved this to us better than any other Master, by the numerous studies which he has made of every part of the human body, with a love that is only equalled by his scrupulous conscientiousness.

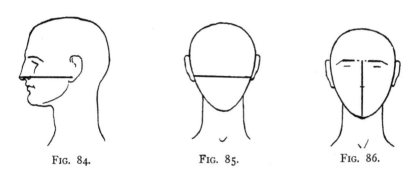

FIG. 84. FIG. 85. FIG. 86.

Figs. 84, 85, and 86 show you three proportions which are generally the same.

Namely : the measurement from ear to ear is equal to the one from under the chin to the eyebrow, and you will find the distance the same from the ear to the point of the nose.

FIG. 87.

Fig. 87. This diagram shows you that the centre of the face lies on a line drawn though the inner corner of the eye, mid-way between a line drawn under the chin and another across the top of the cranium.

PART III

PART III

FIGURE FROM NATURE

FRAMEWORK

WE take for our study a figure half life-size—that is, about 32 to 34 inches in height. The framework I am going to describe will serve not only for a figure of this proportion, but also for a larger one, say of 6 to 9 feet high.

In figures of these proportions the framework may be erected quite straight—that is, without action; but for one of larger proportions, the frame must at once represent the action, and must be made from a previous sketch, carefully planned with the help of measurements and plumb-line, else it would not possess the necessary strength to support a large mass of clay; therefore, in a larger figure the lead pipes for the lower limbs are replaced by irons fastened in such a way that they can be moved at the artist's will without sacrificing strength and bearing power.

In a second volume I shall supply a series of drawings

of frameworks for various works, from which you will see that the principle remains the same, and that it is only the proportions of the iron and lead pipes which are different ; they must be strong in proportion to the size of the work, and there must be the possibility of putting in more wooden supports and butterflies.

You require a wooden turn-table for your work as well as for your model ; further, a wooden 1-inch board about 18 inches square with two strong battens underneath to prevent the warping of the board.

On this square you fix with screws an iron support, bayonet-shaped, so to say, which is to support the frame and consequently all the weight of clay.

This iron, for the half-life-size figure, should be about 20 × 10 × 5 inches (Fig. 88); so that allowing 3 inches thickness of clay for a plinth, it should enter the figure slightly above the middle of its height and below the posterior processes of the Ilium. If inserted lower, it would have too much weight resting on it, besides there being the danger of the frame being too movable, and thus unable to retain the given pose or action.

The horizontal branch had better be too long than too short ; for the vertical portion of your support is liable to get in the way of the legs, for instance, in a walking action. I should advise any length between 9 and 12 inches.

The third portion of the iron should not go up too high in the torso, as one has sometimes occasion to change the action

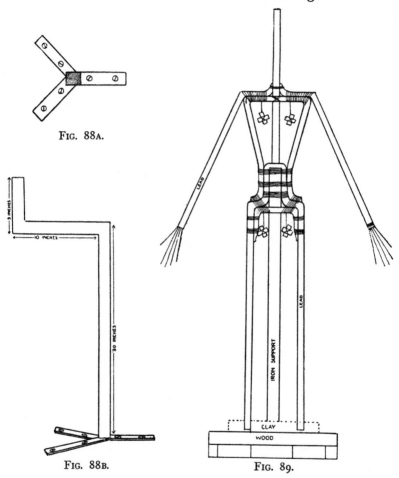

Fig. 88a.

Fig. 88b.

Fig. 89.

of one's work, and if the iron went too high, the torso would lose its suppleness. 5 to 6 inches therefore suffice.

There are poses which necessitate the iron to be fixed at the side of the figure and not at the back.

FIG. 90.

The iron being screwed on, you make your framework on it by means of lead pipes, which you secure firmly on to the iron by means of copper wire. I give the preference to copper wire over galvanized iron wire, as it is more pliable, less liable to break, and can be twisted tighter than iron wire round the lead and iron pipes. Fig. 89 will give you a clear idea how to make your frame.

The next step is to make a *Scale of Proportions.*

For modelling purposes, you will find the following plan the surest and quickest, I fancy. (See Fig. 90.)

1. Draw a horizontal line on a board.

2. Take half the total height of the model (you will rarely have callipers big enough to take the total height), and measure it off on the horizontal line as A B, and with the distance A B as radius in your compasses, describe an arc from A through B.

3. Measure half the height of your framework; place one leg of the compasses on B, and with the other intersect the arc to get point C.

4. Join by a straight line points A and C, and your scale is ready.

You have only to apply it to your work, by striking an arc for every measurement, with A for a centre on lines A B and A C, and the distance from one point of intersection to the other will give you the proportional measure.

It will be well to strike the arc a little beyond the lines, so that you write on the outside whatever measurement it is. You will find this a very correct and rapid scale.

The same method is used for enlarging, but not for more than twice the size of the original.

Framework and Scale being ready, place the former on your stand, taking care to see that the stand is quite horizontal, and place the board with the scale on an easel close to you.

Now the model should be placed and posed on a turning throne, at such a distance from your work, that you get a good view of the entire figure.

As it always happens that by slow degrees the model loses the pose, owing to fatigue, it is advisable, that before the sitting you should well impress the pose on your mind and eyes, by trying it yourself. That will make you well acquainted with the points and force of the action, so that you concentrate your

efforts not to deviate from your lines when the model should
do so.

It will be better to give the model a frequent rest for a few
minutes, than to work from a tired model, as an experienced
model will often, almost imperceptibly, transfer the weight of
the body from one leg to the other ; and to a beginner the pose
may appear to be the same, although the spirit
of it is completely altered. This difficulty can
be overcome by paying careful attention to the
pose at the beginning, and by studying it, first
on yourself, and then on the model, and think-
ing of it all along as your work proceeds, so
that you have no need to change your work,
except by emphasizing it more.

Let us now begin our work, and take the
action indicated in the diagram.

The first thing is to establish the *chief line*,
which is the key to the pose. (Fig. 91.) We

FIG. 91. FIG. 92. therefore stand right in front of the model,
and, plumb-line in hand, take a vertical line from the centre
of the *supra-sternal notch*, and watch where it passes the
leg which carries the weight of the figure, which, in a pose
like ours, will almost always touch the projection of the lower
extremity of the tibia that is, the internal *malleolus*—or inner
ankle-bone. (Fig. 92.) Then press a piece of clay on the

framework, midway between the shoulders, where you fix a point representing the top of the sternum, stand straight in front with your plumb-line, and adjust on the framework the pipe which represents the leg, so that it touches your line, leaving just enough space for a covering of clay, and allowing the pipe to be in the centre of the limb.

From the back view the chief line is indicated by the spinal column as far as it extends, and lower down by the general direction of the carrying leg. This line coincides in all its bearings or curves with the chief line of the figure, as seen from the front view. (Fig. 93.)

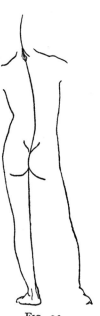

In sculpture the *posterior* chief line is more important than the *anterior* chief line, for we must consider the vertebral column as the central and fundamental part of the skeleton.

FIG. 93.

The different parts of the bony system are attached to it, either directly or indirectly, and from it depends the movement and the place of the pelvis. As for modellers, after the chief line of the back and of the front are settled, and for draughtsmen, the chief line according to the view they have to copy, they must both occupy themselves with *the lines of contrast*, presented by the action.

In this pose the side lines of the figure are parallel in their general direction to the chief or central line. If this central line is not exact, the exterior outlines cannot be so either; therefore you understand my assertion that the chief line is the key to the pose. (Fig. 94.)

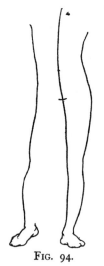

FIG. 94.

Now proceed to place the other leg of the framework into its pose, and observe your model well with regard to the *contrasting lines* caused by the action, and the *contrasts of projection.*

In a pose like ours you will find the following general rule :—

When the figure bears heavily on one leg, the Ilium on the same side is pushed up, for the tibia and femur preserve their entire length in the vertical direction and thus push the hip-bone up; whilst on the other side the Ilium is pulled down as both tibia and femur are bent forwards. The upper part of the body, in order to keep the equilibrium, tends to bend over on the side of the leg which carries, and thus the shoulder will on this side be lowered as compared to the other. Thus you get two contrasts of line in hips and shoulders, the line from one Ilium to the other going downwards, and the line from one shoulder to the other going upwards. (Fig. 95.)

Having observed this, you bend the pipes of the frame accordingly.

Now you turn your model, and note how these same contrasts obtain for the back. (Fig. 96.)

There is not only contrast between the shoulder line and the line of the posterior superior iliac processes, but also with

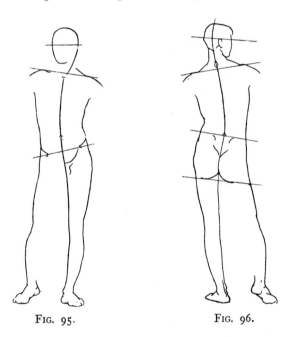

FIG. 95. FIG. 96.

the line of the gluteus maximus; and further, in the leg you will find a contrast between the oblique direction of the bulk of the two gastrocnemius muscles and the lower extremities of the Tibia and Fibula—in other words, between the calf-muscles and

the ankle-bones (Fig. 97). Of course the same contrast exists in the front view.

Another thing: the head being turned towards the side of the free leg, it results that the face lies more or less in the same direction as the iliac processes, and consequently contrasts with the plane of the shoulders. (Refer to Figs. 95 and 96.)

There is another opposition or contrast between the shoulder and the hip: the *contrast of projection.*

Bearing on one leg, this leg not only pushes the ilium up, but also forward, whilst the ilium on the free leg goes backward, and the shoulder, which is already lower in line, moves back with regard to the shoulder above the free leg.

Thus you have two contrasts of projection, which must be marked on the framework by bending the pipes accordingly.

Fig. 97.

As the head turns in the direction of the non-carrying, or free leg, you get another contrast of line and projection with regard to the shoulders, indicated by the *line of eyebrows and ears,* and having indicated all these important lines and planes of contrast, you must think of the

action of arms and hands, in order to obtain
the spirit of the pose from the beginning.

As concerns the leg, I might mention
that you can fix a chief line as indicated
in diagram, Fig. 98, by following the sar-
torius muscle from *its origin* at the anterior
superior process of the Ilium *along its whole
length* to the Tibia, and continue the line
along the Tibia to the internal Malleolus.

When you have marked this chief line,
you will note a marked parallelism between
this and the general direction of the ex-
ternal outline of the leg ; it is therefore
an excellent guide to obtain the general
shape.

I often, or almost always, see advanced
studies (I am speaking of modellers) where
the hands have been neglected, and some-
times they are not even indicated. This is
a great mistake. It is impossible to enter
into the spirit of the pose, or action of a
figure, without putting in the position and
action of the hands. It is by the place and
relation to each other of the extremities, *i.e.*
the head, the hands, and the legs and feet,

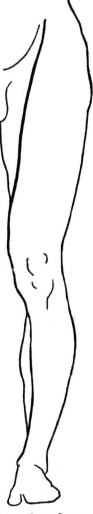

Fig. 98. — Showing
the Chief Line of
the Leg.

that all action is determined, and in the hands particularly you find the *intention* you want to express.

Every study ought from the beginning to be considered as a composition. If we set ourselves the task in our figure studies to express, according to the character and pose of the model some intention or feeling, this study will to the end command our attention, our enthusiasm and intelligence; and artistic feeling will grow in the place of mere patience.

You must, therefore, at once block in the extremities, whose position will determine the action of the rest of the body.

You cannot possibly model an arm properly, without having carefully modelled the hands in which you find the insertions or terminal points of most of the muscles of the fore-arm. It is therefore the natural continuation of the shape of the arm.

The same rule applies to the legs and feet.

I insist on this point, because I see it so often neglected. This neglect is just as ridiculous as it would be to cover a drawing with a sheet of paper with a small hole in it, to enable the draughtsman to see nothing but the head, and to stipple away at it with tiny pencil strokes, without having the whole figure before his eyes—in fact, with the figure only outlined. I have seen such things done!

From the profile the chief line is given by the *direction of the sternum*, the *outline of the pelvis*, and the general direction of the *anterior contour of the carrying leg*. (Fig. 99.)

There are persons, whose vertebral column has a more graceful curve than those of other people; in such cases the chief line of the profile has more movement than that of a straighter-built person.

To find the direction of the pose from the profile view, you must again use your plumb-line, and hold it so that it will cut through the centre of the neck, as seen sideways; then observe where it will pass with regard to the outer malleolus of the standing leg. (See Fig. 99.)

Another matter you must pay attention to is, that the pipes are not crooked, but very straight in the big lines and very neatly bent at the joints,—you might even give them the exact curves of the femur, tibia, humerus, and ulna—that is, if you can! This would give a certain expression and resemblance to the skeleton already in the framework, and would render the work spirited from the very beginning, and at the same time more tempting and encouraging.

FIG. 99.

When, on the other hand, the framework is made carelessly; the pipes loosely joined and crooked, the clay stuck on anyhow, &c., the material difficulties are enormous from the beginning, and the discouragement complete.

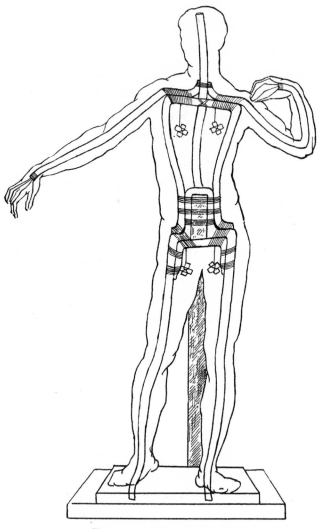

Fig. 100.—Armature in Action.

Let me caution you, therefore, to bestow the greatest care and attention on all the preliminaries.

When the armature or framework has been put into the pose or movement (Fig. 100), cover it all over with a slight layer of clay, just sufficient to mark the chief lines of contrast and projection, as shown in Figs. 101 and 102.

The plinth of clay should now be made, and be at least three inches thick, so that, if it is necessary to lengthen the limbs, one may do it in the downward direction by lowering the plinth, without having to destroy the rest of one's previous work.

On this plinth of clay it is well to fix a small piece of wood, well towards the centre, so that it will give a firm point for measuring.

Starting now from the supra-sternal notch, we draw on the clay the central line of the figure.

This will pass along the centre of the sternum, then continue along the *linea alba*, following the curve which the action of the figure causes, through the *umbilicus* or navel, and down the internal contour of the leg which bears the weight, to the Malleolus internus.

It is best to exaggerate the curves of this line, as one is liable to creep back towards the vertical.

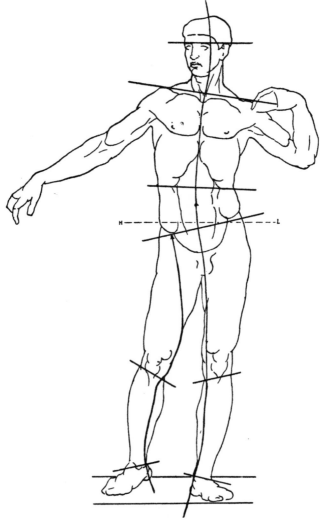

Fig. 101.—Figure showing Chief Line and Lines of Contrast.

The line HL is a horizontal line drawn through the anterior superior iliac process of the standing leg.

Modelling

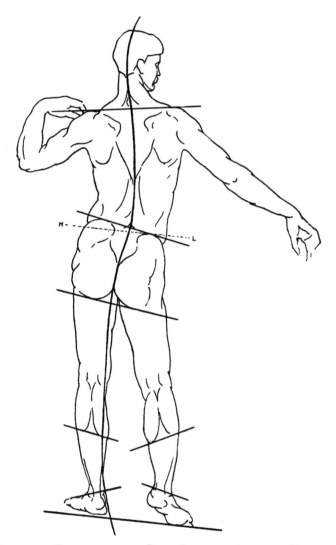

FIG. 102.—FIGURE SHOWING CHIEF LINE AND LINES OF CONTRAST.

FIGURE MEASUREMENTS

You must not take the following measurements before being quite sure of having the pose correct, for the measurements do not assist you to find the pose, but only help you to find the construction. (Fig. 103.)

1. The first measurement to be taken for the figure is the distance from the plinth, *i.e.* from under the arch of the sole of the standing leg, to the upper border of the Patella.

2. The second from the top of the Patella to the anterior superior process of the ilium of the same standing leg. (Fig. 103.)

In order to fix the deviation from the vertical of the anterior superior iliac process, place yourself opposite the model, and take with one hand the plumb-line through the centre of the Patella, whilst with the other you measure the distance from this vertical line to the iliac process.

Only when you have found this distance take the measurement, and fix the point, after observing also very carefully from the profile view the projection of the iliac process in relation to the Patella.

3. The third measurement is the distance across the pelvis from one iliac process to the other. (Fig. 103.)

Before you fix this, you take a horizontal line, starting from the anterior superior process of the ilium in the *standing* leg, to

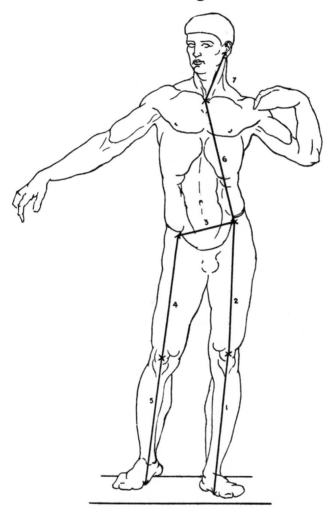

FIG. 103.—FIGURE SHOWING THE ORDER OF MEASUREMENT.

1. From Plinth to top of Patella.
2. From top of Patella to Anterior Superior Iliac process.
3. Space between the Anterior Iliac processes.
4. From Anterior Superior Iliac process to top of Patella in free leg.
5. From top of Patella to Heel.
6. From Iliac of standing leg to top of Sternum.
7. From Sternum to Ear.

ascertain how much lower than it the ilium of the *free* leg is, and having noticed this difference, fix your point. (Fig. 101.)

4. The fourth measurement is from the iliac process of the free leg to the top of the Patella of the same leg. (Fig. 103.)

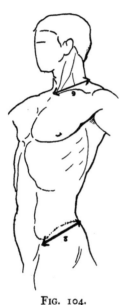

5. The fifth measurement is taken from the top of the Patella of the free leg to its heel. (Fig. 103.)

6. The sixth measurement is from the iliac process of the standing leg to the top of the sternum, *i.e.* the supra-sternal notch. (Fig. 103.)

7. For the seventh measurement take the distance from the supra-sternal notch to the ear, *i.e.* the notch between Tragus and Antitragus. (Fig. 103.)

8. For the eighth measurement take the distance from the profile of the standing leg between the Anterior Superior and the Posterior Superior Iliac Processes. (Fig. 104.)

FIG. 104.

8. From Anterior Iliac process to Posterior Iliac process.

9. From top of Sternum to Seventh Cervical Vertebra.

To obtain this correctly, you must again use a horizontal line, starting from the Anterior process, in order to see how much higher the Posterior Process is in relation to the former.

This measurement must also be taken on the free leg.

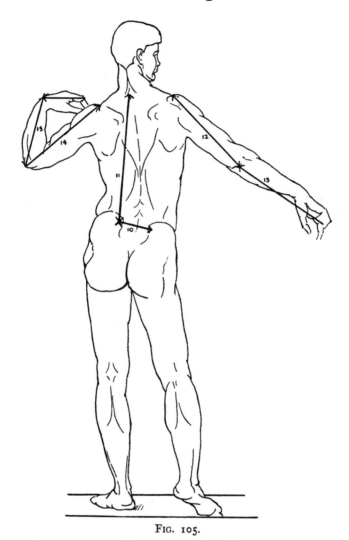

FIG. 105.

10. Space between Posterior Iliac processes.
11. From Posterior Iliac process of standing leg to Seventh Cervical Vertebra.
12. From Acromion process to head of Ulna.
13. From head of Ulna to first articulation of Finger (index finger).

9. For the ninth measurement take the distance from the
Supra-Sternal Notch to the seventh Cervical Vertebra.
(Fig. 104.)

Before fixing this measurement, you must, in the same way
as for the iliac processes, obtain a horizontal line from the top
of the Sternum, to ascertain how much higher the seventh
Cervical Vertebra lies than the Supra-Sternal Notch.

10. The tenth measurement concerns the distance between
the two Posterior Superior Iliac Processes.　(Fig. 105.)

To obtain it correctly, you again apply a horizontal line, and
note how much lower the process on the free leg may be, than
on the standing one.　(Fig. 102.)

The four points obtained by measuring the Iliac Processes
must be fixed and verified with the utmost care, because upon
them depends to a great extent the entire construction, not
only of the torso, but of the whole figure.　They are, architec-
turally speaking, the *plan* of it.

11. The eleventh measurement is from the Superior
Posterior Iliac Process of the standing leg to the seventh
Cervical Vertebra.　(Fig. 105.)

12. Take the twelfth measurement from the Acromion Pro-
cess to the head of the Ulna on both arms.　(Fig. 105.)

13. Take the thirteenth measurement from the head of the
Ulna to the first articulation of the index on both hands.
(Fig. 105.)

It seems almost needless to add that during the course of the work you must constantly verify these measurements, for it happens only too often that in modelling you gradually cover them with clay, until the construction has almost disappeared, and your distances begin to change without reason. As a result, your work becomes disappointing, and the worker tires himself out without obtaining a satisfactory result.

I have aimed at sparing the student such a painful disappointment by introducing into the study of the figure a positive system, based on anatomical construction.

I lay stress on the fact that the measurements I have given you, and shown in diagrams, are of the greatest importance. You may, as your work proceeds, take many others which you consider a help to your work, but let me warn you against taking mere flesh-measurements. They are misguiding, and you can only rely on the measures taken from bone points.

SECTION OF PELVIS

But I must dwell particularly on the measurements of the four Iliac processes, which give a section of the Pelvic Girdle, and on the correctness of which I cannot

ANTERIOR FACE

FIG. 106.

insist too strongly. Fig. 106 shows you this section, which is also the *plan of the torso.*

If these four points on the Ilium, which in their relation to each other *never* vary, are not correct, neither can the con-

struction of the torso be right, nor will the legs come in their proper places.

The measurement from the top of the sternum to the seventh Cervical Vertebra gives us the depth from front to back of neck, two points which are placed above the section of the pelvis. (See Fig. 107.)

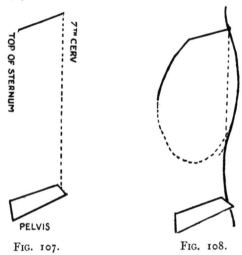

FIG. 107. FIG. 108.

These four points in their oblique direction, viewed from the front, extend or contract the muscles of the back and of the front of the torso; the muscles on the side of the standing leg will be contracted, while those on the side of the free leg will be extended.

(Fig. 108.) The place of the seventh cervical being fixed, it must be joined through the curve of the vertebral column

(which varies in different persons, as already pointed out) to the pelvic girdle. (Fig. 108.)

In observing the movement in the Lumbar region, you will find that the pelvis is at right angles with the Lumbar Vertebræ.

As I have already said, the vertebral column must be considered as the central and fundamental part of the skeleton. It is composed of twenty-four vertebræ :—

7 Cervical,
12 Dorsal, } Vertebræ.
and 5 Lumbar

The movement of the column is always found in the Cervical and Lumbar regions. (See Fig. 109.)

The Dorsal Vertebræ have little movement, for they have to support the bony cage formed by the ribs—*i.e.* the Thorax— in an almost rigid state to protect the organs of breathing and circulation lodged within it.

The bones of the upper part of the column, *i.e.* the Cervical Vertebræ, support the Cranium.

To the lower part of the vertebral column the Pelvic Girdle is attached ; it almost forms part of it, owing to the fusion of the hip-bone with the Sacrum or Coccyx.

It is to the Pelvic Girdle that the bones of the lower extremities, the legs, are attached.

It follows that the most important points in constructing a figure are, to find the relation between the two Anterior and the

two Posterior Iliac processes, between the Supra-Sternal notch and the seventh Cervical Vertebra.

Imagine the sections of these two lying above each other and joined by the vertebral column. The movement of the latter takes place immediately *above the sacrum* in the *lumbar* region, and again *above the seventh Cervical Vertebra;* the latter determine or guide the direction of the head.

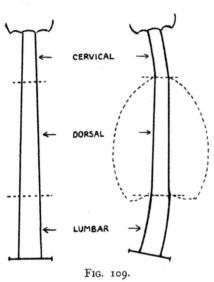

FIG. 109.

When you have fixed these points, you must find from the profile the *projection of the sternum*—that is to say, its *oblique direction forwards and downwards*— in order to ascertain the depth from the front to the back of the thorax. You then complete the body of the thorax in joining the vertebral column to the sternum by means of the ribs. (Refer to Fig. 108.)

Whatever the pose of your figure may be, remember that the thorax is always *equally balanced* on both sides of the sternum, and its shape is almost invariably symmetrical. However oblique the sternum and the dorsal vertebræ may be, we

must build up the thorax equally on either side to bring it up
to the volume of the model. (Fig. 109.)

If you draw a line below the costal margin (which is at
right angles to the sternum), you will find this symmetry very
striking, and you obtain at
the same time another con-
trast with the crest of the
ilium.

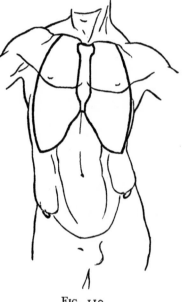

The line of the shoulders
is generally parallel to the
lower border of the thorax
(refer to Fig. 101); even in
the pose which I have chosen
for demonstration, you will
find that a line joining the
two acromion processes is
almost parallel with the border
of the ribs (it is the *muscles*
of the shoulder which follow

FIG. 110.

the raised arm, the shoulder itself is hardly raised).

The symmetry of the thorax on both sides of the vertebral
column and the sternum exists in all the movements of which
the human figure is capable, and as the flat muscles attached to
the thorax follow its shape (refer to Fig. 110), it results naturally
that, unless the bony cage is correctly established, there will be

a want of order and harmony in the position of the muscular forms.

There is another section which will assist us greatly in our modelling of the figure: it is the section through the two Clavicles, the Scapulæ and the Vertebral column. (Fig. 111.)

This section, like the one through the Pelvis, will help us to find the volume of the upper part of the torso, the roundness of

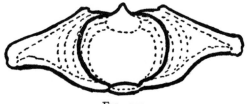

FIG. 111.

its outline, and the right place for the neck, which must be well placed in the centre.

In students' work the clavicles are often blocked in like two straight bones, instead of their giving them the shape of the letter S. If they are made too straight, the pectorals appear flat and the shoulder comes too far forward, which gives the appearance of low relief on a round shape. By carefully studying the section of the collar-bone you will avoid this effect. Observe, therefore, intelligently the form and drawing of the Clavicles, as well as their symmetry, and study at the back the position of the Scapulæ which follow the action of the arms.

This will give you the upper plan of the trunk, just as the section of the pelvis gives you the lower plan, and if you have these two plans well in their right place, the *limbs* will of course find their right place.

I have stated before that in beginning a piece of sculpture you must avoid putting on too much clay, and rather keep your study thin so that you can add to it; but as soon as the pose is settled, you must determine the exact proportions of the bones, their extension in length, and—as far as thorax and pelvis are concerned—also their extension in depth and breadth. For they are not only *invariable points*, but also determine the action and the division of the forms and masses. They are the landmarks of the torso, they are architecturally-speaking the framework of the house.

By fixing all the prominent points of the bones in their proper proportions of length and width, and in their right place as regards the movement, one obtains the foundation of the figure, the points of origin and insertion of the muscles. Our knowledge of Myology and exact drawing will then join the separate parts together into a harmonious *ensemble*.

In laying the clay on in the direction of the planes which the muscular fibres present, and by drawing, we evolve out of

the general form the particular character of the form of the model before us.

The influence of the curved form of the bones makes itself felt in all the limbs of the human figure. The muscles, more or less fleshy, always follow the curve, and you might truthfully say that the curves of these bones give the cue to the shape of the leg as well as to the shape of the arm.

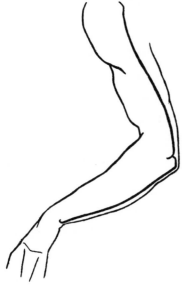

Fig. 112 shows you how the form of the Humerus and Ulna influences the form of the arm.

Fig. 113 proves how the Femur and the Tibia influence the shape of the leg from the profile, as well as from the front view.

Figure to yourself a student ignoring the curves of these bones. What will happen to

FIG. 112.—SHOWING THE INFLUENCE OF THE HUMERUS AND ULNA ON THE ARM.

his work ? He will place form upon form without any principle, and his work will be heavy, without charm and clearness : I can only compare it to a piece of ornament which lacks a chief line, where every detail, be it flower or leaf, is placed by chance, regardless of a definite law of direction, and the result is confusion.

A thorough knowledge of *Osteology* from my point of view is more important than that of *Myology*, for the skeleton determines the movement, the proportion and construction of the figure, and its careful study is indispensable to the study of external forms.

I repeat what I said in Chapter I. : *Anatomy teaches us the general law of the human form, whilst the living model shows us the same laws applied and modified by individual characteristics*, which we have to express by drawing.

But remember that all models, whatever their age and sex, will always have the same bones and muscles, with the same attachments.

In the study and knowledge of Anatomy the student will therefore find a positive guide to the general facts, although the anatomy of every model will present some different aspects and individual characteristics. It is these individual characteristics in their infinite variety, which the artist must endeavour to express.

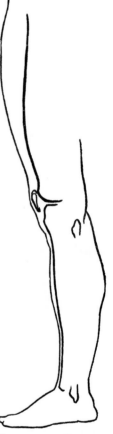

Fig. 113. — Showing the influence of the Femur, Tibia and Patella on the Leg.

It should, however, not be imagined that the knowledge

of Anatomy would suffice to make a work of art : far from it. It is only the handmaiden of art ; it is the means by which we understand the cause of form and shape, and it helps us to put clearness, strength, and expression into our studies.

A figure, therefore, in which one had only applied anatomical knowledge, without observing the particular characteristics of the model, might be a scientific piece of work, but it would never possess any artistic merit.

In order to well represent objects *such as they appear*, it is important that you should know them *such as they are*. You can only see correctly with your mind's eye, and a form which you may have drawn, without understanding it yourself, you cannot hope to make clear to others. I have seen this very well expressed, although I do not recollect where :

"The ignorant look, the intelligent see."

To copy Nature, you must observe and understand her.

At the beginning of our studies, in drawing as well as in sculpture, we must understand the *Geometry* of the figure, which is *real* and *permanent*, without regard to the visual alteration when seen foreshortened.

Take as an example the capital of a column. You see it foreshortened, and yet you know it keeps its positive proportions, its height, width, and volume—in other words, its geometric construction. If you ignore this geometric construction, you

will hesitate and be doubtful from the beginning about the choice of the points to be fixed.

I now draw your attention to the movement of the muscles of the Abdomen, *i.e.* their *contraction* on the side of the standing

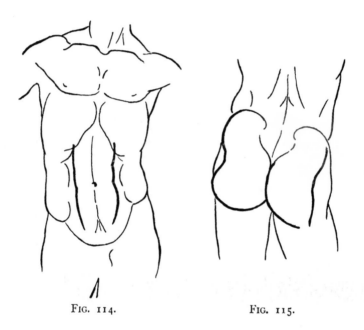

FIG. 114. FIG. 115.

leg, their *elongation* or extension on the side of the free leg. (See Fig. 114.)

A similar contraction is evident in the Gluteus muscle of the standing leg, and a similar elongation of the same muscle in the free leg. (Fig. 115.)

I have tried thus far to impress you with the importance of the *chief lines* of the figure, as well as with the *contrasts* of *line* and *projection* in the movement of the figure, and how necessary it is, not only in this pose, but in any and every action that we want to represent, to discover these lines and apply ourselves to their study.

The next task we have to set ourselves is to study the contrast in the character of *form*, in the direction of the planes presented by the muscles and their fibres, which cover the skeleton, and which play such an important factor in the exterior form by giving it mechanism and expression.

A certain law exists in every object of nature, which, for want of a more expressive term, I might call the *law of radiation* —that is, the *tendency of all lines to converge to one central point*, or, if you like it better, the *divergence of lines from one central point*. Such central points are not only found in the human form, but also in drapery, in leaves, flowers, trees, &c.

Let us observe the Deltoid and great Pectoral muscles. We find that these two large muscles are inserted almost at the same place on the upper arm, and that thence the muscular fibres separate like rays to their respective attachments or origins,—the Deltoid to the Clavicle, Acromion, Scapula, and spine, the Pectoral to the Clavicle, Sternum, and fifth rib.

These two muscles alone, radiating from one point, go a long way towards covering the trunk, and the movement of

their planes and their radiation make a striking contrast with the vertical direction of the parallel fibres of the Biceps muscles. (Fig. 116.)

If you observe the general direction of the muscular fibres in the Torso, you will find those of the pectorals attaching them-selves to the upper part of the Torso, to the Clavicle, and that *gradually* they descend to the Sternum and to the fifth rib.

Also that those of the Serratus Magnus and of the External Ob-lique follow this downward direc-tion, and attach themselves to the lower part of the Torso, on the Ilium.

FIG. 116.—SHOWING CONTRAST OF THE FIBRES OF BICEPS WITH RADIATION OF PECTORAL AND DELTOID.

Here there is also radiation, and in direct contrast to it are the muscles of the Abdomen, the fibres of which are vertical in their direction, like those of the Biceps. (Fig. 117.)

These contrasts of direction exist in a more or less accen-tuated degree in the whole figure, and it is by observing them that one adds to the expression of form. For this very reason, it would be foolish, if, in our studies—whether they be of sculpture, painting, or drawing—we aimed at a smooth texture

more or less agreeable to the eye ; we should, on the contrary, analyze the forms we see, and search for their cause before we represent them. Our study ceases, when by some trick we

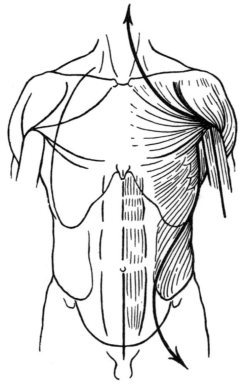

Fig. 117.—Showing the contrast of the Abdominal Muscle with the radiation of Pectoral, Serratus Magnus and Oblique.

polish the clay, or try to give colour, or in a drawing produce velvety shading. It is lost time, utter waste of time! You

may spend your life in working like this, and you will never
make any progress. You must on the contrary, so to speak,

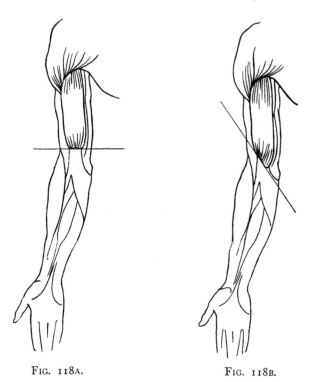

FIG. 118A. FIG. 118B.

FIG. 118A.—SHOWING THE APPEARANCE OF THE ARM WHEN THE LOWER
BORDER OF THE FIBRES OF THE BICEPS IS AT RIGHT ANGLES TO ITS AXIS.
FIG. 118B.—SHOWING THE OBLIQUE DIRECTION OF THE ATTACHMENT OF THE
FIBRES OF THE BICEPS.

dissect the form, and penetrate it in order to understand it. A
pleasing surface will come in a later stage.

I should like also to mention two matters of minor import-

ance, but still of importance, which I have very frequently seen neglected. I refer to the arm and particularly to the Biceps and Triceps. The fibres of the Biceps do not merge into the tendons of insertion all at once in a horizontal line, but join it in an *oblique* direction from the outer to the inner side, thus making an agreeable contrast with the vertical direction of this muscle. The oblique, flattened plane, caused by the tendon of the Biceps, is still enforced on the inner side of the arm, by the tendon of the Brachialis Anticus, and should be well indicated. If this obliquity is neglected, the effect is very heavy and architectural. (Fig. 118 A and B.)

The tendon of insertion of the Triceps does not exactly follow the line of the Humerus, as I frequently see it represented, but goes obliquely from inwards to outwards, and thus we have another contrast between its direction and the general direction of the arm. (Fig. 119 A and B.)

In Drawing as well as in Modelling you must endeavour to give expression to the great variety of character which exists in the different parts of the human body. It is evident that the diversity in hardness and rigidity, which exists between the bones, cartilages, tendons, muscles, and fatty parts, will produce different effects on the surface form covering them.

By observing this diversity you will avoid the particularly objectionable effect of a drawing looking as if it had been made after a figure composed of cotton-wool.

In the upper arm you will find that the forms are rounder and fuller than those of the fore-arm, for in the former the

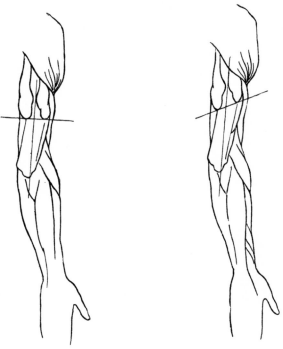

FIG. 119A. FIG. 119B.

FIG. 119A.—Showing the appearance of the Arm when the Tendon is in the same direction as the Humerus.

FIG. 119B.—Showing the oblique direction of the Tendon of the Triceps.

tendons are short in comparison to the fibrous or fleshy part of the muscles, whilst in the latter the tendons are long and extend over a large surface.

The same remark applies to the lower extremities. The thigh shows rounder and fuller forms, whilst in the leg the bones and tendons are visible.

In the trunk you observe that the Thorax has greater complexities in the movement of different forms, and a greater solidity of appearance than the abdominal part, which is not closed in by bony structure, but by vertical muscles. This difference of character gives great force to the Thorax, and makes at the same time a welcome change and rest between the thoracic part and the pelvic girdle. The bony structure reappears on the surface in the crest of the Ilium (in the Iliac furrow) and the lower part of the trunk takes again the aspect of solid construction.

These contrasts, *i.e.* the strong structures of Thorax and Pelvis, separated by the soft and flat muscular mass of the Abdomen, impress on us the fact, that all the movement of the Torso must take place in this soft and flexible middle part, which coincides with the Lumbar Vertebræ, the movable parts of the Vertebral Column.

An antique figure which shows to perfection this contrasting character of Thorax and Abdomen is the Ilissus. The movement is of an incomparable suppleness and accuracy, and the abdomen is rendered in the marble with a knowledge that cannot be too much admired. Its volume is moderated and held back by fibres, which appear neither too loose nor too

soft, and yet have a marvellous elasticity. The abdomen forms one great mass, over the flatness of which the vigorous construction of the thorax predominates.

The whole of this admirable fragment has evidently been conceived and drawn with one impulse, with one inspiration, so that everything is in harmony with the rest, and although the head is missing, the body is still a marvel of expression.

I can affirm, without hesitation, that it is the finest piece of sculpture in existence, and that one cannot find a more perfect model to study from.

I shall not further insist on the differences or contrasts in character or style of drawing, feeling certain that, having drawn your attention to a few, you will readily find other parts and points where such contrasts of form and character of drawing exist.

I will now draw your attention to a principle which the Old Masters have sometimes exaggerated, and done so with full intention, for the artistic advantage of their works. I refer to what I might call *Spaces of rest* between the masses. These neutral spaces give to the whole figure, as well as to the separate parts, suppleness and distinction.

Nothing is so hard—and consequently rare in Nature—as two big masses, which, at the point of meeting, form a more or less acute angle.

Let us take for an example an arm in profile view. If the

outline of the Deltoid makes an angle where it meets the Biceps, and if the Biceps, lower down, where it meets the mass of the Supinators, makes an angle, it will look heavy and lack spring. (Fig. 120.)

When, on the other hand, you exaggerate the principle which I mentioned, and separate these large masses by a narrow plane

FIG. 120. FIG. 121.

FIG. 120.—SHOWING THE ARM IN THE SAME POSITION WITHOUT THE "POINTS OF REST."

FIG. 121.—DIAGRAM SHOWING THE "POINTS OF REST" IN THE ARM.

of rest, you obtain much more spring and elegance in the form and especially more refinement. (Fig. 121.)

You will find this principle, not only in the outline of the arm, but just as much between the muscles of the face, and in all the other parts of the body. (Fig. 122.)

A large mass is always, in a more or less accentuated way,

separated from another by a line or slightly curved plane which I call a rest. Not only in the outer *contour*, but also in the *sections*, do we find this principle applied.

For instance, if we take the section of the chest, we find the flat plane of the sternum separating the large masses of the Pectorals, just as the vertebral column separates the masses of the lumbar muscles. (Fig. 123.)

If, instead, the two Pectorals were attached to the centre of the sternum, and the lumbar muscles to the centre of the spinal column, the section would lack elegance and strength (Fig. 124.)

Wherever the bones appear on the surface, or rather are *subcutaneous*, there is a certain firm rigidity of drawing which

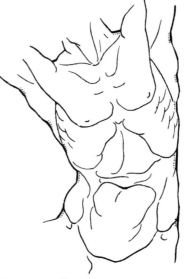

FIG. 122.—THE TORSO WITH THE "POINTS OF REST."

impresses on us the fact, that underneath the muscles there is the solid framework of the bones which support them, and on which they depend completely.

These points of rest, on the outline as well as in the sections, are generally caused by the bones or the tendinous

parts, which are more rigid in drawing than the muscles. Therefore, these firm, slightly-curved flatnesses, which the subcutaneous bones cause, form, by their tranquil simplicity of aspect, a contrast to the variable alternative roundness of the muscular fibres, and give an impression of resistance, which at the same time detracts from the monotony which would exist, if an even roundness of form prevailed all over the figure.

In the beautiful antiques, especially in the Torso Belvedere of the Vatican, you observe the application of this principle.

FIG. 123.—SECTION OF THE THORAX FIG. 124.—THE SAME WITHOUT THE
 WITH " POINTS OF REST." " POINTS OF REST."

It is not only in the outlines that this is evident, but these intervals of rest show in a more or less emphasized manner between all the large muscles, so that, notwithstanding the enormous muscular development of this torso, it remains elegant, elastic, and supple.

I therefore repeat and impress on you that these intervals of rest, or planes of separation, between the masses occur in every part of the figure ; and I am convinced that, having drawn

your attention to this principle, you will see it and apply it yourselves in all the other parts which I have not mentioned.

To model does not merely mean making a model of a statue; this term applies as well to the product of Painting as to that of Sculpture. We talk of good and vigorous modelling and weak, poor modelling of heads, hands, &c.

In Painting, the beautiful modelling depends on *drawing* and *colour*: it signifies rendering by means of light and shadow the round or flat projections of a solid body.

In Sculpture, it depends on understanding and drawing with intelligence the often slightly-curved half-planes, an intelligence which can only be acquired by a thorough knowledge of the anatomical mechanism which lies underneath the skin; for it is the movement of the muscles and their fibres, which in their contrasting directions form the large variety of planes which the skin covers, enveloping and following them in all their undulations.

The ignorance of Anatomy in this, as in the construction of the figure, can only produce in the execution a result which is weak and unintelligent, and consequently uninteresting.

Besides, he who is ignorant of it, cannot so clearly see these movements of planes on the surface, as he who knows it. Even if he sees them, he will never give them such animation,

strength, and feeling of delicacy, for he does not know the origin of these planes, nor their cause.

In order to model a form, it must be drawn first by the shadows or half-tints which surround it. These are formed by the, more or less rapid, action of planes, whose place or point of origin is narrow, but which spread by radiation over the large surface of the form.

Let us take the Pectoral for an example.

Its modelling cannot be obtained by a mere slightly curved plane which surrounds it and draws its outline. If you stopped at that, the result would look like a lifeless board, or, if you simply rounded it off, it would look like a cushion stuffed with cotton-wool, without the " morbidezza " of nature.

On the other hand, with regard to these shadows, if you boldly and wisely indicate in them the starting of the number-less planes which surround them, by spreading them and again modelling them together on the larger surface, you will obtain an expressive form and a great variety of movement.

When all these movements of planes are blocked in, they must be blended together by the skin which delicately covers them, by simplifying them, by almost making them disappear, and by these means you will obtain an *animated simplicity*. The opposite proceeding can only result in a *dead simplicity*.

In working out these—planes, you should never forget to separately observe from below, or from the side, the section of

each separate form, in order to give them their richness of form.

If you worked only from the front, the result would certainly be a poor and flat form. By working across the form you will be obliged to look at it from underneath, and thus give it fulness and richness.

In this stage, more than ever, you should compare the relative values of half-tints and shadows, for it frequently happens that, in indicating the planes before-mentioned and their radiations, the half-tints which draw the form are *almost of equal value.*

At this point, when a shadow appears too black, it does not always mean that the depression is too deep, but the cause is rather found in the fact that the angle formed by the light and shade is too acute.

Or, if it is not dark enough, that the angle is too obtuse.

The study of these angles is very important. You can only arrive at them by the section of the form—that is, by looking at it from underneath.

To obtain a strong shadow it is not necessary to make a hole, but to make the angles more or less sharp.

The Palette of the sculptor is made up of black and white, and all the different tones are formed by the variety of the angles which give light and shade.

You should never make the half-tints which surround a form too narrow—that will rob them of breadth ; for the richness

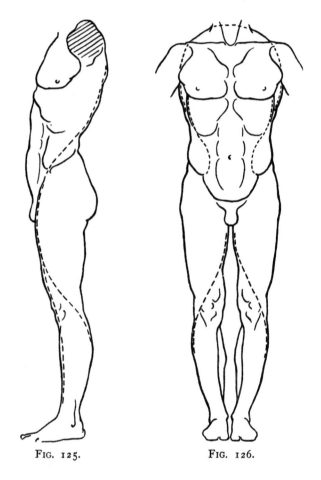

FIG. 125. FIG. 126.

and breadth of form depends absolutely on the half-tint which surrounds it.

If you must exaggerate, it is preferable to make these half-tones rather too large, for that will give not only richness to the form, but will produce separation between the various forms, which will give more life and spring to the whole.

In drawing an outline you should mentally continue it to the point which it may meet on the other side of the figure.

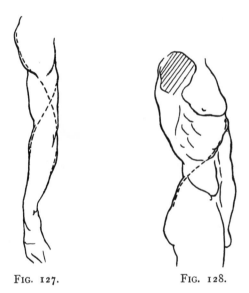

FIG. 127. FIG. 128.

Take, for instance, the general direction of the outline on the profile, caused by the Shoulder-blade and the Quadratus Lumborum, and continue across the figure to observe its relation to the general outline of the leg. (Fig. 125.)

Do the same for the outline of the Trapezius muscle, to find its relation with regard to the dorsal (Latissimus dorsi). (Fig. 126.)

Continue the outline of the thorax from the front view with regard to the internal and external oblique muscles. (Fig. 126.)

Continue the anterior outline of the carrying leg along its posterior outline. (Fig. 125.)

Observe in the arm the relation of the Deltoid to the posterior outline of the fore-arm. (Fig. 127.)

These lines may be traced or drawn on all the views of the figure—as, for example, on Fig. 128 ; by means of this, the general relation of form to form will be ascertained, and you will get harmony of lines at the same time as their movement ; you will avoid a piling-up of forms without any relation between them.

It is, so to say, in oblique lines the equivalent of the horizontal and vertical lines, which you employ to find the position of different points on the figure.

And you might trace such lines *ad infinitum.* I only mention a few, feeling certain that, if a student has once grasped this principle, he will find many others by himself.

COMPARATIVE PROPORTIONS

I am much averse (in our studies from the living model) to the application of rules of proportion which some books give us, which teach that so many noses, or so many fingers, compose the length of an arm or a leg.

If we applied this information to our studies from Nature, it would destroy in our work the character and individuality which every being possesses, and the result would be very commonplace work ; for it is just the *proportions* which lend individual character to the head, as well as to every other part of the figure.

Nevertheless, I believe that it is useful to know certain *comparative proportions*, which will enable us, in making a sketch or composition, to avoid gross mistakes.

I have indicated a few such in a diagram of comparative proportions. (Fig. 129.)

In the following measurements we observe a minimum of variation or difference :—

In the LEG—The distance from beneath the arch of the foot to the upper border of the Patella is equal to that from the centre of the Patella to the Crest of the Ilium on the standing leg.

But I have also found, in rather long legs, that the

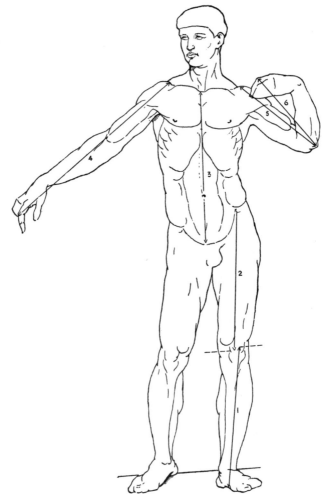

FIG. 129.—GENERAL COMPARATIVE PROPORTIONS.

1. ⎧ From Plinth to top of Patella.
2. ⎨ From centre of Patella to Iliac process.
3. ⎩ From Pubic line to top of Sternum.
 These three proportions are generally equal.

THE ARM.

4. Three heads in length from Acromion to first articulation of index finger.

5. From Acromion to head of Ulna one head and a half.

6. From head of Ulna to first articulation of finger one head and a half.

From Plinth to top of Patella two heads.

From centre of Patella to Iliac process two heads.

proportion from the ground to the top of the Patella was equal to the distance from the top of the Patella (instead of its centre) to the Anterior Superior process of the Ilium.

You will also find that this measurement from under the foot to the top of the Patella equals the distance from the supra-sternal notch to the line of the Pubes.

Generally speaking, these three measurements are the same.

Further: The length of the leg to the top of the Patella contains two heads, and the distance from the centre of the Patella to the Ilium the same.

ARM :—

In the outstretched arm, the measurement from the Acromion process to the first articulation of the Index contains three heads.

In a long arm the third head comes only to the middle of the first Phalanx.

There is, as a rule, one head and a half in the distance from the Acromion process, or Shoulder, to the head of the Ulna (the Elbow), and one head and a half from the Elbow to the end of the first of the Phalanges.

I think the knowledge of these few comparative proportions will be sufficient to prevent you from mistakes, when you have no model to guide you.

But to use, in your studies from life, other proportions than those presented by the model, would be quite contrary to all

idea of study; for all your attention must be engrossed by searching for the personal characteristics of your model. That is what *artistic study* means, and it is only by this kind of study that you will develop your powers of observation and lay in a store of knowledge to draw on for composition and design.

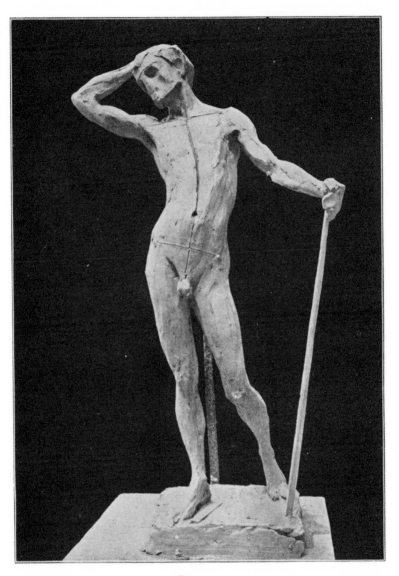

FIG. 130.

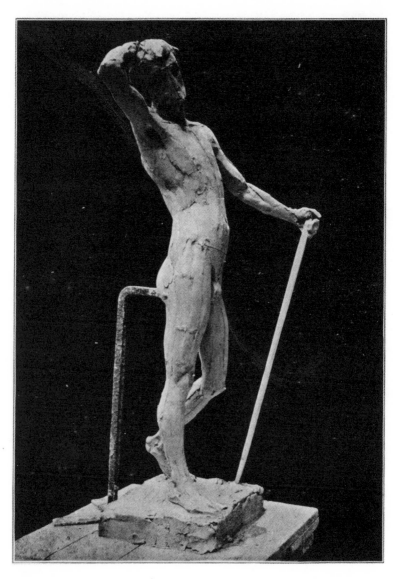

FIG. 131.

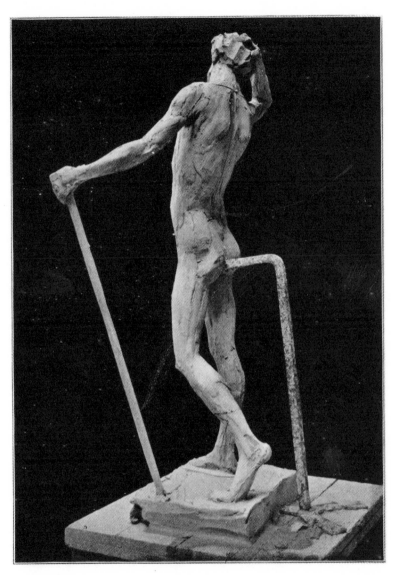

FIG. 132.

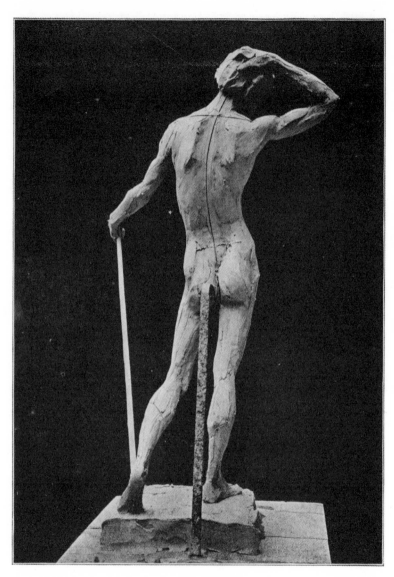

FIG. 133.

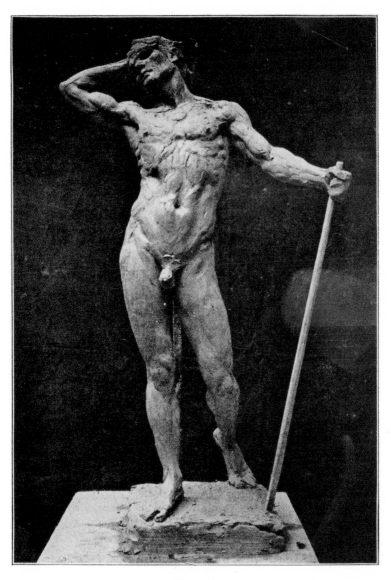

FIG. 134

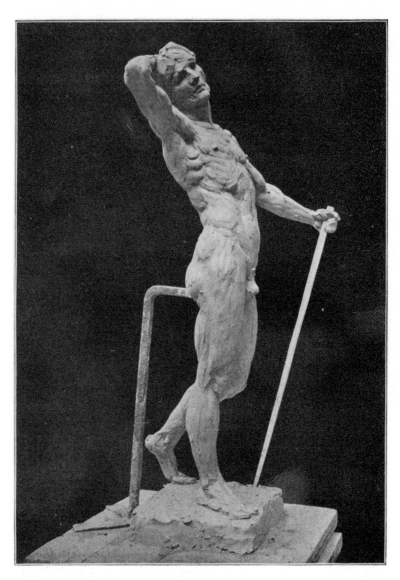

FIG. 135.

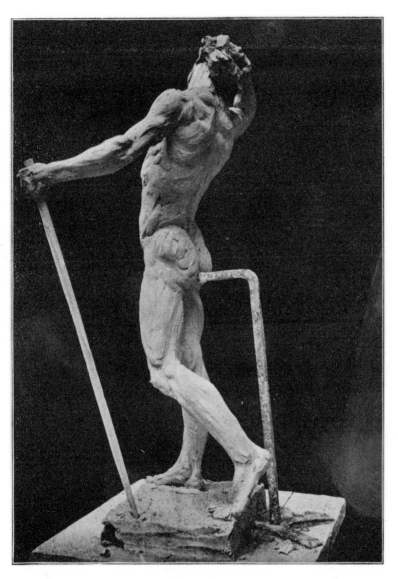

FIG. 136.

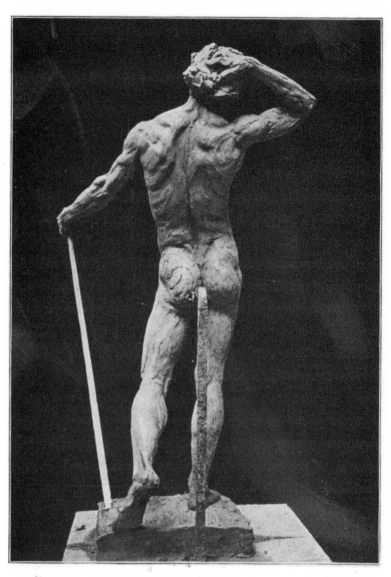

FIG. 137.

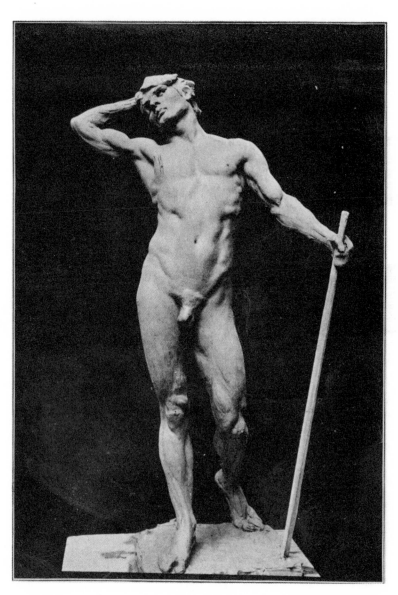

FIG 138.

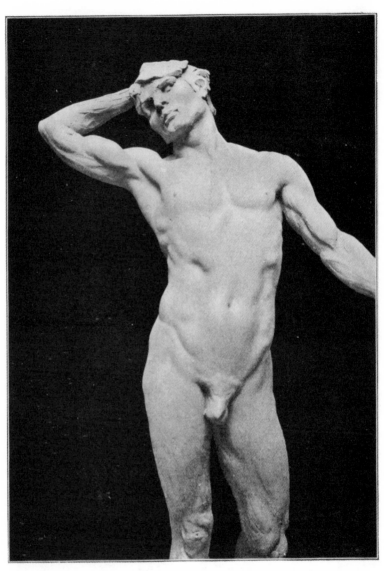

Fig. 139.

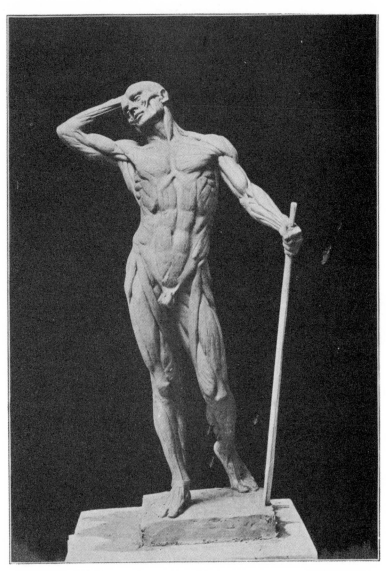

FIG. 140.

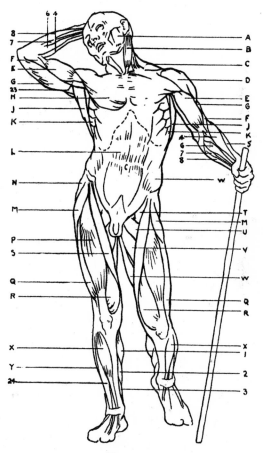

Fig. 141.

The numbers and letters refer to the same muscle in all four diagrams.

A. Masseter.
B. Sterno-cleido-mastoid.
C. Trapezius.
D. Deltoid.
E. Biceps.
F. Brachialis Anticus.

G. Triceps.
H. Pectoralis Major.
J. Latissimus Dorsi.
K. Serratus Magnus.
L Rectus Abdominis.
M. Tensor-Vaginæ-Femoris.

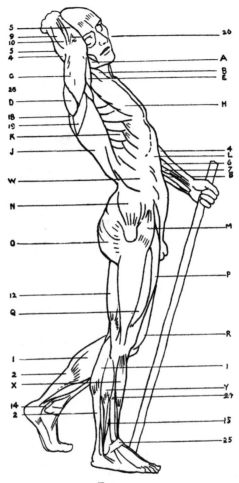

FIG. 142.

N. Gluteus Medius.
O. Gluteus Maximus.
P. Rectus Femoris.
Q. Vastus Externus.
R. Vastus Internus.
S. Sartorius.

T. Iliacus and Psoas.
U. Pectineus.
V. Adductor Longus.
W. External Oblique.
X. Tibialis Anticus.
Y. Peroneus Longus.

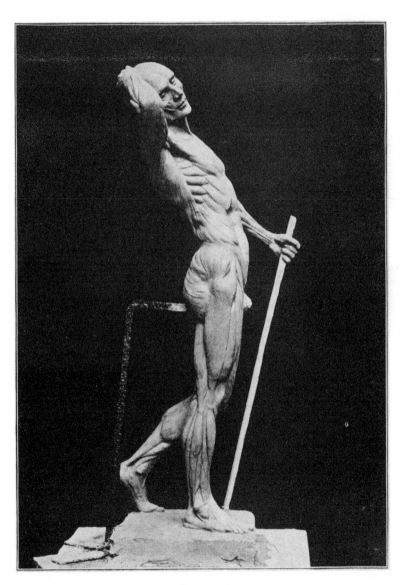

Fig. 143.

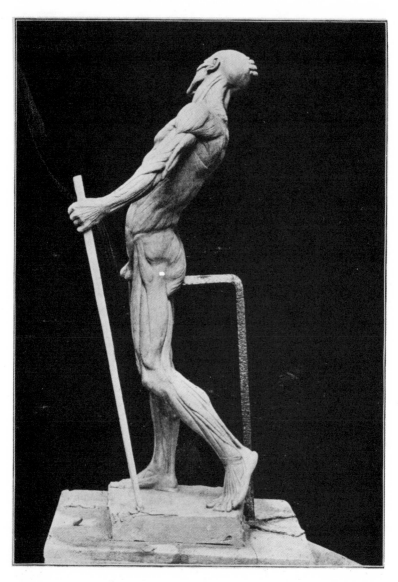

FIG. 144.

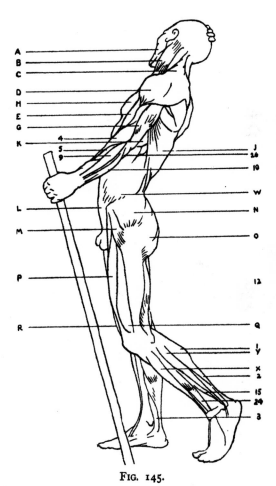

FIG. 145.

1. Gastrocnemius.	8. Flexor-carpi-ulnaris.
2. Soleus.	9. Extensor-communis Digitorum.
3. Long Flexor of the toes.	10. Extensor-carpi-ulnaris.
4. Supinator Longus.	11. Semi-tendinosus.
5. Extensor-carpi-radialis-longior.	12. Biceps Cruris.
6. Flexor-carpi-radialis.	13. Semi-membranosus.
7. Palmaris Longus.	14. Long Flexor of Great Toe.

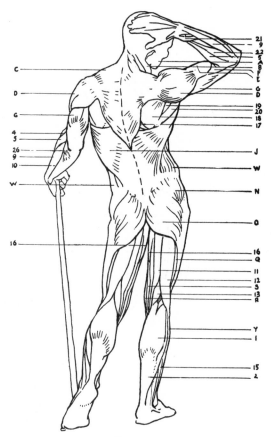

FIG. 146.

15 Peroneus Brevis.	21. Extensor-ossis-metacarpi-pollicis.
16. Gracilis.	22. Extensor-carpi-radialis-brevior.
17. Rhomboideus Major.	23. Coraco-brachialis.
18. Infra-spinatus.	24. Long Extensor of the toes.
19. Teres Minor.	25. Anterior Annular Ligament.
20. Teres Major.	26. Anconeus.

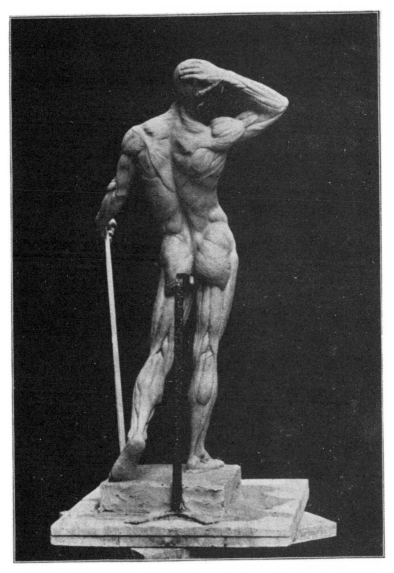

FIG. 147.

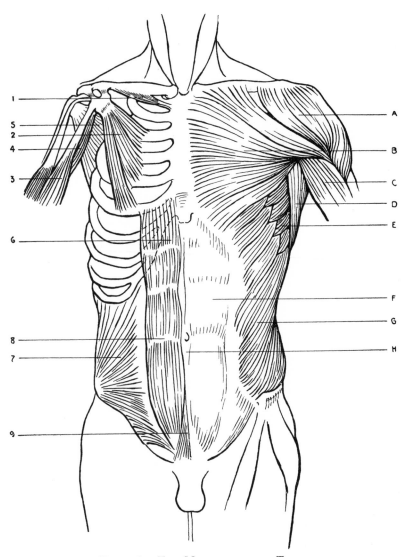

FIG. 148.—THE MUSCLES OF THE TORSO.

A. Deltoid.
B. Pectoralis Major.
C. Biceps.

D. Latissimus Dorsi.
E. Serratus Magnus.
F. Aponeurosis of External Oblique.

G. External Oblique.
H. Linea Alba.

DEEP PORTION.

1. Subclavius.
2. Pectoralis Minor.
3. Biceps.

4. Coraco-brachialis.
5. Subscapularis.
6. Rectus Abdominis.

7. Obliquus Internus Abdominis.
8. Lineæ Transversæ.
9. Pyramidalis.

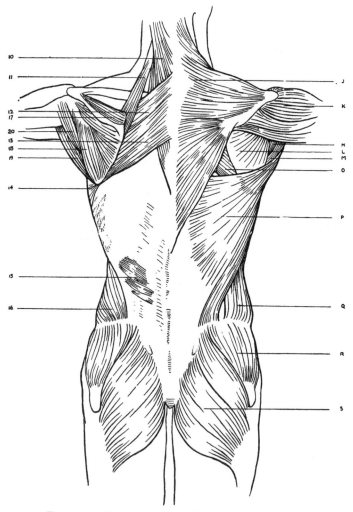

FIG. 149.—MUSCLES OF THE BACK OF THE TRUNK.

J. Trapezius.	N. Teres Minor.	R. Gluteus Medius.
K. Deltoid.	O. Rhomboideus Major.	S. Gluteus Maximus.
L. Infra-spinatus.	P. Latissimus Dorsi.	T.
M. Teres Major.	Q. External Oblique.	

DEEP PORTION

10. Splenius.	14. Serratus Magnus.	18. Infra-spinatus.
11. Levator-anguli-scapulæ.	15. Serratus Posticus Inferior.	19. Teres Major.
12. Rhomboideus Minor.	16. Obliquus Internus.	20. Teres Minor.
13. Rhomboideus Major.	17. Supra-spinatus.	

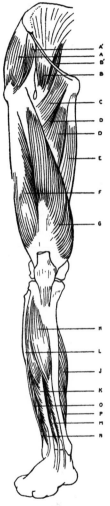

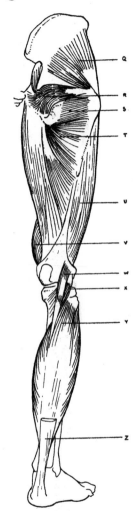

FIG. 150.

FIG. 151.

MUSCLES OF THE LEG.

A A'. Gluteus Medius and
 Maximus.
B B'. Iliacus and Psoas.
C. Pectineus.
D D'. Adductor Longus and
 Adductor Brevis.
E. Adductor Magnus.
F. Vastus Externus.
G. Vastus Internus.
H. Tibialis Anticus.

J. Soleus.
K. Extensor-longus Digi-
 torum.
L. Peroneus Longus.
M. Extensor-propius-pollicis.
N. Peroneus Tertius or
 Anticus.
O. Peroneus Brevis.
P. Flexor-longus Digitorum.
Q. Gluteus Minimus.

R. Obturator Internus.
S. Quadratus Femoris.
T. Adductor Magnus.
U. Vastus Externus.
V. Vastus Internus.
W. Plantaris.
X. Popliteus.
Y. Soleus.
Z. Tendo Achilles.

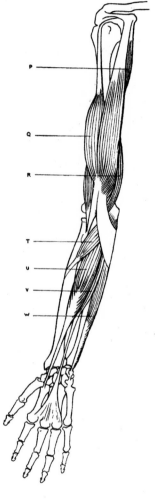

FIG. 152.

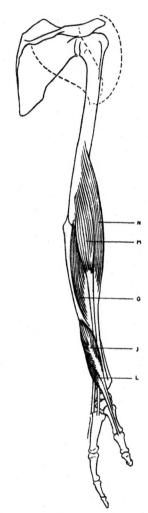

FIG. 153.

MUSCLES OF THE ARM.

J. Extensor-ossis-metacarpi-pollicis.
K.
L. Extensor-secundi-internodii-pollicis.
M. Extensor-carpi-radialis-longior.
N. Spinator-radii-longus.
O. Extensor-carpi-radialis-brevior.
P. Coraco-brachialis.

Q. Biceps Cubiti.
R. Brachialis Anticus.
S.
T. Pronator-radii-teres.
U. Flexor-carpi-radialis.
V. Palmaris Longus.
W. Flexor-carpi-ulnaris.

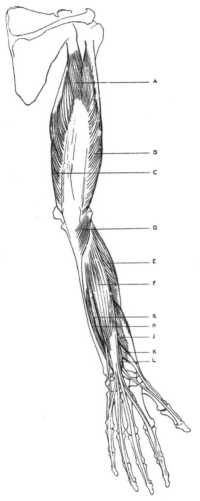

FIG. 154.—MUSCLES OF THE ARM.

A. Triceps.
B. Triceps.
C. Triceps.
D. Anconeus.
E. Supinator-radii-brevis.
F. Extensor-communis Digitorum.

G. Extensor-minimi-digiti.
H. Extensor-indicis.
J. Extensor-ossis-metacarpi-pollicis.
K. Extensor-primi-internodii-pollicis.
L. Extensor-secundi-internodii-pollicis.

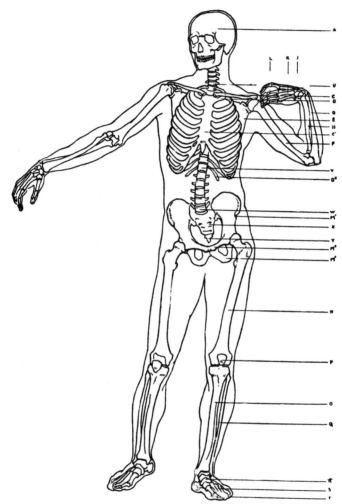

Fig. 155.—The Bones.

The letters refer to the same bones in all these diagrams.

A. Skull.
B. Hyoid Bone.
C. Clavicle.

C′. Sternum.
D. Ribs. D^1, first Rib ; D^{12}, twelfth Rib.
E. Scapula.

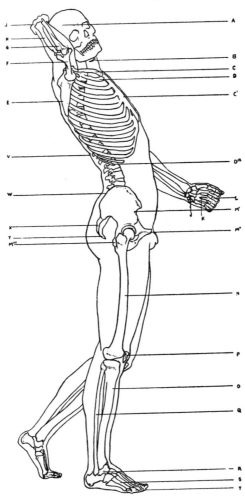

FIG. 156.

F. Humerus.
G. Ulna.
H. Radius.
J. Carpus.
K. Metacarpus.

L. Phalanges.
M. Innominata. M′, Ilium ; M″, Pubis ; M‴, Ischium.
N. Femur.
O. Tibia.
P. Patella.

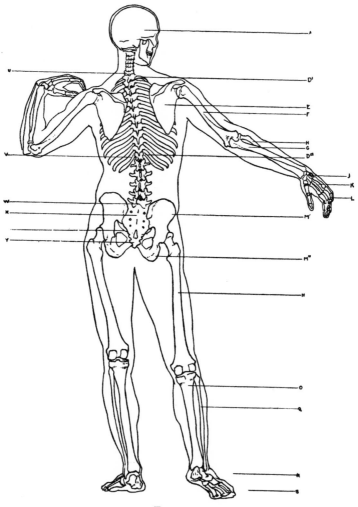

FIG. 157.

Q. Fibula.
R. Tarsus.
S. Metatarsus.

T. Phalanges.
U. 7th Cervical.
V. 12th Dorsal.

W. 5th Lumbar.
X. Sacrum.
Y. Coccyx.

ATTACHMENTS OF THE MUSCLES

MUSCLE		ATTACHMENTS
A. *Masseter.*	1st.	Inferior margin of zygomatic arch.
	2nd.	External surface of the ramus and the angle of the lower jaw-bone.
B. *Sterno-cleido-mastoid-eus.*	1st.	Mastoid process of temporal bone, and backwards some distance along the superior curved line of the occipital bone.
	2nd.	By the inner head to the front of top of sternum, and by the clavicular head to inner third of upper border of clavicle.
C. *Trapezius.*	1st.	Spines of all dorsal vertebræ and last cervical; ligamentum nuchæ, from last cervical vertebra to occipital protuberance, and one-third of superior curved line of the occiput.
	2nd.	Outer third hinder border of the clavicle, inner border of the acromion, upper border of spinous process of the scapula.
D. *Deltoid.*	1st.	Spinous process of scapula and outer third of clavicle.
	2nd.	Deltoid impression on the humerus.
E. *Biceps.*	1st.	By the long head above glenoid cavity, by short head to coracoid process of scapula.
	2nd.	By a long tendon to back of bicipital tuberosity of radius.
F. *Brachialis Anticus.*	1st.	Lower half of anterior surface of humerus.
	2nd.	Below coronoid process of ulna.

MUSCLE		ATTACHMENTS
G. *Triceps.*	1st.	By the middle head, beneath glenoid cavity on neck of scapula ; by the outer head, to outer side of upper half of humerus ; by the inner head, to inner side and lower half of the humerus.
	2nd.	Upper border and sides of the olecranon process of the ulna.
H. *Pectoralis Major.*	1st.	Aponeurosis of the external oblique muscle of the abdomen, front of body, to hilt of sternum, and adjacent costal cartilages, to inner half of clavicle.
	2nd.	Bicipital groove of humerus.
I. *Latissimus Dorsi.*	1st.	By an aponeurosis to the lower six dorsal spines, to all the lumbar, upper two or three sacral spines ; also to the posterior third of the iliac crest, and lowest three or four ribs.
	2nd.	Bicipital groove of the humerus.
K. *Serratus Magnus.*	1st.	Upper eight ribs.
	2nd.	Base of the scapula.
L. *Rectus Abdominis.*	1st.	Pubic crest and symphysis.
	2nd.	Fifth rib, fifth, sixth, and seventh costal cartilages, and xiphoid cartilage.
M. *Tensor Vaginæ Femoris*	1st.	Anterior superior iliac spine, and a small surface on the outer lip of the crest of the ilium.
	2nd.	Fascia-lata.
N. *Gluteus Medius.*	1st.	Upper part of outer surface of ilium.
	2nd.	Outer surface of trochanter major.
O. *Gluteus Maximus.*	1st.	Lower border of sacrum and coccyx and adjacent portion of ilium.
	2nd.	Over trochanter to fascia and back of femur below trochanter.
P. *Rectus Femoris.*	1st.	Anterior inferior iliac spine and above acetabulum.
	2nd.	By common tendon to the patella.

MUSCLE	ATTACHMENTS
Q. *Vastus Externus.*	1st. Outer side of back of femur.
	2nd. Common tendon to the patella.
R. *Vastus Internus.*	1st. Inner side of back of femur.
	2nd. Common tendon to the patella.
S. *Sartorius.*	1st. Anterior superior iliac spine.
	2nd. Inner side of front of tibia.
T. *Iliacus and Psoas.*	1st. Iliac fossa and crest, base of the sacrum, capsule of hip joint, also twelfth dorsal and the five lumbar vertebræ.
	2nd. Trochanter minor.
U. *Pectineus.*	1st. Spine and crest of Os Pubis.
	2nd. Behind trochanter minor on the shaft of the femur.
V. *Adductor Longus.*	1st. Os Pubis (by a narrow flat tendon).
	2nd. Middle third of back of femur.
W. *External Oblique.*	1st. By digitations with the Latissimus Dorsi and Serratus Magnus, to lowest eight ribs.
	2nd. To the anterior half of the iliac crest and abdominal aponeurosis.
X. *Tibialis Anticus.*	1st. Upper half of outer surface and outer tuberosity of tibia.
	2nd. Inner and under side of cuneiform and first metatarsal bone.
Y. *Peroneus Longus.*	1st. Upper half and head of fibula.
	2nd. Under side of metatarsal bone of great toe.
1. *Gastrocnemius.*	1st. By two heads to back of condyles of femur.
	2nd. Back of Os Calcis by the tendo Achilles.
2. *Soleus.*	1st. Back of head of fibula and part of upper fourth of tibia and fibula.
	2nd. Back of Os Calcis.
3. *Long Flexor of the Toes.*	1st. Back of tibia below soleus.
	2nd. Third phalanx of four outer toes.
4. *Supinator Longus.*	1st. Upper part of epicondyloid ridge of humerus.
	2nd. Base of styloid process of radius.

MUSCLES		ATTACHMENTS
5. *Extensor carpi radialis longior.*	1st.	Lower part of epicondyloid ridge of humerus.
	2nd.	Base of metacarpal bone of first finger.
6. *Flexor carpi radialis.*	1st.	Inner condyle of humerus, fascia of fore-arm.
	2nd.	Front of the base of metacarpal bone of fore finger.
7. *Palmaris Longus.*	1st.	Inner condyle of the humerus fascia of fore-arm.
	2nd.	Palmar fascia opposite the middle of the wrist.
8 *Flexor carpi ulnaris.*	1st.	Inner condyle of the humerus, inner side of olecranon, and upper two-thirds of posterior border of ulna.
	2nd.	Pisiform bone, annular ligament, and palmar fascia.
9. *Extensor communis digitorum.*	1st.	External condyle of the humerus.
	2nd.	By four tendons to the back of the bases of last two bones of the fingers.
10. *Extensor carpi ulnaris.*	1st.	External condyle of humerus.
	2nd.	Back of base of fifth metacarpal bone.
11. *Semi-Tendinosus.*	1st.	Back of tuberosity of ischium.
	2nd.	Inner side of front of tibia.
12. *Biceps Cruris.*	1st.	By long head, back of tuberosity of ischium; by short head, lower two-thirds of back of femur down to the external condyle.
	2nd.	Head of fibula.
13. *Semi-Membranosus.*	1st.	Back of tuberosity of ischium.
	2nd.	Back of internal tuberosity of tibia.
14. *Long Flexor of Great Toe.*	1st.	Back of fibula below soleus.
	2nd.	Under side of base of last phalanx of great toe.
15. *Peroneus Brevis.*	1st.	Outer side of fibula below Peroneus longus.
	2nd.	Tuberosity of fifth metatarsal bone.
16. *Gracilis.*	1st.	Os Pubis (descending ramus).
	2nd.	Inner side of tibia beneath internal tuberosity.

MUSCLES		ATTACHMENTS
17. *Rhomboideus Major.*	1st.	Upper five dorsal spines.
	2nd.	Base of scapula from root of spine to lower angle.
18. *Infra-Spinatus.*	1st.	Inner two-thirds of infra-spinous fossa.
	2nd.	Greater tuberosity of humerus.
19. *Teres Minor.*	1st.	Upper two-thirds anterior border of scapula.
	2nd.	Greater tuberosity of humerus.
20. *Teres Major.*	1st.	Inferior angle of scapula, axillary margin of the bone.
	2nd.	Bicipital groove of the humerus.
21. *Extensor ossis meta-carpi pollicis.*	1st.	Back of ulna, back of radius.
	2nd.	Back of metacarpal bone of thumb.
22. *Extensor carpi radi-alis brevior.*	1st.	External condyle of the humerus.
	2nd.	Base of metacarpal bone of second finger.
23. *Coraco-brachialis.*	1st.	Coracoid process of scapula.
	2nd.	Ridge in middle of inner side of humerus.
24. *Long Extensor of the Toes.*	1st.	External tuberosity of tibia, upper part of inner surface of fibula.
	2nd.	Last phalanges of four outer toes.
25. *Anterior Annular Ligament.*		Consists of two bands : the upper placed vertically in the leg above the ankle joint; the lower is placed obliquely across the highest part of the tarsus ; together they contain the tendons of the tibialis anticus, long extensor of the toes, peroneus tertius, and extensor of the great toe, in a sheath.
26. *Anconeus.*	1st.	Back of external condyle of humerus.
	2nd.	Outer side of ulna below the olecranon process.

MODELLING AND SCULPTING THE HUMAN FIGURE

Section Two

PREFACE

By all students of Sculpture, Professor Lanteri's admirable book must be welcomed with enthusiasm. At a time when it is more or less the fashion in many Art Schools to admit "impressionism," alas! even in the noble and restrained Art of Sculpture, it is indeed refreshing to read these pages, written not only with healthy vivacity, but with a thoroughness of knowledge, aye, more, a scientific insight uncommon in a tentative and experimental period of both teaching and learning.

It is the more satisfactory as coming from the Professor of the Royal College of Art, whose school therein has produced so many admirable sculptors, and where at this moment all the sound principles so elaborately set forth in this book are being practically initiated. When I say practically initiated I mean that there is no axiom illustrated on these pages which is not forcibly maintained in practice in the school which is lucky enough to have Professor Lanteri as Professor. I would rather call my preface a "tribute" than an introduction: a

tribute in the sense of keen admiration for the industry, the
success, and the stimulating cause which are such worthy ele-
ments in the Professor's teaching. Enthusiasm is a great deal
in a teacher : without that quality he is a lifeless block, may be,
of erudition, but when erudition, may I say in these days of
hurry, and classical thoroughness is combined with the power
of inculcating enthusiasm, then a rare and very perfect teacher
is found. Words may be very picturesque, oratory may be
perfect, rhetoric catching, but without the balance of sound
reasoning and practical common sense, they are as the leaves
of the Sibyl which were blown away from out her cave, leaves
perhaps full of wisdom, but disconnected with each other and
therefore useless. Sculpture is so noble an Art that it cannot
be played with ; it is an Art which demands scientific investi-
gation, which demands real knowledge, not ephemeral or
subsidiary, but lasting and essential. We cannot guess at
form nor can we fluke excellence when dealing with masses
and planes of infinite intersections and varieties : the initiating
steps must be sound and safely erected. In this nature Sculp-
ture has a close affinity with Architecture, it is structural, if it
is not it is worthless. To the amateur it is easy to produce
some effect, just as it is easy to make a good deal of a few
well-chosen sentences in a foreign language, but the fraud is
very easily and very soon discovered, and the amateur
sculptor and linguist remain so to the end of time.

Preface

This book is one that ought to warn superficial students that they must labour, that the Art of Sculpture is so difficult and exacting in demands of accuracy as well as of good taste, that before entering in her fields, it may be well to remember that ancient saying in a very wise Book not sufficiently studied, " Take off thy shoes from off thy feet, the ground on which thou standest is holy ground."

It is as if Professor Lanteri had that motto before his mind when he prepared these pages of words and illustrations. He has approached his subject seriously, religiously, as a teacher and as a workman; his readers must read, mark, learn, in the same spirit of reverence for the Art of which Lanteri is so distinguished an ornament.

Though I am a painter by trade, as colloquialism would express it, the other great sister Arts, Architecture and Sculpture, have, from my boyhood, in a measure, run alongside of my craftsmanship as a painter; had this not been so, I should not have ventured to use my pen on this occasion.

I know the difficulties, I know the charms, I know the mazes into which the mysterious spirit of Form may lead or mislead.

I know that it is useless to model, except in the highest degree unsatisfactorily, without a sound and complete knowledge of the human form. Not only anatomically, but may I say decoratively, must the figure be studied part by part, and

as a whole also. The many and ever deviating sections, the
innumerable interlacing of planes, the endless varieties of
surfaces, which go to make infinite and complicated outlines,
must be studied not only by the eye generally, but by the
mind specifically : and this is no easy task. " Impressionist
mists" and "Will-o'-the-wisp" suggestions will lead and mis-
lead till humility is taught to the student by finding himself
floundering in a slough of despond : he may perhaps call for
the Pedant, who has been his *bête noir*, to save him, and in
modesty perhaps say, " If I had followed your track when I was
foolish and vain, I might have found the 'delectable moun-
tains'"; the Pedant, kind and indulgent, will take the foolish
wanderer by the hand and set him into a straight road. The
word Pedantry may be used in the sense of abuse, it may also
imply the cause of final success. Students should be pedantic,
narrow if you like, prejudiced if you will, positive also, but in
the lines which their predecessors have laid down for them by
centuries of labour and experience, and not guided by their
own vagaries, which at the bottom of them have nothing but
emotion. Let us feel, yes, feel intensely, but we can only be
artists when reason and emotion have joined hands, the one
guiding, the other impelling. And this principle I take it to
underlie all that the author seeks to enforce. All character,
all reason, every form and combination of forms contain com-
binations of emotions which Art can convey, but the artist is

powerless to convey them until he has trained himself to under-
stand how and why certain combinations are impressive, either
by rhythm or sudden transitions. It is I think not the least
admirable chapter which deals with Composition. Composition
can be taught, originality cannot; the original student is some-
times held back by his originality, it may impede his progress,
because the initiating vision is so strong that he is apt to rush
into its embrace regardless of the pitfalls between him and it.
For the original genius, pedantry is probably as essential as to
the student less endowed ; it serves as a *check* upon his over
ardent and sanguine nature ; it acts as a balance against heed-
less or even reckless novelty.

Professor Lanteri in the long course of years has instructed
so many students that he probably knows better than most of
us do that " the genius " is not of necessity the individual who
in the long run does best ; though of a certainty he will do
best if he submits to authority in his student days. It is
especially for the cleverest fellows that this book must prove
of so much service. The experience in these pages is enor-
mous, every possible pitfall has its fence round it, and every
imprudent step which a student might take will find therein a
guide which will land him at least somewhere ; and some-
where is a long way upon the road to excellence, because it
means that a goal has been attained with a purpose, and by an
effort which has been sustained and thorough. What more

can I say except to wish my friend Lanteri the success he deserves, and that success will appeal to him most warmly which will be gained by his students under his generous and able tuition. If one might suggest a motto, might it not be a repetition of Michael Angelo's : "Sempre Imparo!"

W. B. RICHMOND.

CONTENTS

CHAPTER I

CHAPTER II

Contents

xii

Contents

MEDALS

Contents xiii

COMPOSITION

xiv Contents

Contents

Contents

Contents xvii

MODELLING AND SCULPTING THE HUMAN FIGURE

CHAPTER I

RELIEF FROM NATURE

When we model a study in the round, we must, as soon as the pose and action are arranged, obtain the proportion and construction of the figure. In modelling a relief, which is an interpretation of nature, we can, on the contrary, only gradually by our work obtain the appearance of this construction.

The effect of perspective has to be produced by a super-position of planes. These alone can give to a flat surface the appearance of roundness which the object possesses in nature.

The study of relief offers therefore much greater diffi-culties than the work in the round, which is a positive thing, whilst in relief,—beyond the outline of the figure, which remains the same as in the model, all the rest is artifice.

It is a grave mistake to let young beginners work in low-relief, as I have often seen it done! In order to do relief-studies, one must already be well acquainted with the construction of the human frame (only to be taught by studies in the round) so that we may suggest the construction by the more or less artificial means employed for relief.

Measures taken with the callipers are of as little use in relief as in drawing ; for there is the perspective to be considered, which loses the true proportion pertaining to all the parts of the body.

The lower the relief, the greater the difficulty ! Unless, the student is content to draw an outline on the background, and to fill it in with a certain quantity of clay, laid on in an even thickness, and then to put into this mass a few anatomical details. At that rate any one can do it,—but that is not true study from nature.

There is no absolute law for relief, it may be more or less projecting, and the sculptor must choose the degree of projection, which, for decorative purposes, depends on the place to be occupied by the work. Its projection, treatment and style ought to be governed by the architectural surroundings and by the height at which it will be placed.

In no case must the relief by too rich effect, or too much movement of lines, destroy the architecture that sur-

rounds it, for from the decorative point of view its object is only to enhance the architectural effect.

I have seen plenty of such examples, where the sculptor seems to struggle with the architect to draw attention to his work only ;—a vulgar mistake, for the result is always destructive of the harmony of the whole.

I also know several cases, where, in order to enrich the effect of the relief, the sculptor has not hesitated to cut into the wall, even almost through the wall, to produce a violent shadow, darker than the strongest shadow of the whole architectural work which he is decorating ; so that unity and harmony are so completely destroyed as to alarm the mind of the spectator about the solidity of the structure ; for where the eye does not receive the impression of strength and possible duration, there is an unconscious misgiving, which will prevent the work of art from entirely satisfying us, however much we may admire it.

The Greek sculptors of the best epoch have never committed such mistakes, on the contrary, they more than any others have applied themselves to respect the principle, that the whole is more than the part.

Therefore in any relief designed for decorative purposes, we must above all harmonise the effect, that is the lights and shadows, as well as the style and lines of the composition with those of the surrounding architecture.

In beginning our first study of relief from nature we have to trouble about nothing except the projection which we judge to be appropriate to the pose and the character of the model. To begin with I should advise the relief to be rather high, that is about an inch of projection for the highest parts. That will allow you to accentuate the principles which I shall try to explain further on.

The object of our study in relief is to suggest in its slight projection as much as possible the effect of nature, not only in the outer contours, but also in producing the idea of roundness.

In decoration you cannot treat every pose in relief ; limbs in perspective are not suitable for it, for, although they may be successfully executed, at a distance the result will be hardly intelligible, but rather confused and painful to look at.

Observe with what care Phidias has avoided all poses in perspective in his frieze of the Parthenon.

All the same it will be a good exercise, after some first studies of simple action, to make others with slight fore-shortenings, as in a composition there may happen to be some foreshortenings that cannot be avoided without des-troying the lines of the composition.

For a first study I advise the student to give his model a very simple pose, where the limbs will be presented as much as possible in their entire length, but yet with some

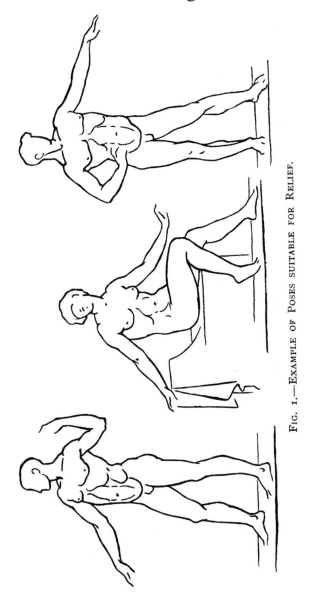

FIG. 1.—EXAMPLE OF POSES SUITABLE FOR RELIEF.

contrasts in the large planes, as for instance in the direction of the plane of the upper or thoracic part of the figure with that of the lower or abdominal part of the torso, as well as the plane of the head in contrast with that of the thorax. (See example of poses in Fig. 1.) However simple the pose,

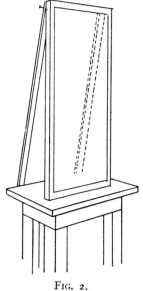

FIG. 2.

the difficulty will be sufficiently great to make the study interesting.

Having posed the model, you make a clay background about 32 inches high and of a width according to the development of the pose. This proportion is best for a first study; you will gradually go on to the natural size.

Fix this background to the modelling-stand by means of two battens, their upper end nailed to the top of the board, the lower one to the turn-table, see Fig. 2.

It is very essential to place the background vertically on the stand in order to get your figure well balanced, Fig. 3. If the bottom of your background projected beyond the upper part, you would put too much clay on the upper part of the figure in order that it should meet the plumb-line, and should the relief afterwards be placed in a vertical position,

the figure would fall forward. If the upper part of your background should overhang, the opposite result would happen. See Figs. 4, 5, 6, and 7.

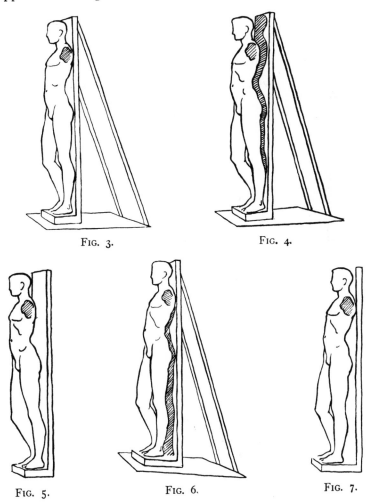

FIG. 3.

FIG. 4.

FIG. 5.

FIG. 6.

FIG. 7.

This settled, you draw with a modelling-tool on the clay
background the pose of the figure in its larger lines, that
is, as for the figure in the round, the chief
line of movement, the line of contrast of the
shoulder with the iliacs, and so on. (Fig. 8.)
I shall not here repeat the principles of the
movement which I have already described
in the first volume.

Now you fill this clay outline in to the
maximum of relief that you wish to give to
the figure (Fig. 9). The drawing has fixed
the contrast of lines and the general direction
of the movement, and now you attend to the
contrasts of planes.

With a large wire-tool like Fig. 10 you
firmly cut the large surfaces in their general
direction and without reckoning with details
(see Fig. 11); after these large planes you go
on to the lesser ones according to their im-
portance and thus come gradually to the
details.

FIG. 10.

There is another way of making a relief
of one inch projection: You make a background of two
inches thickness, on which you draw the chief line and the

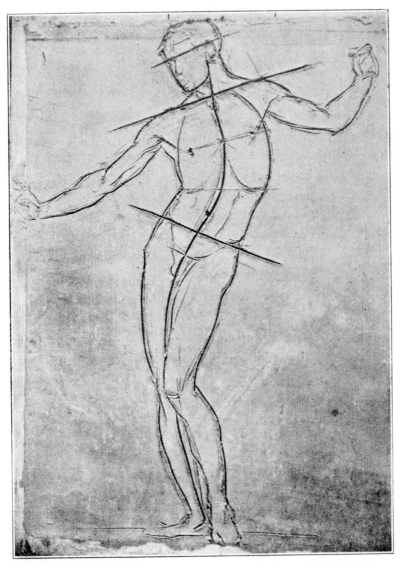

FIG. 8.—Showing Chief Line of Pose and Lines of Contrast.

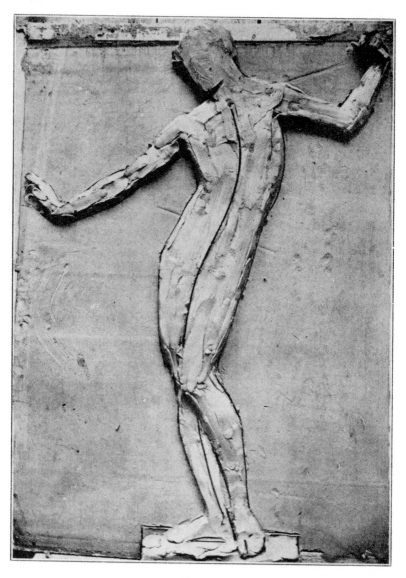

FIG. 9.

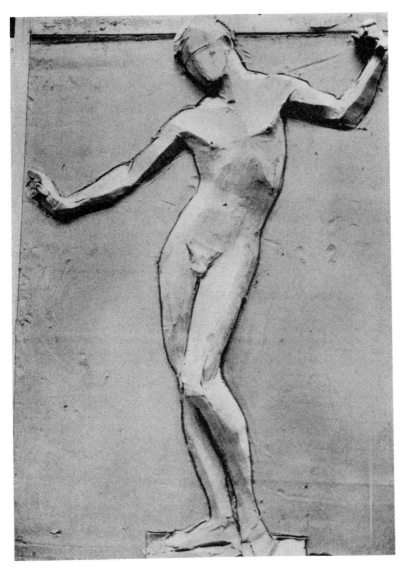

FIG. 11.—SHOWING THE LARGE SURFACES.

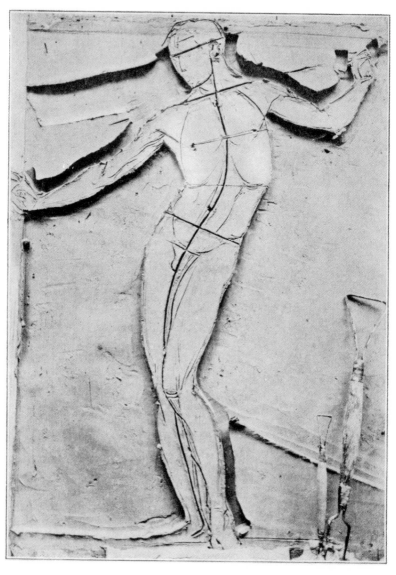

FIG. 12.—COMPARE THIS METHOD WITH THAT SHOWN IN FIG. 9.

Modelling

outlines with a wire tool to the depth of one inch (Fig. 12),
and then cut off the planes as before-mentioned. You will
obtain the same result as by the first process and perhaps
attain it more rapidly.

Both these ways of working are equally good for a
relief of one inch depth, but the latter is preferable for a
very low relief and not permissible for a higher relief than
one inch.

The essential thing to be obtained one way or the other
is the general substance of the figure. If you begin by in-
dicating the head, then the neck, the thorax, and so on
to the feet, by trying to give immediately the relation of
planes and forms to each other, there will always be a lack
of unity in the relation of the planes worked in that piece-
meal fashion; they seem not to blend and you will some-
times dig into the background or get so much projection
that it will approach the actual form in the round; in
short, the sense of continuation and construction is lost from
the beginning.

Having to give a flat surface the idea of natural round-
ness, we can only by lucky, that is, not readily perceptible
deceptions get a successful effect, but our principal aim must
be to obtain this by the superposition of planes, particularly
in the outlines of the figure.

As I said before, if you are content with drawing an

outline, filling it in with clay to a certain thickness and indicating in this mass some divisions of form, you will produce the effect of a paper doll cut in outline and stuck on a background. It will be inert and cannot for a moment suggest either the construction or the atmosphere which surrounds the living model, because it has apparently only one plane,

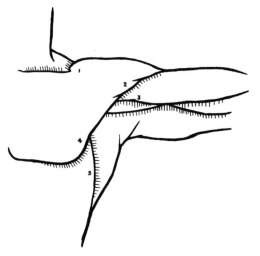

or rather two : that of the figure and that of the background.

To avoid this result, the most important principle in relief is to attend to the superposition of planes in the outer contours, and then to the inner outlines given by the various forms of the figure.

FIG. 13 —SUPERPOSITION OF PLANES.

In Fig. 13, which represents the Deltoid, Trapezius, Biceps, Thorax and Dorsal, you will observe that the contours around these muscles present five superpositions of planes :

1. The Deltoid is outlined in projection over the Trapezius muscle.

2. The Deltoid is projecting over the Biceps.

3. The Biceps is outlined over the Coraco-Brachialis and over the Triceps.

4. The Pectoral is outlined above the Thorax.

5. The Thorax lies over the Dorsal.

Suppose we let the student gain this experience for himself, that is, make only one big contour round this mass of muscles without any superposition of muscles within the outline, and let him blend all the planes together as shown in Fig. 14 ; then on a fresh background exaggerate the prin-

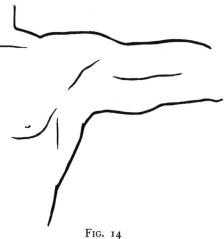

FIG. 14
Compare with Fig. 13.

ciple of superposition. He will immediately perceive the difference of strength in the form and the effect of distance which every higher plane gives to the adjoining one. He will notice the suggestion of roundness to be obtained, when each plane serves as foil to the other,—whilst with the previous attempt the effect from the distance is only that of the paper-doll stuck on a background.

This principle repeats itself in all the contours formed by the human figure. If you take the leg, (Fig. 15), in the interior outlines you will find, although perhaps less accentu-

FIG. 16.

FIG. 15.

ated than in other parts, the following superpositions:

1. The Sartorius is outlined over the internal mass of the various Adductor muscles of the thigh.

2. The Vastus Internus (part of the great Triceps of the leg) is outlined against the Sartorius and the mass formed by the inner Condyle of the Femur and the head of the Tibia.

3. The Patella stands out over this same mass.

4. The Tibia is outlined against the Gastrocnemius.

In the foot seen from the front, as in Fig. 16, you will easily notice the following superpositions :—

(*a*) The interior profile of the Instep over the heel,

(*b*) The plane formed by the mass of the toes over the Metatarsus,

(*c*) The outline of the arch against the leg and the external ankle-bone.

FIG. 17.

Let us also look at the inner view of the arm. There we find :

1 The Deltoid overlying the Biceps,

2. The Biceps over the mass of the Supinators,

3. The Biceps over the Coraco-Brachialis and Triceps,

4. The Coraco-Brachialis over the Triceps. (See Fig. 17.)

You will see from these examples, that this principle extends to all the exterior and interior contours of planes which the body presents, and you can easily find more examples for yourself.

Let us now look at the torso from a three-quarter view as given in Fig. 18.

You find here first: the superposition of one Pectoral over the other Pectoral; *i.e.* the Pectoral nearer to the eye than the other (2) which follows the receding plane of the upper mass of the torso, is outlined above this latter.

2. In the central part of the torso the mass of the Abdominal muscles (3) nearest to the eye stands out against the further ones (4) for the same reason.

3. The mass numbered 4 is relieved over the Oblique muscle numbered 5. The other Oblique, numbered 6 being more projecting than the abdominal muscles, is superposed on these. It is the same with the outline of the thorax; (7) its cartilaginous part stands out above the abdominal muscles, and so on.

You will have realised that this is one of the most important points in the study of relief. The few examples of superposition which I have demonstrated are the most accentuated ones, but you may continue them *ad infinitum.* Occasionally you find them with very delicate gradations, but having practised your eye by study, they will end by lying

FIG. 18.—SUPERPOSITION OF PLANES.

quite clearly before you. The more you have made this principle your own, and applied it with all the conscientiousness that our profession demands, the more will you be able to appreciate its value.

Thus the first thing we have to look out for after the pose, is the relation of the large surfaces to each other, that is, their relative projections according to the view we have of the model.

These relative projections must be copied faithfully in your studies. At a later period, when your work has a decorative purpose, or when you do a composition in relief, you may dodge a little, but not in the elementary studies you are doing.

I am perfectly aware that to copy nature faithfully in relief as relative projection, does not often produce a good relief according to the laws of harmony, but regardless of these considerations, our studies from nature must be executed with perfect sincerity and great respect for the model.

When you are more advanced in the study of relief, and have quite mastered its principles, you may, even you must take some liberties to obtain the harmony of planes which a relief requires; but this belongs to the domain of composition, of which I shall treat later on.

To return to our first study: Having with the wire-tool

(Fig. 10) cut the surfaces broadly, and sharply, you may perhaps lose the outlines, but do not be alarmed at that, for you will recover them more easily by the careful drawing of the planes they contain.

The large mass of more or less accentuated planes, each receiving the light differently, give not only a rich effect to the surface, but also suppleness to the form.

In this work of relief anatomical knowledge is necessary, but it does not play so important a part as in the figure in the round; for what we are modelling is not the actual, real thing, only we have to do our best to suggest the effect of nature.

It would even be damaging to work much with a view to anatomy, for one might unconsciously fall into working in the same style as from the round; one would be inclined to add to the projection and not only might one exceed the projection settled for the work, but also by attending only to the anatomy of the model, one would neglect the study of the superposition of planes, one would blend all the forms together and obtain again the doll-like effect. *See* Figs. 19, 20, 21; the difference only being, that this one would be round, instead of flat; but there would be the same lack of suppleness in the contours.

On a round part the light glides and does not come to a stop, it determines no proportion and does not arrest the

eye ; the latter too, sweeps over the whole form without being arrested by characteristic points of the whole.

Let the student gain this experience for himself. Sketch out any relief by strongly exaggerating the flat planes, in

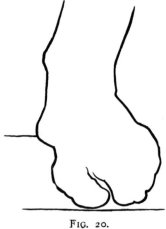

FIG. 20.
Compare with Fig. 16.

FIG. 19.
Compare with Fig. 15.

the outlines as well as in the interior forms. Then sketch out the same subject in higher relief, round the planes off and blend them in exaggerated fashion. Now place both these reliefs side by side at a

good distance, and you will become aware of the difference in quality of the two. The one with flat planes will, so to speak, write down all the forms and fix their character,

because light as well as shadow will be held in place by the arresting angles ; in the other one, on the contrary, the light will spread all over, and will consequently write down nothing ; it will be vague and undecided all over.

After you have applied in your study all the above-mentioned rules and firmly drawn it, with perhaps a little

FIG. 21.
Compare with Fig. 17.

exaggeration, it will be easy to modify the latter, to take off its crudeness or hardness. You have only to let yourself be guided by your anatomical knowledge to give the right direction to the forms, just as you would do when modelling in the round. Fig. 22.

The study of relief must, even more than the study in the round, be done by colour. You must not work long under the same effect of light and shadow ; you must

frequently change the lighting, but be careful always to place your work and the model under the same effect.

As it is impossible to give in a relief of one inch thickness the same intensity in the dark shadows that you see in the model, you must make a scale of values. If the darkest shadow in the model has, figuratively speaking, an intensity of

TONE VALUE IN THE MODEL

COMPARATIVE TONE VALUE IN RELIEF

FIG. 23.

sixteen degrees, and if we cannot obtain more than four degrees of depth in our relief of one inch projection, all the secondary values must be taken in the same proportion, *i.e.* as 16 to 4. Fig. 23.

By changing the light you have the advantage of lighting up what was in shadow, and may then observe the richness

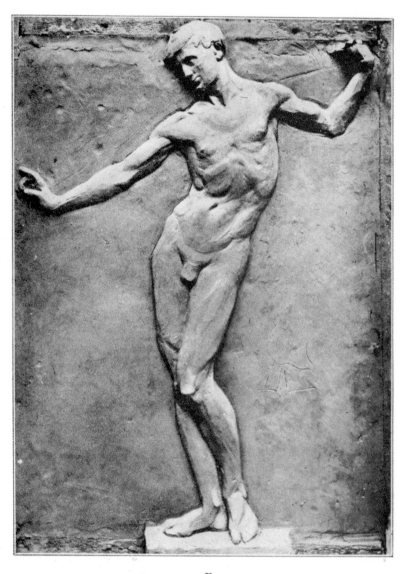

Fig. 22.

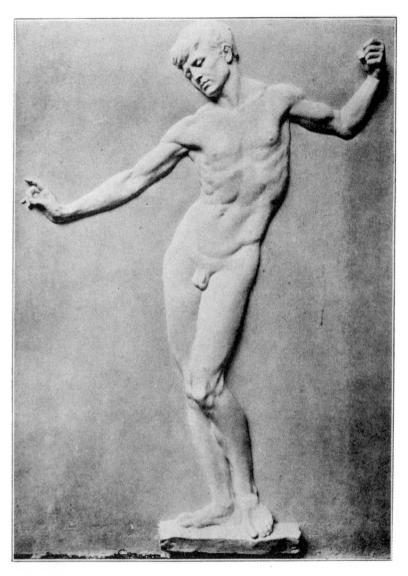

FIG. 24.

of planes which you did not notice when in shadow. And you can give the breadth of substance of nature to these planes, which might have appeared hollow to us whilst they were in shadow. Then, by turning again, and placing this part on which you have just worked in full light, you will observe other things and thus your work will progress. (Fig. 24.)

CHAPTER II

DRAPERY

In the study of drapery it is just as necessary to learn construction, as in the study of the head and figure, for of whatever material it is arranged, the construction of the folds is invariably the same.

Fig. 25.—The Eye of the Fold, showing the Starting-point of the Planes.

Before trying an arrangement on the figure we must study a fold by itself.

All folds have a movement of surfaces or planes. This movement starts from a certain point and is constantly repeated. We may call it the anatomy of the fold.

One of its chief characteristics is, what in studio-slang we call, "the eye of the fold"; it is here that we find the starting-point of all the planes, as indicated in Fig. 25.

You will easily understand this, if you take a piece of clay and make an even round stick of it, about eight or nine inches long; imagine this to represent a fold falling vertically, of even thickness all its length.

Having pressed this stick of clay in the middle and turned it at a right angle (Fig. 26), you will find that the pressure in the centre has pushed the material out and formed a more prominent point than the surrounding

FIG. 26.

part; this is called the eye of the fold, and by an invariable rule, directly above this eye will be a projection. (Fig. 27.)

It is important to observe the direction of planes round this projecting point. (Fig. 28.)

Around the eye there is a rapid movement of planes, which gradually extends until it meets with a corresponding movement starting from another eye. (Figs. 28 and 29.)

This principle applies to any kind of drapery, although it is more or less accentuated in the different materials. In silk (Fig. 30), for instance, which is a rigid material, the eye

FIG. 27.—SHOWING PROJECTION OF THE EYE OF THE FOLD.

is more angular, the differences in the proportion of the fold are more marked than in any other material ; the background, or rather the interior of the folds, is generally larger, the drawing of the folds is less elegant, more broken up, giving rather a "baroque" effect. Employed in sculpture, this material may give a brilliant effect, but a slightly vulgar one ; however, as you may be called on to make a statue in modern costume, where silk is frequently employed, it is well to make a special study of silk folds, and by simplifying the

lines and details, by treating the whole broadly, you may succeed in giving it a good sculptural effect. Modern Italian sculptors make a point of getting an exact representation of

FIG. 28.—SHOWING DIRECTION OF PLANES ROUND THE EYE OF
THE FOLD.

this material, and the result is the vulgarity which characterises this school.

In velvet (Fig. 31) the projecting point about the eye is

more rounded. In muslin (Fig. 32) the eye is less palpable, the folds being softer. This is the material which lends itself best to sculpture; being light and transparent, it allows the form underneath to be visible, though clothed; the proportions of the folds, which are as a rule small, make a good

FIG. 29.—DIAGRAM SHOWING MOVEMENT OF PLANES ROUND THE EYE OF THE FOLD.

contrast to the breadth of the human form; they follow its undulations and blend with it. The Greeks employed muslin more than anything else for draping the figures of women and sometimes by way of contrast, to give more richness, they combined it with another material that fell in larger

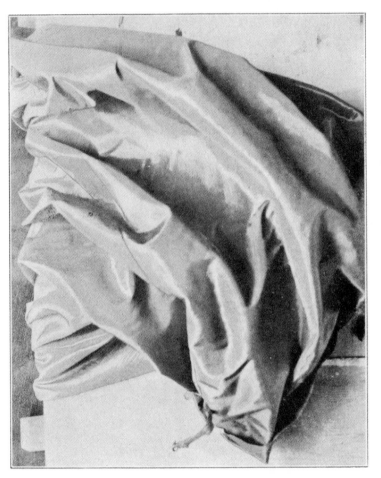

Drapery Arranged on a Board.

FIG. 30. — SILK.

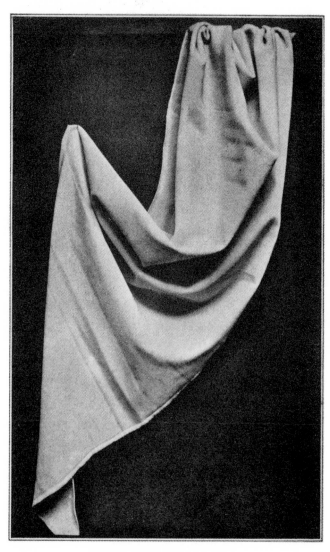

Drapery Arranged on a Board.

Fig. 31.—Velvet.

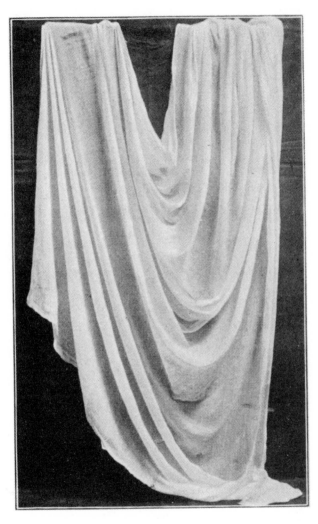

Drapery Arranged on a Board.
Fig. 32.—Muslin.

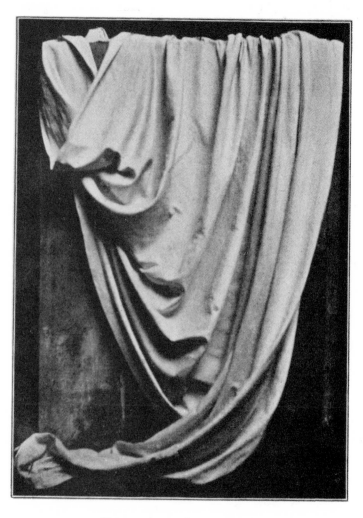

Drapery Arranged on a Board.

FIG. 33.—GROUP OF FOLDS SUITABLE FOR COPYING.

folds. But, although less pronounced than in silk or linen, the principle mentioned above exists in muslin folds. Knowing this rule well, you can easily detect it notwithstanding all the accidental details which at first seem to conceal it.

You can have an exaggeration of this principle by trying to make a fold with a piece of oil cloth, and there you will easily observe it.

But I warn you against attempting to model a fold without having grasped this principle, for, I repeat, it is always the same, and every arrangement of drapery is a repetition of it in all the folds which compose it.

We must not forget, that, as in the figure or bust, or any other subject of sculpture, it is preferable to begin by laying on a small amount of clay, and to add to it gradually in order to obtain the quantity of the model we wish to represent. By putting on too much clay to begin with, you are compelled to cut and scrape off, and thus you entirely lose the freshness and expression of the model.

Now having well grasped the rule which I have been trying to explain, provide yourself with an even background of clay on a board, also with another board and fix both in a vertical position.

Arrange a group of folds of different forms (Fig. 33) on the second board and begin to copy the same from the front view. Lay the clay on in small rolls to indicate the drawing

and the composition of the folds, as well as the exact proportion of distance from eye to eye. It is just these distances which—as in the construction of the bust or the figure— give you the characteristic likeness of the arrangement of drapery. See Fig. 34, photograph from the clay in the first stage.

After having indicated all the folds from the front-view, work on both sides from the profile, in order to establish the variety in the projections; then come back to the front-view and work from below.

Now you may begin to mark the projection above the eyes, and from these points indicate the movement of the planes or surfaces by exaggerating it. See Fig. 35, photograph from the clay in the second stage.

In progressing with your work, instead of seeing to the superficial part of the folds, it is preferable to finish the bottom or interior first, so as to avoid spoiling the exterior of your work.

Having most carefully finished the interior parts, you may go on to finish the projecting parts. This mode of proceeding will give suppleness to the work, and by joining the surfaces of the deep underparts to those of the projecting parts, you get a continuation of planes which will give restfulness and breadth to your work.

I strongly insist on this way of progressing, having often

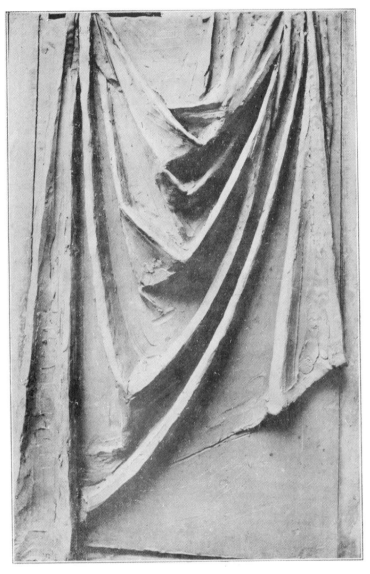

Modelling Drapery on a Board.

FIG. 34.—FIRST STAGE.

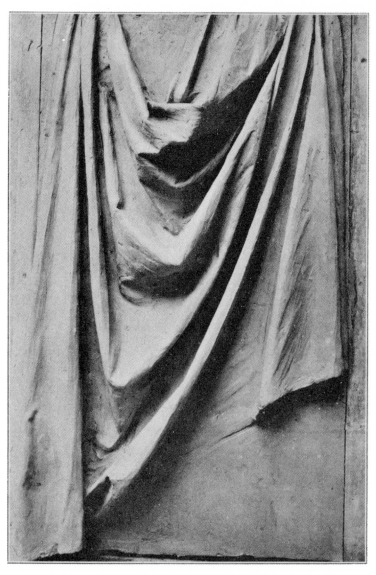

Modelling Drapery on a Board.

Fig. 35.—Second Stage.

found that students are very careless about the interior parts, not only in draperies, but in every other work they do. There is a little difficulty about it, which seems to prevent them, a certain want of skill—not to call it laziness.

The moment when the student has grasped that it is the finishing of the interior parts which give suppleness to the outer face, or surface, he has made a great step in advance.

You may work indefinitely on the more visible parts, but if the inner depth is not finished with the greatest care, you will only produce an inert mass of folds.

In Nature what is hidden from sight is worked out as carefully as what is before our eyes—hence its grandeur of aspect. It is the same as in a head for the back part of the ears, the interior of the nostrils, &c. As I have already stated in the previous volume regarding this subject, it is impossible to obtain the supple aspect of either feature if the interior parts are not drawn and modelled first. And I must again and again impress on you, to finish the interior parts first, else you will never obtain a life-like effect.

I should like to draw your attention to the great care with which the drapery of Gothic figures is executed. If you look at the section of the folds, you will note that they are not a simple cut into the stone, but extend sideways underneath the projecting folds (see Fig. 36), so that the shadows produced by these deep-lying parts are not hard shadows, on

the contrary, often some light will get upon them and cause a charmingly transparent shadow, from which the outer fold

FIG. 36.—SECTION OF GOTHIC DRAPERY.

is strongly detached. It acts thus as a foil and gives a rich effect, while at the same time simple and chaste in line and planes.

Having finished the interior parts and studied the surfaces as far as line, proportion of length and comparative width are concerned, and modelled the movement of the planes, a few realistic details may be useful to interrupt the hardness which the exaggeration of the planes may have caused.

Here it is a question of taste to choose details which will add life and force to the work, and to suppress others which would be useless for this purpose and might only give an effect of confusion.

In the same way as for the head and figure, you may at this point work by colour. Try to put your drapery and your own work in the same light, that is, under the same effect of shadow and light and work by comparing the values of shadows in the model and in your study. You will thus obtain simplicity. (See Fig. 37, photograph from the clay in the third stage, and Fig. 38.)

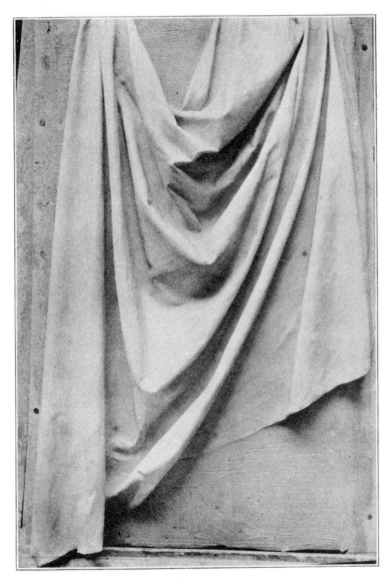

FIG. 37.

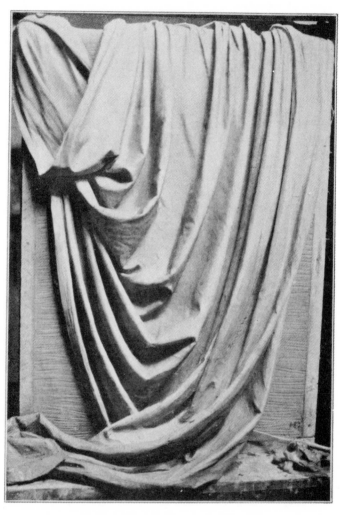

FIG. 38.—COPY IN CLAY OF FIG. 33.

The tools for modelling drapery are the same as for any other modelling. You will find a wire tool and a tool which has the shape of the thumb, as shown in Figs. 39 and 40, extremely useful for the ground. Besides these it will be necessary to have two brushes, a flat one and a round one; their size will depend on the size of your work. You will find them very helpful for cleaning the inner part of your folds, as they will allow you to reach more easily into the depth of the hidden parts than any other tool that I know of. They will particularly assist you to smooth the surface of these inner hollow portions.

For the finishing stage of the drapery-study you ought to use softer clay; it will be more plastic or pliable than the foundation of the work, and render it easier to simplify exaggerated portions by spreading it lightly with the finger over them, without destroying the planes obtained before.

FIG. 39. FIG. 40.

THE ARRANGEMENT OF DRAPERY

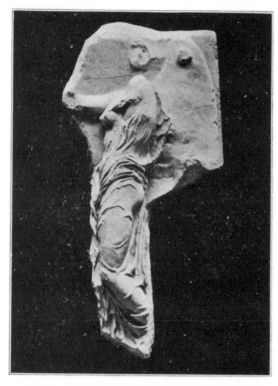

DRAPERY is the generalisation of clothing. The garments which adapt themselves to climate, manners, and taste are called costume.

Antique art at its zenith always draped its figures, only in archaic period or in the period of Roman decadence do we find an imitation of costume.

In Greek statuary male figures, apart from portraits, were rarely clothed. In bas-relief, which comes near painting, the Greek costume found its place, being so extremely simple, that it lent itself easily to sculpture.

The living model, draped and left undisturbed, gives us

at every turn excellent arrangements, but, in order to copy these without alterations, one must work very quickly, as the model can after all only sit for a limited time. And this is a quality one acquires only in time, and after having previously studied drapery on a lay-figure or plaster cast, and knowing well the principles and laws of the direction of folds and their masses.

It behoves us therefore to make at first a study from or after an immovable object which will allow us the necessary time to comprehend the principles, which the Greeks have taught us so well by their magnificent works, and which I shall try to put before you.

Later on, when you are quite familiar with the subject, it will be an excellent plan to make studies in this style from the model (Fig. 41, 42, and 42A), rapid sketches wherein you force yourself to give its spirit and reproduce the large movement of the fold as well as the general character of the model. But to begin with it needs a careful study of the principles and reasons, which when well known, give you the necessary skill to make studies from nature in small proportions.

Although the arrangement of drapery on a figure may be a matter of individual taste, there are certain canons which you must know and follow.

Firstly: An arrangement of drapery must on no account

by false direction of folds hide the figure ; on the contrary, each fold, each detail of folds must contribute to explain the nude underneath by its movement, direction, and form. If this rule is not adhered to, the result will be a confused mass of lines without obvious reason or harmony.

Secondly : There must be a general direction, a chief or leading movement in the arrangement of the drapery, which the artist will select according to the pose of the figure and the decorative effect he wants to obtain.

For this sort of study it is a good thing for the student to begin with a simple arrangement on a plaster-cast ; then gradually go on to more complicated arrangements with different materials—for instance, a muslin tunic, and over this tunic a piece of flannel arranged in folds ; this will be an excellent practice in observing the different thickness of folds as well as their different treatment.

A plaster-statue that is to be draped should be covered with a solution of bees'-wax and turpentine. You may use the following recipe : Pour a pint of turpentine into a saucepan, take a piece of bees'-wax as big as an egg and shred it finely before putting it into the saucepan to dissolve. Place this saucepan on a gentle flame, or better still, lest it should catch fire, inside a larger pan filled with hot water, and let it melt, stirring it occasionally. When the wax has been reduced to a liquid state, dip a large brush into this mixture

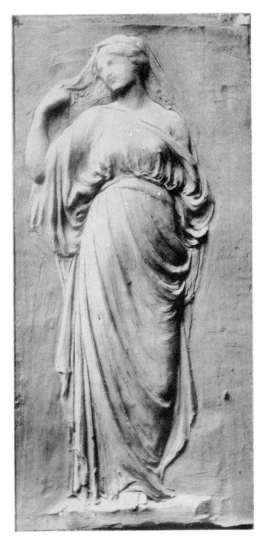

FIG. 41.—TIME SKETCH FROM THE LIVING MODEL

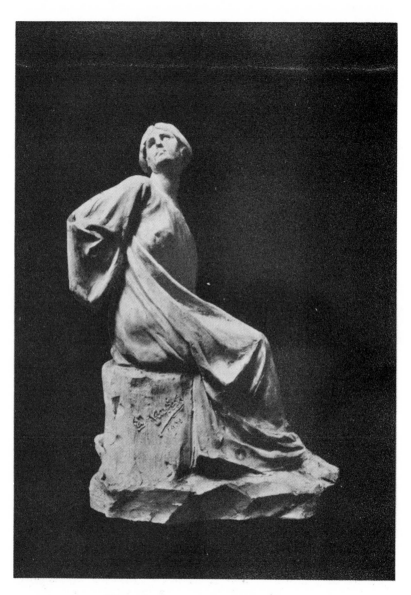

FIG. 42.—TIME SKETCH FROM LIFE.

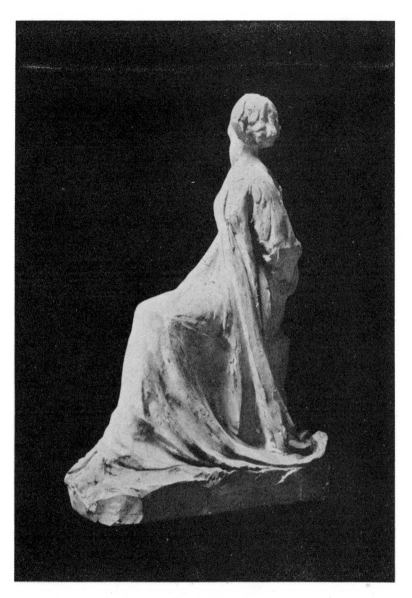

FIG. 42A.—TIME SKETCH FROM LIFE.

and paint the statue over with it, allowing it to dry quickly. If necessary, give it another coat of the mixture an hour later. For this second layer you must of course reduce the solution again to a liquid state, else the wax would lie too thick on the statue. This coat of wax and turpentine will prevent the statue from absorbing the moisture of the drapery, so that it does not dry before you have had time to make a serviceable arrangement of folds.

It is preferable to use a damp material for your first drapery studies, because the folds will adhere better to the statue than if they were dry, and you obtain by these means an exaggeration which will show up the principle more clearly.

Dip your material—and I would recommend a rather thick material at first, for instance, flannelette—into water and wring it out again, leaving enough moisture in it to make the folds fall well. Then cover the statue with this material and you will immediately observe that all the projecting points of the figure arrest the drapery and become starting-points for other folds. I now only mention this very important matter, but shall enlarge on it further on.

The first thing to do is to find a chief line, that is, the general direction of the fold or the mass of principal folds, which will, so to speak, be the line of expression ; for this fold, or mass of folds, must be directed according to the

movement of the figure, and must contribute to its expression of action. Fig. 43.

This chief line will divide the figure in unequal parts, and those parts will be filled by masses of folds.

Between each of these masses you must find some rest, that is some plain part, for these spaces of rest will give value to masses of folds, and will at the same time allow the forms of the figure to appear through. Figs. 44 to 53.

You must avoid in the large masses to have the folds equal in size; that would become monotonous. A certain variety of volume in the folds will on the contrary cause more variety of shadow and light, and give at the same time more interest to the arrangement. I am well aware that there are examples, for instance in Byzantine art, where the folds are generally parallel in direction and of equal size, but I do not think that you should follow their example in a study.

The most important rule for an arrangement of drapery is, that all the lines made by the folds should take their starting-point from the salient points of the nude; all such salient points become centres of radiation for the folds. See Figs. 45 to 53.

As in Architecture and Drawing, so in Sculpture, it is the salient points of the outline that determine the proportion and stamp its character on the work, so the lines of folds,

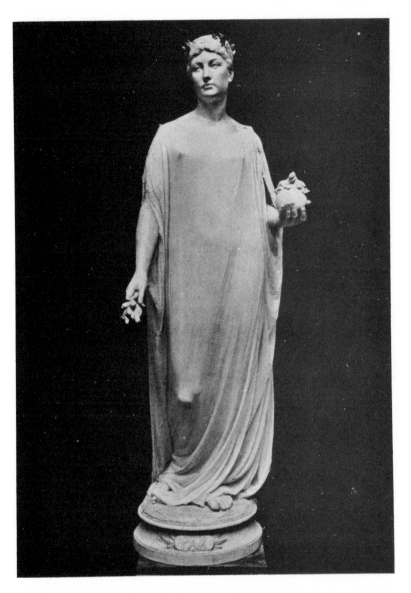

Drapery Arranged on Plaster Cast.

FIG. 43. — CHIEF LINE OF DRAPERY.

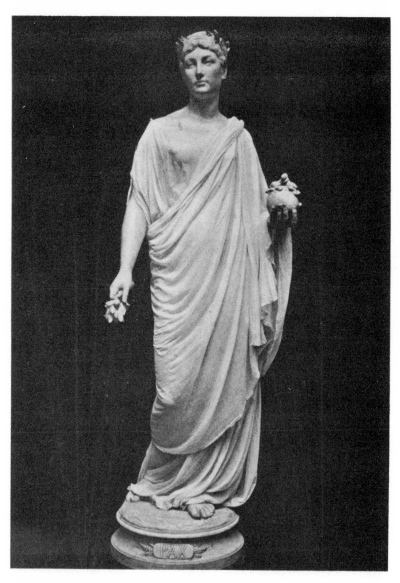

Drapery Arranged on Plaster Cast.
Fig. 44.--Complete Arrangement.

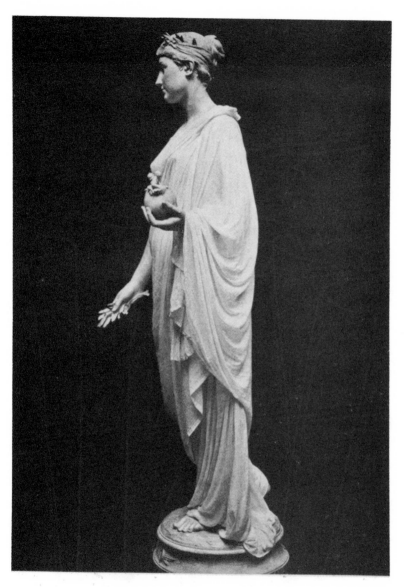

Drapery Arranged on Plaster Cast.
FIG. 45.—SIDE VIEW OF FIG. 44.

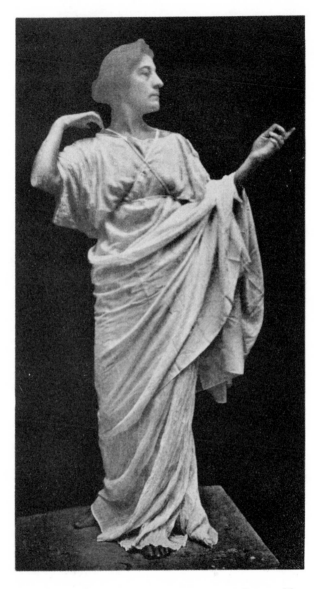

FIG. 46.—ARRANGEMENT OF DRAPERY ON THE LIVING MODEL.

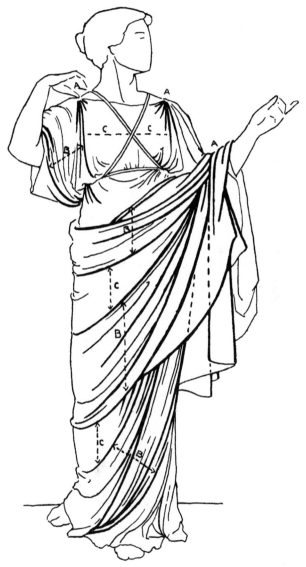

FIG. 47.

A. Point of radiation of the folds.　　B. Mass of folds.　　C. Space of rest.

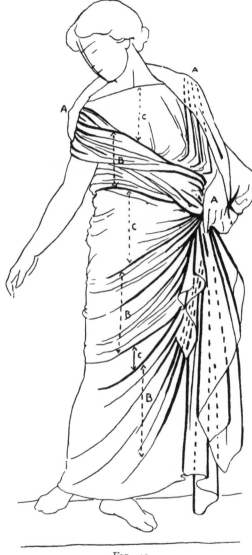

FIG. 49.

A. Point of radiation of the folds. B. Mass of folds. C. Space of rest.

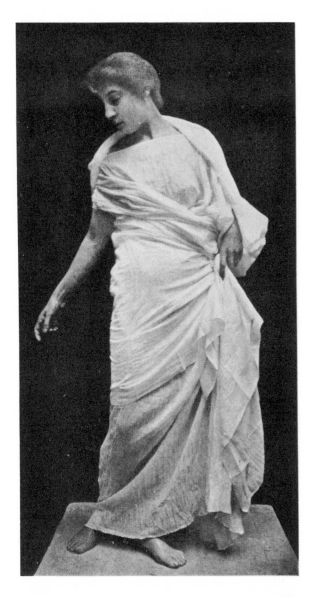

FIG. 48.—ARRANGEMENT OF DRAPERY ON THE LIVING MODEL.

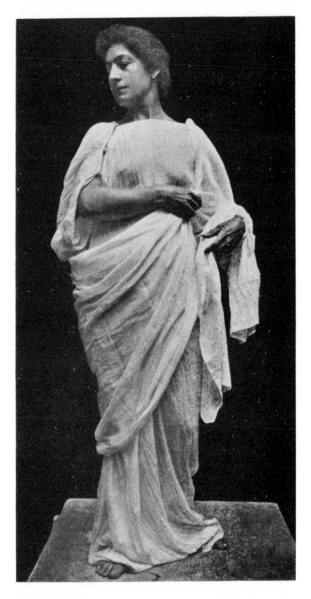

FIG. 50.—ARRANGEMENT OF DRAPERY ON THE LIVING MODEL.

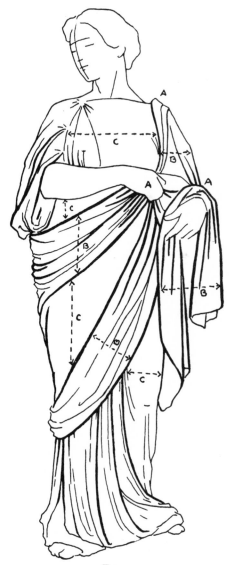

FIG. 51.

A. Point of radiation of the folds. B. Mass of folds. C. Space of rest.

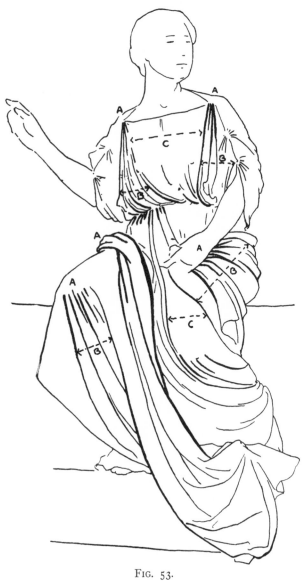

Fig. 53.

A. Point of radiation of the folds. B. Mass of folds. C. Space of rest.

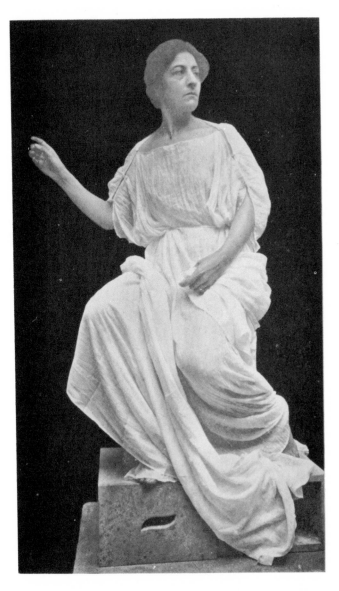

FIG. 52.—ARRANGEMENT OF DRAPERY ON THE LIVING MODEL.

coming from different directions and blending with each other at the salient points of the nude, attract the eye of the spectator and guide it to the characteristic points. When you have these central points well established, the arrangement becomes strong and "clear," and the folds springing from there will complement and accentuate the figure in its action and proportion.

You will see by the diagram, Fig. 54, where the folds take a false direction of radiation, and by comparing it with Fig. 55, where the folds go to the one starting-point, how the former is wanting in harmony and construction.

It is not only the salient points of the nude figure which become starting points for the folds, but also the movements which raise a drapery. If the latter is carried over the arm, and you bend this arm, the folds will close up at the joint, and cause radiation. See Fig. 56.

Or if the drapery is grasped by the hand, the folds will group themselves in a very small space and spread out thence in their various directions. See Fig. 57.

Again, if a drapery is supported by a limb stretched in a more or less horizontal direction, its folds will be strewn over the limb without any radiation, as you see in Figs. 58 and 59 where the folds appear in an almost equal distance over the raised limb until they touch the knee, and there, the direction of the leg passing from the horizontal to

Modelling

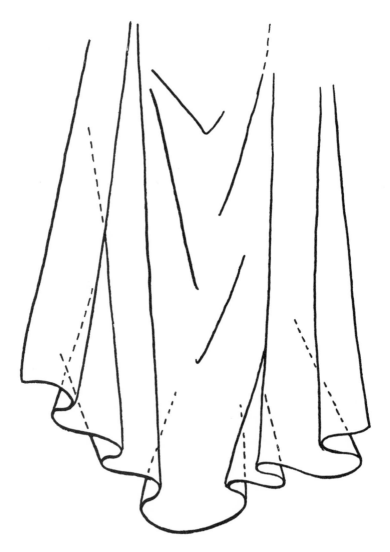

Fig. 54.—Drapery showing False Direction of Folds.

the vertical, with the knee projecting, radiation takes place.

You will also note in this same figure, that the background,

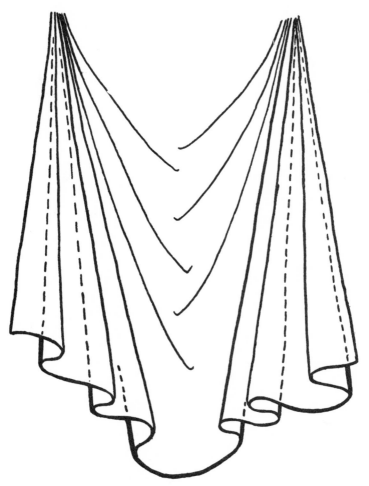

FIG. 55.—DRAPERY SHOWING RIGHT DIRECTION OF FOLDS.

or back-plane of a fold is generally larger than the fold itself;
Fig. 59A, it is smoother and more even than the fold, it

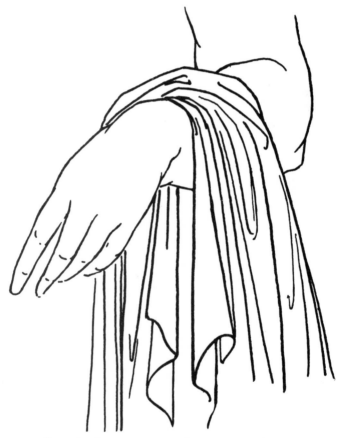

FIG. 56.—BENT ARM WITH RADIATION OF FOLDS.

appears lighter and brighter, so that it makes a strong foil
for the fold, which appears almost like a half-tint on the

light background; this pushes it forward, and gives relief
to the work without a great projection, it allows the folds

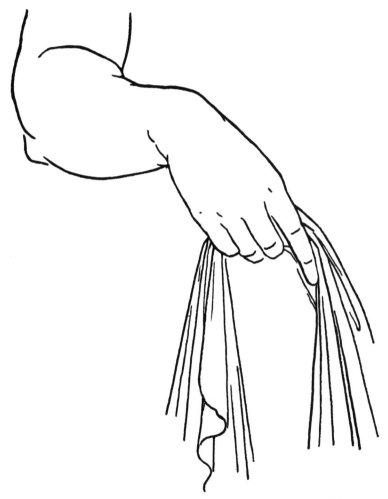

Fig. 57.—Radiation of Drapery when Grasped by the Hand.

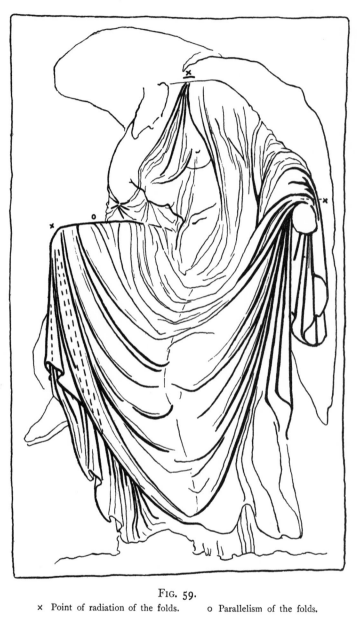

FIG. 59.

× Point of radiation of the folds.　　　o Parallelism of the folds.

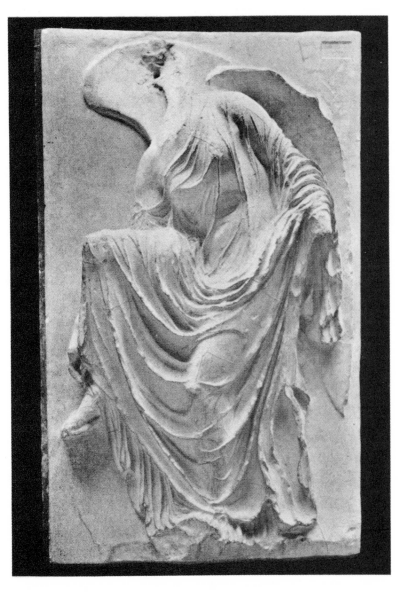

FIG. 58.—VICTORY. SHOWING PARALLELISM OF THE FOLDS ON THE THIGH
AND RADIATION FROM THE KNEE.

to follow the form of the nude and to give it force and richness.

If you study the greatest masterpiece of draped Sculpture, "the Fates" by Phidias, (see photograph of "the Fates." Fig. 60) you will deduce these principles very plainly from them. See Fig. 61 of a diagram after "the Fates."

When you have the chance of seeing a cast from this group, or the original in the British Museum, I advise you to look up

FIG. 59A.

into the folds from underneath. You will then observe another principle : namely, that all the shadows cast by the folds will draw the section of the nude ; these shadows follow completely the graceful undulations of the figure and illustrate its form.

If on the other hand the shadows of the fold which touch the nude were in a more or less straight, horizontal or vertical line, the substantial force of the figure would disappear, and although the statue is in the round, it would have the appearance of low-relief.

Fig. 61.

× Point of radiation.

FIG. 60.—THE FATES.

Let us for instance take the example of a girdle placed underneath the bosom. If the line of the girdle were quite horizontal (see Fig. 62), the line would never suggest the roundness of the body. But if you exaggerate the round direction of this line (Fig. 63) by following as near as you

FIG. 62.—SHOWING GIRDLE IN A HORIZONTAL LINE.

FIG. 63.—GIRDLE FOLLOWING THE SECTION OF THE FIGURE.

can the section of the figure at this part, you will observe that the statue loses nothing of its roundness and consequent force.

All these rules you must learn in the beginning, but later on, your artistic feeling may and must take those liberties

which your own ideas suggest ; but understand, that for all art-work, in order to take liberties you must first know the unalterable laws of nature, and then, if you want to accentuate here and there, in order to give strength and character to your work, you will not do it in haphazard fashion.

In the arrangement of drapery we come very near to the subject of composition, for the latter is more the result of feeling than calculation.

Your taste must dictate harmony and grace of line in the matter of folds. The expression which you want to obtain in a figure must guide you in the general movement of folds for their direction.

One of the most important points therefore is the harmonising of the lines of drapery with those of the figure ; however this, if carried too far, might become insipid and affected. Here it is that artistic feeling comes in. A discordant note thrown in with spirit and discretion may, by contrast, give value to the other lines. A great contrast in the direction of the lines of drapery with the movement of the figure may even accentuate this action. See the example in photograph, Figs. 64, 65, 66.

All folds which touch the nude must be what I would call discreet, but where the folds are away from the figure, you may take all the liberties which good taste will allow. See photograph of the figure of " Victory," Fig. 67.

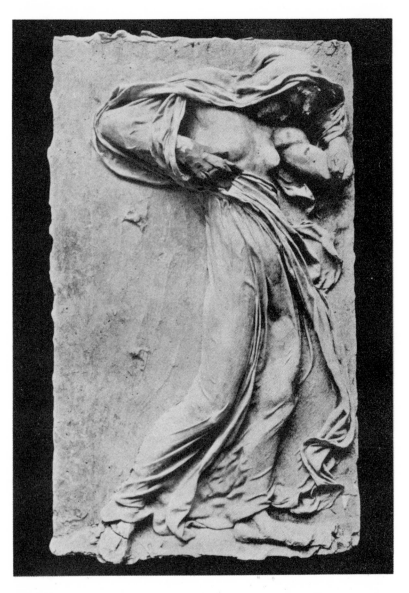

FIG. 64.—ARRANGEMENT OF DRAPERY ON A PLASTER CAST, SHOWING
CONTRAST OF THE LINE OF DRAPERY WITH THE MOVEMENT OF THE FIGURE.

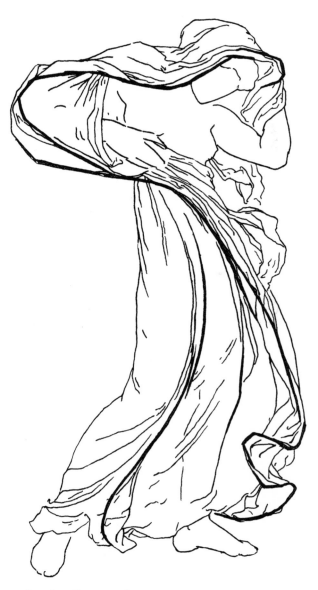

FIG. 65.—SHOWING LINE OF CONTRAST OF FIG. 64.

In this figure you will note with how much care and delicacy
this principle is carried out ; the folds adhere to the nude in
following the model and the undulating curves of its forms,
which are strong and well-rounded, and, notwithstanding, the
figure looks and is perfectly clothed ; but the folds which float
around this figure are treated with great liberty and an
abundance of lights and shadows, some of them carved deep
into the marble block, and yet simple in character, for the
light glides so softly over them that you pass gradually to
half-tint, and from half-tint to shadow without the shadows
being absolutely black. The treatment of this floating drapery
makes a violent contrast with the sober effect which the
drapery touching the figure produces, and thus they give
value to each other.

In nearly all the best antique statues, those in the round
and those in relief, you find a repetition of this treatment.
Like everything instantaneous, floating draperies cause the
sculptor great difficulty, and here he ought to be guided
almost entirely by his artistic feeling, for these draperies
become, as we might say, the frame for the figure ; they
add to its movement, and even indicate the previous move-
ment.

For a relief it is fairly easy to obtain a good *motif* of
floating draperies by throwing a piece of linen on a back-
ground in the lines one wants (Fig. 68). This means may

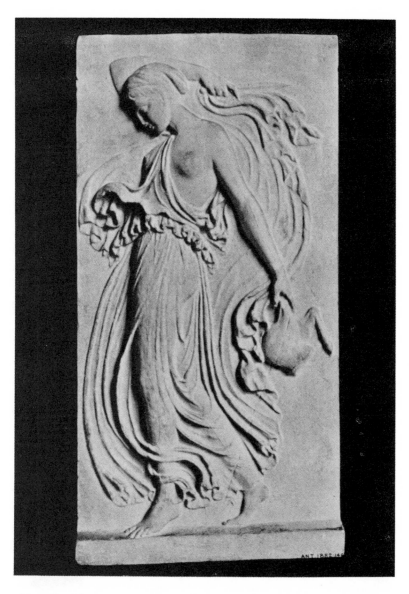

FIG. 66.—MAENAD: CHIMAIROPHONOS. SHOWING CONTRAST OF LINE OF
DRAPERY WITH THE MOVEMENT OF THE FIGURE.

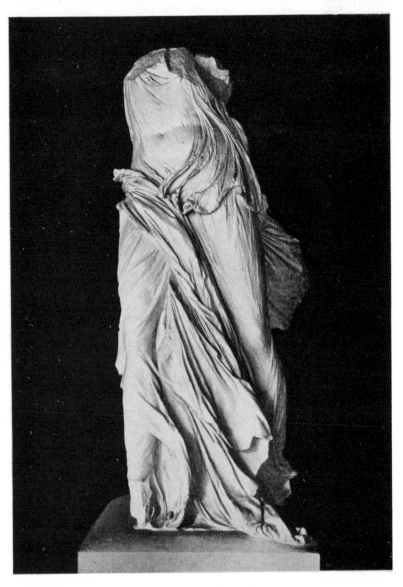

Fig. 67.—Victory (Nike) of Samothrake.

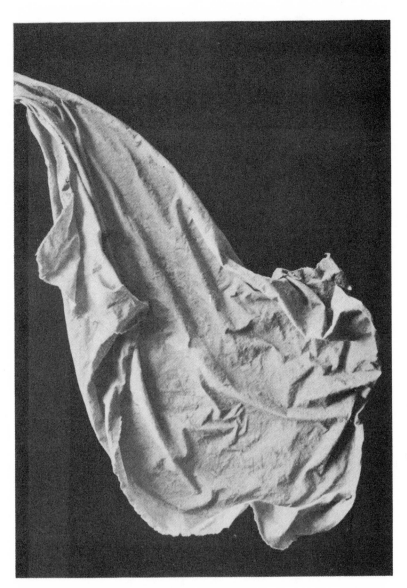

FIG. 68.—FLYING DRAPERY ARRANGED ON A BACKGROUND.

also be employed for a figure in the round by giving in the execution a greater movement of planes than you obtain with the drapery arranged on a background.

In a floating drapery the principle of radiation of the folds must be still more emphasised, as you see in Fig. 69, where the folds grouped at the starting-point spread out below it,

FIG. 69.—RADIATION OF FOLDS IN FLYING DRAPERY.

so as to suggest that the air swells and supports the material. Parallel folds could never render this effect so well, which fact you will at once realise when you compare the figures 69 and 70 with each other. See also Fig. 71.

If the character of the garment and the fineness of the material require small folds, they must be distributed in groups, so that several of these small folds form only a

subordinate part of a large mass formed by a principal or leading fold.

The drapery ought to help us in explaining the action or expression of the figure-subject. If, for instance, the figure is floating in the air, the drapery ought to explain whether

Fig. 70.—Parallelism of Folds in Flying Drapery.

it is ascending or descending. If it is ascending, a column of upper air will weigh on the draperies; if it is descending, on the other hand, the air sustains them and holds them up.

The play of the draperies ought also to show whether the figure is in repose or in action, or, when the action has ceased, whether it was slow, quick, or violent. (Fig. 72.)

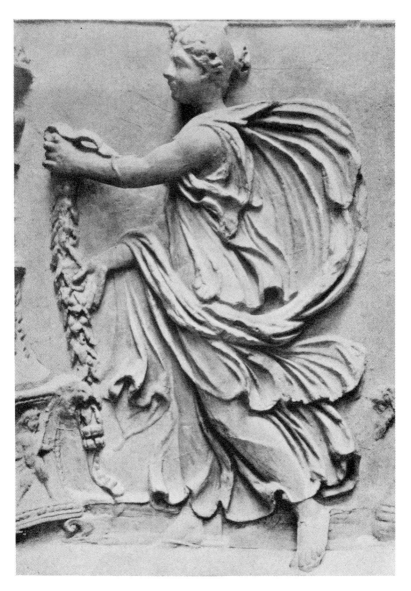

FIG. 71.—FLYING DRAPERY.

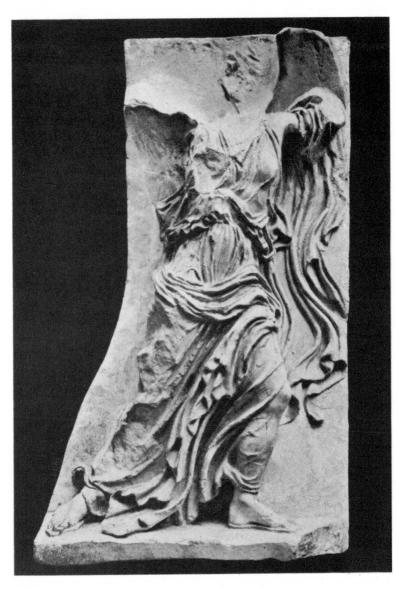

FIG. 72.—FLYING DRAPERY.

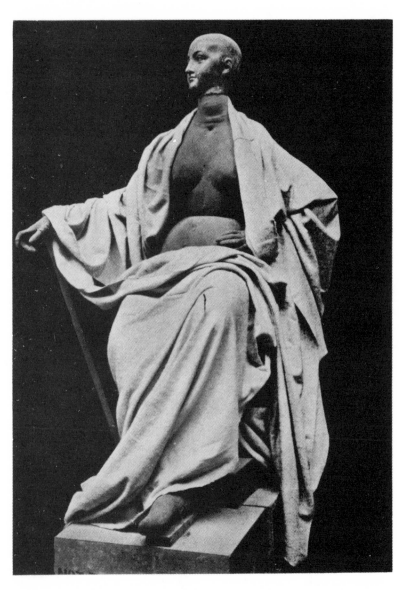

FIG. 73.—EXAMPLE OF ARRANGEMENT OF DRAPERY ON THE LAY FIGURE.

In draping his figures the artist must not forget that the nude figure is the principal part, and that draperies are only accessories, destined to clothe it but not to hide it, and that they must on no account be the result of caprice or whim.

To avoid mistakes, the sculptor should model his figure in the nude before draping it ; without this precaution he would run the risk of going astray, and would add to or take off without noticing it from the proportion of certain parts of the body, especially of parts where outline and form are hidden under the folds.

The nude of a figure to be draped should be rather stout than thin, for the shadows cast by the folds cut the figure in several parts and make it always appear of lesser volume.

It will be easier for you to copy drapery by using a lay-figure (Fig. 73), or a sketch from the nude in wax, or a sketch in clay, modelled in the desired action and afterwards cast in plaster ; but you must always keep account of the fact that drapery so arranged cannot have the suppleness which it would have if arranged on the living model.

You often hear it said that drapery reveals the lay-figure when there is hardness in the folds ; you must therefore be very careful in the disposition of your drapery, and also take care that the execution should be *naïve* and not betray the lay-figure.

The genius of the antique conceived drapery as a *motif* of variety, an expression of gracefulness and refinement. In order to enhance the attraction of beauty, they surrounded it with mystery, but a mystery which was not impenetrable and which allowed you to divine the form underneath.

In your first studies of drapery arrangements, you must faithfully copy what you see in the model; you can never be too honest and sincere in study. Sincerity will make you observe nature better than interpretation will, and the different observations which nature in its varied character suggests to you, will furnish your artistic mind and prevent you in the future from repeating yourself, and thus will give variety to your future works of art.

However, as no arrangement of drapery whether on lay-figure, or statue, or living model, will give us without fail exactly what we want for a work of art, you will have to choose what to suppress and what to amplify. But do not commit the mistake of thinking that you must modify from the beginning in the arrangement on the model whatever does not absolutely please you.

I have often experienced, that when I had copied as sincerely and literally as possible what was before my eyes and expected to have to make great changes to improve on the lay-figure, I found to my great surprise when the work was finished that there was very little, sometimes nothing, to

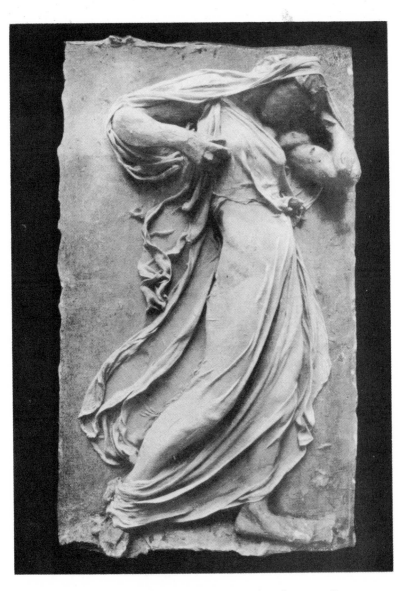

Fig. 74.—Arrangement of Drapery on a Plaster Cast.

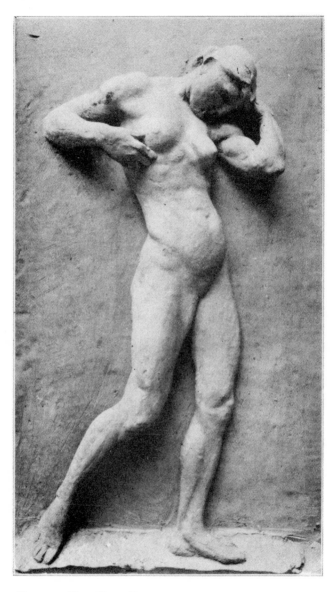

Fig. 75.—The Nude Preparations for Copying Fig. 74.

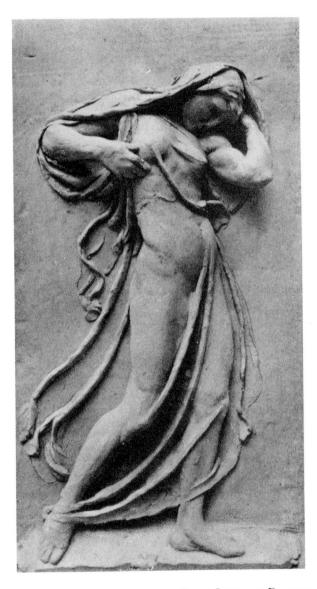

Fig. 76.—First Stage, showing Chief Lines of Drapery.

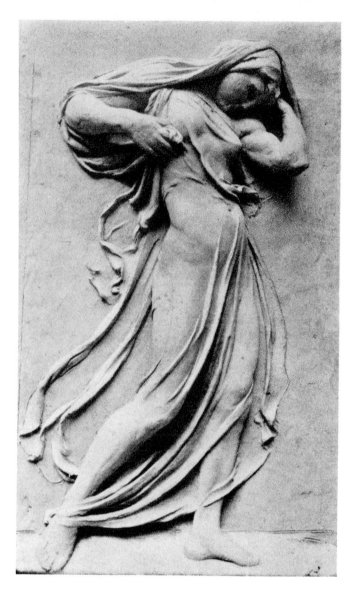

FIG. 77.—SECOND STAGE.

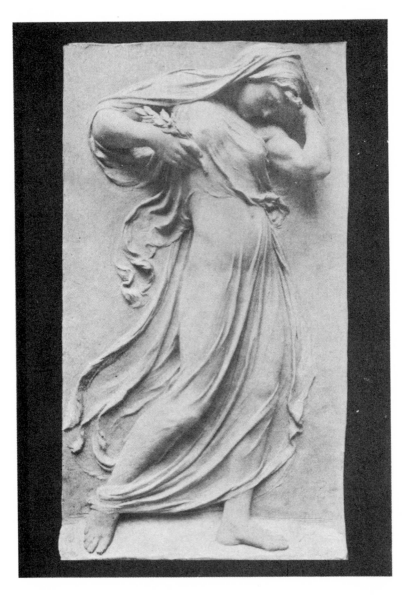

FIG. 78.—THIRD STAGE.

change. But on the contrary, if you begin with suppressing in one place and adding in another, the result will be that none of your folds would agree and harmonise, for in the nature of folds one fold is the sequence of another. By proceeding thus you would have to make constant changes, and the model on the lay-figure would not be of any use or help to you.

Let us never forget that nature demands above all things to be respected. That will save us discouragement and sorrow ; our faith in nature gives us confidence and strength to struggle on. True courage and boldness as we admire it in the greatest artists can only be born from the feelings which study has developed. False courage, the conceit and self-consciousness of ignorance, is the most regrettable, most dangerous vice for an artist. It radically stops all development and progress. Modesty, the inclination for *naïve* research are, on the contrary, the most precious qualities in a beginner. He will get bolder in proportion as he understands better and has his artistic feeling more strongly developed. Such courage will not degenerate into vainglorious self-conceit.

Modelling from an arrangement of Drapery on a Plaster Cast.

Figs. 74-78 show the various stages of the work.

Obverse.

ISOTTA ATTI DA RIMINI (FOURTH WIFE OF
SIGISMONDO PANDOLFO MALATESTA).

BY MATTEO DE PASTI OF VERONA. 1446.

Reverse.

AN ELEPHANT.

BY MATTEO DE PASTI OF VERONA. 1446.

MEDALS

CAMEOS AND INTAGLIOS

Connected with Low-Relief Sculpture is Glyptic Art, that is, the art of graving in relief or hollowing out hard stones.

If we suppose that all historic monuments of Architecture, Sculpture, and Literature had been destroyed, that the remembrance of the Old World had been completely effaced from the memory of Man, and that in this shipwreck or deluge of human knowledge nothing had been saved but a

collection of engraved stones, coins, and medals, the dis-
covery of this treasure-trove might suffice perhaps to rebuild
and recompose the history of the vanished monuments and
time. These engravings on metal and hard stones are
indeed as books printed on them; they give speaking de-
scriptions; men and objects are outlined on them by tangible
representations; their inscriptions are concise, but lucid,
eloquent, and definite.

The word Glyptics signifies engraving, and is in par-
ticular applied to hard stones, that is, gems, rock-crystal,
precious and semi-precious stones. We distinguish Intaglios,
i.e. gems, where the design is hollowed out, and Cameos,
where the design is carved in relief.

It is through these cameos and intaglios that we know
what the master-pieces of Ancient Sculpture were like, as
they frequently contained low-relief copies of famous works
and were splendidly executed by the Greeks and Romans
—I remind you here of the *Maenad* of Scopas in the
British Museum Gem-room and the *Philoctetes* by Pythagoras
in the Berlin Museum—and again in the Renaissance times
by artists of the northern nations.

The originals for the cameos as well as for the intaglios
are modelled in wax, and the stone is afterwards engraved
by means of iron tools ending in a small disc or a ball,
which is moistened with oil and diamond-dust. The other

end of the tool is fixed to a diminutive lathe, and the worker's hand and eye are used to guide and direct the tool.

But this is a branch of art which has declined in our times, as there is little demand for artistic modern cameos.

MEDALS

The art which concerns us more nearly is that of medal-engraving.

A medal is a piece of metal like a coin, but whilst coins bear the impression of a sovereign state or its ruler, and are circulated as means of exchange or money, medals are never circulated as such, but are struck in celebration or remembrance of persons or events, and are bestowed as a mark of distinction by sovereigns or authorities.

A medal has two sides, the face or obverse, so named because it generally bears a head, and the back or reverse, which bears some relief or simply an inscription. Its engraving demands a laconic, concentrated style, and restricts the artist to give only what is essential and indispensable of the forms of his model.

The medallist has the choice of several styles of work : he can carve his figure in relief on a steel puncheon, and take from this relief the hollow mould or matrix into which the medal is struck, or he can directly hollow the mould

out in steel and use this as matrix for the impressions of the medal—and this is the method which was formerly most in use—or he can have his model cast and work it up by hand.

Of late years the art of engraving medals and coins has gone down. Mechanical processes are employed, and the result is mediocrity. Medallists are often content to make their model four times as large as the proportion which the medal is to have, cast it in plaster and cast-iron, and have it reduced by machine to the desired size.

This is a very undesirable proceeding for figure-subjects on a medal, for the figures which are conceived in the large proportion of the model come near the relative proportion of nature which produces a petty effect in a medal. You will have observed in all antique medals or cameos, that the extremities of the figures are comparatively strong and large, that you are struck at once with the head and its character, the hand and its expression, that the personage stands well on his feet and retains thus in its small size a good balance and a grand air.

If you happen to make the proportions of the head and limbs exactly comparative to those of nature, which is generally done when first making a model on a large scale, after reduction it will appear like a rope-dancer or marionette, and will consequently lack force and nobility of aspect.

So you must learn the artifices or tricks which cause this branch of art to be not a simple imitation of nature, nor a mathematical reduction of objects, but a proud interpretation which prevents the artist from falling into cold servility.

The impression of any image or sign on a medal is called " type." The use of this word is neither indifferent or accidental. The very word indicates the principal quality required in a figure graven on gold, silver, or bronze : you must imprint on it, above all, the typical character of life— in other words, you must idealise it by comprehensive generic accents of life, as you must to a certain extent do in all works of sculpture, but more than ever in a medal.

In the most ancient medals the type is not yet the human head, but an inanimate object or a symbolical animal.

In the fourth century B.C. the face of the medal loses its allegorical character ; instead of local divinities it represents portraits, frankly resembling—I remind you of the medals bearing the portraits of Alexander and Antiochus. However, the reverse of the medal, which yields to the engraver's invention an open field, retains still a symbolical treatment of the nature and history of the country. If they have not a religious significance, the representations are in a way heraldic ; some are the arms of the people or the

cities. Thus the reverse is in divers ways a more or less ingenious emblem which gives the mind something to understand or to guess at.

The laws of Numismatics, so marvellously written and laid down in Greek medals, and still well known and understood by the Romans, were lost awhile in the Middle Ages, the coins of which present a barbaric severity. Attempts to revive the art, like that of the Hohenstauffen emperor, Frederic II., who had his gold coins engraved after the pattern of antique coins, remain isolated, and it is reserved to the Masters of Italian Renaissance in the fourteenth and fifteenth centuries, above all to the genius of Vittore Pisano (who died in 1451), to revive the art of the medallist and bring it to rare perfection. Even in going nearer to nature he interprets it in masterly fashion by the character of the heads, which, even if you see them but once, make a lasting impression, so that you cannot forget them. They are no longer ideal figures, but living, speaking men, freely sculptured personalities, which stand out from the rest of humanity in history.

In the sixteenth century German goldsmiths and engravers distinguished themselves in engraving medals after designs of great painters. Albrecht Duerer is said to have himself executed three of his many drawings for medals.

In the seventeenth century Georges Dupré (who died in

1643) flourished in France (medal of the Doge Marcantonio Memmo), Fig. 79. His medals express not only the bodily and moral physiognomy of the individual, but seem to palpitate

Obverse.

FIG. 79 —MARCANTONIO MEMMO, DOGE OF VENICE (b. 1556, Doge 1612, d. 1615).

BY GEORGES DUPRÉ.

with life—the typical gives way to the realistic portrait. Although of high merit, his work is inferior to that of Vittore

COIN BY PISTRUCCI.

Modelling 65

Pisano. A good many other medallists are found at this time among French artists, and the art-branch is considered so important that Louis XIV. founded the "Académie des Inscriptions," whose sole task was to provide inscriptions in classical Latin in the correct official style.

The modern inferiority of this art, and in particular of the numismatic branch—here I wish to except the fine representation of St. George and the dragon on some of our gold and silver coinage by Pistrucci—is almost entirely due to the previously described method of working, and the mechanical reduction of a model conceived in a different proportion. An unconscious, brutal machine, of blind obedience and mathematical monotony, has been substituted for the fibre of the artist's hand, the will of his soul.

Besides, in our coinage, struck on a flat disc, the relief must be even everywhere ; the thickness or depth of the type is kept exactly to the level of the borders, so that the coins may be piled up. Such necessity is not imposed on the engraver of medals, which, not being made for bankers and money-changers, may at least retain degrees in the relief and keep free from those exigencies in which the beautiful is sacrificed to the useful.

Study the beautiful Greek (Fig. 80) and Roman medals, as well as those of the Renaissance, especially Pisano's. These masterpieces will reveal their secrets to you and prove to

LYSIMACHUS. PHILIP ARIDAEUS.

SYRIA, B.C. 145–142.

LOCRI OPUNTI.

FIG. 80.—GREEK MEDALS.

you more than any other examples that greatness is independent of dimensions, for greatness is a quality of the mind.

In any branch of sculpture the treatment is different for different proportions, and this is more especially the case with medals; the smaller they are the more need for simplifying the working. The Greeks understood this better than anybody else, and Pisano after them.

If you look at any Greek statuette of the good time, it strikes you as a whole by its grand aspect, and you do not take heed of its proportion, because it impresses you in the same way as a life-size work would. Nowadays, details, as numerous as they are useless, take away from the largeness of the work, and the public rejoices in this photographic sculpture, and says: " How beautifully done," where they ought to say: " How petty!" " How trivial!"

If you model your medal at once in the actual size, you will certainly make every touch in the scale of its general proportion, and will not feel the desire to overload it with wrinkles, crow's-feet, and details of hair; large planes will receive the light, and a few touches on them will give an air of fineness without looking poor.

A medal ought always to be treated broadly, but to model with breadth does not mean that you should carry this to boldness or insolence, as is so often done in these days—

fortunately more in painting than in sculpture. The medal ought to show style more strongly than work on a larger

Obverse.

FIG. 81.—LEONELLO D'ESTE, LORD OF FERRARA (b. 1407, lord, 1444, d. 1450).

BY VITTORE PISANO OF VERONA (b. 1380, d. 1456).

scale. By style I mean simplified truth, divested of all insignificant detail, in fact the typical aspect. There is nothing more difficult than to get hold of intelligent life. You cannot

seize it by a literal imitation. If that were sufficient the
photographer would be the best portrayer—and you know how

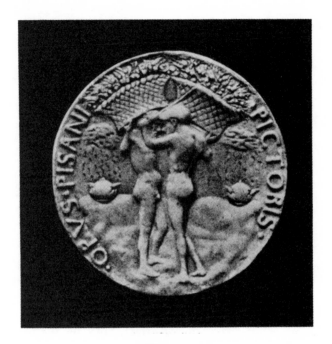

Reverse.

FIG. 81.— TWO NUDE MALE FIGURES BEARING BASKETS OF OLIVE BRANCHES
ON THEIR HEADS.

BY VITTORE PISANO OF VERONA.

deceptive the infallible truth of the photographer's portrait is.
An artist gifted with a soul can draw forth a soul.

Before a feeling and thinking being you must feel and

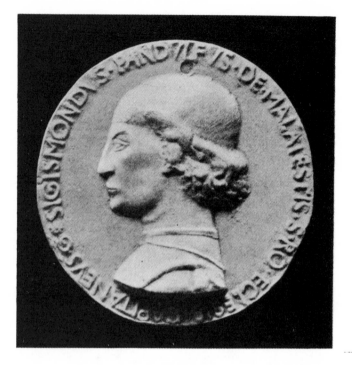

Obverse.

FIG. 82.—Sigismondo Pandolfo Malatesta, Lord of Rimini (b. 1417, lord, 1432, d. 1468).

By Matteo de Pasti of Verona. 1446.

think yourself, consequently you must choose everything : the attitude, the lines of the dress, and even the proportion of the background, which is capable of making the head look smaller or larger.

If the person is tall, it will be well to make the crown

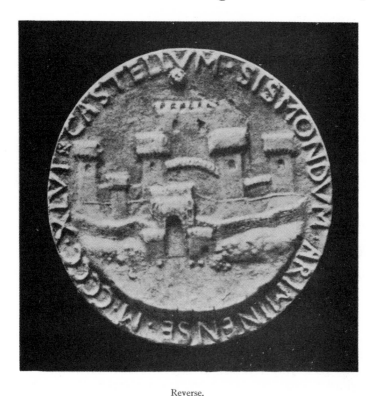

Reverse.

FIG. 82.—THE CASTLE OF RIMINI.

BY MATTEO DE PASTI OF VERONA. 1446.

of the head almost touch the upper border of the circle of the medal ; if the person is small, a certain distance left above the head will clearly indicate this fact.

In the interpretation of nature which the medal requires, the artist must work with spirit. By spirit I understand not

only the aptitude of seizing delicate degrees and making them stand forth by co-ordinating or contrasting them, but also the talent of perceiving the essential qualities which go to make a face and whatever there is characteristic and expressive in it.

This spirit shows to a marvellous extent in Vittore Pisano's work. His medal of "Leonellus Marchio Estensis" (Fig. 81) is in truth a surprisingly admirable portrait; so is the Malatesta by Matteo Pasti (Fig. 82); you see there in indelible lines an individuality which you could not possibly mix up with any other—it is full of style, because it is the typical personification of a man with that peculiar character.

EXECUTION

Before beginning a medal I advise you to make a life-size drawing of your model in order to study the proportions, the details, and the movement of the forms. This drawing should be sincere and faithful without attempting any interpretation. You can thus in the first sitting observe the carriage of the sitter, the pose of the head, you can analyse and familiarise yourself with all his other characteristics.

The best proportion for a medal is a diameter of from two to four inches, such as the masters of the Renaissance adopted. In a larger size the portrait loses the necessary concentration,

the eye cannot so quickly seize its general character, and it comes near the proportion of the medallion.

FIG. 83.—PREPARATION IN CLAY.

On an even slate stick some modelling-wax, as thick as the projection of your medal is to be—(see Fig. 83)—without troubling about detail, beyond forming a rounded mass, diminishing in thickness at the outlines and giving in very

low relief the idea of a section of a head. This will help to give the appearance of substance and solidity to the head. If you begin by making the forehead, then the nose, mouth, &c., there will be a want of homogeneity and unity in the general plan. The principle is the same which I have expounded in the chapter on Relief from Nature.

Of course you must at once give to this mass the pose of the head and the direction and planes of the shoulders,— if there are any shoulders. After that you hollow out the eye, project the nose and place the ear, which is generally parallel to the space containing nose and eye ; then from behind the ear draw the outline of the jaw to the chin and from the nose trace the profile line of the upper and lower lip to the chin. On this line draw the line of the mouth, indicate its corners and the outlines of the lips, then the forehead and outline of the head, the neck, and so on.

So far you should have worked with the light falling on the back of the model's head, so that the profile throws a cast shadow on the background. You will find it easier to draw broadly and you can better judge of the drawing and of the proportions, than if the light fell on the profile of the face.

Having thus placed the features, there follows the working of the planes, which should be done as broadly as possible, at decided angles which will allow you to test whether their direction is exact. (Fig. 84.)

And now you must change your light continually. I go
so far as to say, take the medal in your hand and follow

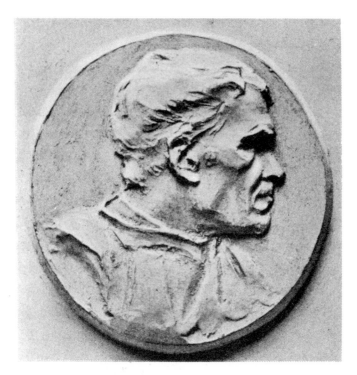

FIG. 84.—INDICATION OF FEATURES AND PLANES.

your model about the studio, so that you get a perpetual
change and yet have the same effect of light and shade on
your work as on your model.

Examine also from the front-view the relation between

the projections of the different parts, as, for instance, the relation of the forehead to the cheekbone, to the jaw and neck, the projection of the eye compared to the nostril, the relation of the latter to the mouth and chin, the cheek to the ear, and so on.

You must keep a strict eye on these relations, so as to bring them into harmony and into the general scale of the medal. I repeat that you cannot change the light too often, for if you work too long under one effect, the likeness obtained under this will disappear under another effect, and what appeared to be neatly drawn will look confused.

It requires very attentive, precise, and careful work before a medal can pass the examination and resemble the model under all effects of light.

In progressing with your work you must also be very cautious not to lose its general substance by hollowing out certain parts, or by allotting too much projection to others, and thus losing the foundation-plane.

The superposition of planes must be executed in the wax with great precision, it may even be pushed to hardness; you must verify them in every possible effect. In short, everything must be precise and sharp; nothing must be left to accident, there must be no jugglery with artful touches. In the plaster it will be easy to simplify and soften.

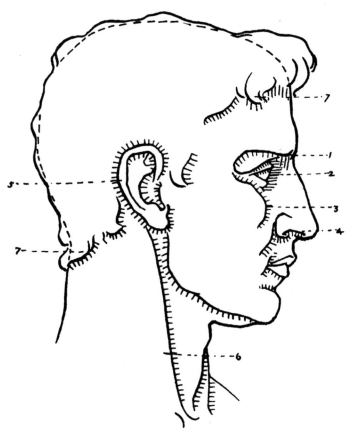

FIG. 85.—SUPERPOSITION OF PLANES.

The principal superpositions of planes are:

1. The forehead over the eyebrow.
2. The eye over the nose.
3. The cheek over the eye, nose, chin, and neck.
4. The wing of the nose over the upper lip.

5. The ear over the posterior part of the cranium.

6. The sterno-cleido-mastoid muscle over the profile of the neck.

7. The hair over the whole of the upper part of the face and over the posterior part of the neck, &c. (Fig. 85.)

When you have pushed your work in the wax as far as the material will allow, that is, if everything is well in place, the characteristic attitude and resemblance obtained, by decided drawing, the planes strongly defined, you may proceed to the casting in plaster of your medal.

With a soft brush wipe a little oil over the wax model and the slate background ; then mix your plaster—not too thick though—and throw a spoonful on the wax, blowing it about, so that it enters into all the hollow parts and makes a slight covering over the whole ; when it is settling add more plaster, to about the thickness of one inch. Be careful to cover enough of the slate, so as to leave a good space all round the head, in order to have enough material to cut the background out of.

After about twenty-five minutes, or when the plaster begins to feel hot, you may remove the mould from the slate. For this purpose place the slate with what is on it under water for two minutes, and then push a fine chisel underneath the plaster, use it as a lever, and raise the mould, which will readily come off the oiled wax.

You have by these means obtained a mould (Fig. 86) in which you can work and improve your medal to a degree which can only with difficulty be obtained in wax. Suppose

FIG. 86.—MOULD FROM FIG. 84 RETOUCHED.

any of the forms, say the cheek, lacks roundness and richness, it is easy to attain that effect by gently hollowing with a rounded tool this form, which was convex in the wax and is concave in the mould. You must bear in mind that

the amount which you take from the mould will add to the projection in the proof.

With fine and rounded tools you may thus go over all the parts of the medal which you wish to raise in relief.

In order to keep account of what you are doing, squeeze from time to time a piece of wax or clay into the mould over the parts on which you have been working, and you will at once see the effect in projection.

At first you will find some difficulty in knowing what you have done in the mould, as well as what you are able to do in it. It is an extremely rapid means of advancing your medal and giving freshness and brilliance to the forms. I advise you to practise it until you have well mastered its uses and advantages.

The difficulty of this method of working is greatly lessened by throwing a strong light from the side on the mould, so that you get violent shadows in the hollow, then screw up your eyes, and after having looked at it for a few instants you will see it in projection, and this impression will last some time, so that it is occasionally difficult to see it again as concave, and you work as if it were really in projection.

Another advantage of this system is, that—the hollow parts in the wax jutting out in the mould—you can finish them and clean them up more easily, round them off when necessary. This will prove a good quality in the cast, for

the interiors will appear finished without having the hardness
which tool-marks in the wax always cause, and there will be
a continuity in the modelling, a gentle blending of surfaces
with interior parts, in fact it will greatly assist in giving
the quality of unity and harmony.

After having worked in this way all over the medal, it
is well to take a wax squeeze of the whole medal, in order
to see if it will be well to go on working in the mould or
better to continue the work in relief.

If the work answers to your expectation, you take a
proof in plaster. The first thing to do is to soap the mould
with boiled soap : put half a pint of boiling water in a sauce-
pan and add a good tablespoonful of black soft soap of un-
adulterated quality to it. Let this boil, and stir it until it is
quite dissolved ; when cold, keep it in a corked bottle. I
strongly recommend you to use no other preparation, as unless
the soap is boiled, there will be unevennesses on the cast,
for soft soap never gets quite dissolved when put on with
cold water. Nor would I advise you to use hard soap by
rubbing a wet brush on it and paint the mould with the
froth ; this will cause an undesirable thickness in the mould
and corresponding bluntness in the proof.

You may use the boiled soap hot or cold, it matters not
which, only it must be liquid, and should it be too thick, add
some boiling water to thin it.

The mould is then completely filled with this liquid soap and left with it for a few minutes ; then the liquid is poured off, and after having given it some more time to absorb the soap left on its surface, you remove with a soft brush whatever traces of soap are left in the hollows, and let it lie flat till the surface appears dry ; that will be in about 10 minutes' time. Now take four or five drops of olive oil in the hollow of your hand, and rub a thoroughly dry, soft brush on it, so that its hairs just get moistened at the extremities. If it should have imbibed too much oil and show diminutive drops at the ends, you must wipe them off on a clean linen rag. Wipe this brush gently over the surface of the soaped mould until you perceive a diffused sheen on the upper face of the plaster. After this place the mould in a vessel and cover it up with clean water, and leave it there until it cannot absorb any more water. This will take about three-quarters of an hour if the mould was quite dry.

If you do not use this precaution, you will have small holes in your cast which are caused through the dryness of the mould tending to absorb moisture from the cast and leaving air-bubbles in its place. When the mould is quite saturated with water, take it out of the pail and blow the large drops of water off ; it does not matter if a few small drops remain, as they will assist the plaster to run in the mould when you cast the proof. When everything is ready

and a clay-band put round the mould to keep the plaster up, you mix the plaster very evenly. Then proceed as before, *i.e.* blow the first layer all over the surface to make it go into all the deep parts—you may even assist the process with a damp brush—and when it gains consistency, fill it up with plaster to a depth of one-half to three-quarters of an inch. It is preferable to make these early moulds and proofs rather thick. Allow the cast to set for about half-an-hour and then plunge it for a few minutes into water. This will assist the process of detaching the one from the other, for which you push a very slender blade between mould and proof. By gently pressing they will separate. If there should be any difficulty, you put the whole back into the water and manipulate the blade so that the water will glide between the two surfaces. Of course, these directions apply only to work which will draw off in one piece, where there is no undercutting.

A few minutes after you have drawn the cast off, and whilst the plaster is quite fresh, you can work on it with advantage by wrapping a fine linen or lawn rag over your finger, and modelling gently over the surface of the medal, as if you were modelling it in clay. This will blend and simplify the planes. You resume then the working from the model in the same way as you worked in the wax, correct and define the outlines, the superposition of planes, in short, do everything which can lend aid to

accentuating the character; you may also slightly indicate the direction of the hair.

At this stage it will be well to settle the circle of the medal. By means of a pair of compasses you strike a circle on the background, using as a centre the ear or a point near it; from the same centre you strike two circles within the first, the distance between them depending on the size of the lettering for your inscription. Draw the inscription in place with a very hard pencil, which will slightly enter in the plaster, so that it will appear raised in the next mould (Fig. 87).

You take this next mould in the same way that I described for the first, but soap and oil your proof before putting it in water. When the second mould is ready, work on it or in it as in the first. The indication of the hair, moustache, and beard that you have made on the first proof will be in relief on the mould, and you can now dig them out with a tool according to the projection you wish them to have. Touch up the parts which seemed too flat in the cast by gently digging into the mould; in short, repeat the operation that you pursued on the first mould in such a way that you advance your work with fineness and precision.

The letters standing out in the mould (Fig. 88) will also have to be incised (Fig. 89), so that they will be raised above the background in the next proof.

When you have done all you can in the second mould,

FIG. 87.—CAST FROM FIG. 86 RETOUCHED, AND INDICATION OF LETTERS.

take a fresh proof on which you continue your study in detail. You will always find it useful to wrap a rag round your finger when modelling over a fresh proof, to reduce and soften projections, for instance, of the hair or beard, or of the letters. By rubbing the latter with the rag when they are too high, you obtain much better quality than by using a tool to work them down. (Fig. 90.)

I should like to hint with regard to the hair that it is just as well to put too many details in the mould, as long as they are correct in their direction, because it is so easy

FIG. 88.—MOULD OF FIG. 87 WITH LETTERS IN PROJECTION.

to rub them down with the rag until there is hardly anything left to show of them but the planes, which will suggest the fineness of hair with the slight indications that are left.

If your medal has to be very small, say only one and a

half inches in diameter, and also very flat, it is preferable—
after having made a large drawing and perhaps modelled it
first in the larger size—to work it directly on the plaster to

FIG. 89.—LETTERING INCISED AND FACE AND HAIR RETOUCHED.

the required size. You take for this purpose a small
previously prepared plaque of plaster, thoroughly dry, and
draw the outline of the head and neck sharply on it in the
actual size you want, plunge it in water to soften the plaster,

FIG. 90.—CAST OF FIG. 89 RETOUCHED.

and when sufficiently soft to yield to a knife, cut it down
outside the drawn contour to the background, until you have
left enough relief for the head. When your background is
tolerably level, you begin to work on the plaster in the
same way as on the wax; the plaster being of firmer
substance, you can at once arrive at greater precision than
in the wax. When you have done all you can on the

plaque, take a mould of it, with the usual preliminaries of soaping and oiling, and in this mould you relieve the parts that are too flat, and work exactly as I have described it for the previous work.

As it is rather difficult, when you cut the plaster down round the head, to get a perfectly even background, and entirely in the same plane, the first mould gives you an opportunity

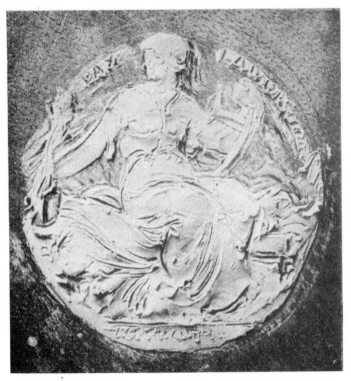

FIG. 91.—ROUGH SKETCH OF COMPOSITION.

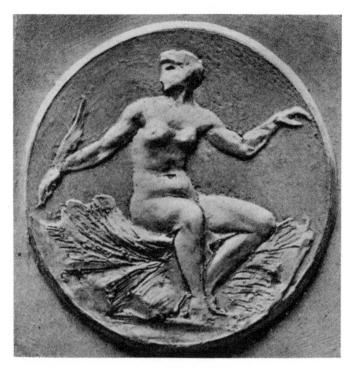

FIG. 92.—SKETCH IN CLAY.

to remedy this defect. Take a sheet of fine sand-paper and lay it flat on a table or any perfectly level board, and then rub the face of the mould lightly on it, taking care to hold it quite horizontally, until the surface of the background is absolutely flat. Of course, the head being hollow, you do not run any risk of injuring it by this proceeding.

If you have to represent a draped figure, you must make

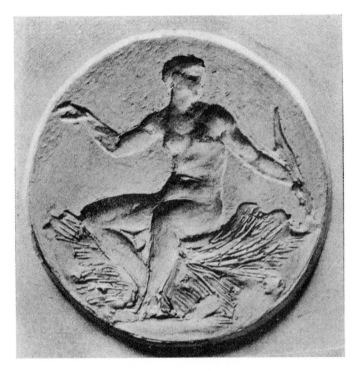

FIG. 93.—MOULD OF FIG. 92.

your composition first on a larger scale (Fig. 91), then make a study of it in drawing from nature, so that you are quite sure what you want to obtain in the medal.

Suppose this figure is to be on the reverse of a medal of three inches diameter. You trace on a slate a circle of this dimension, within which you sketch in clay the nude figure, at first in fairly flat projection. (Fig. 92.) Then

you find the planes and contrasts as in the study of a relief, when you have the pose, the proportions, and the intended effect of surfaces. Take care to make the nude rather full,

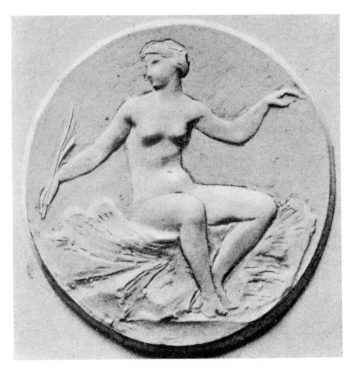

FIG. 94.—CAST FROM MOULD, FIG. 93, WORKED UPON.

so that you have afterwards in the plaster sufficient material to draw the contours without making the figure poor and lean. The nude of a figure that is to be draped should be

Modelling

of rather comfortable proportions, particularly when it is for a small size, such as a medal.

Arrived at this stage, you must take a first mould, on

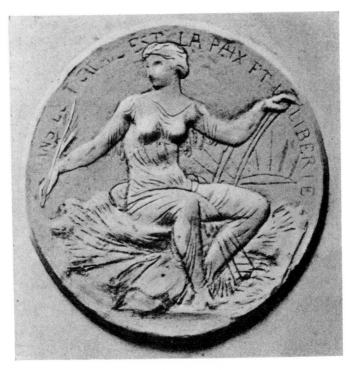

FIG. 95.—CAST WITH OUTLINE OF DRAPERY INCISED.

which you work in the same way as for a head. (Fig. 93.) Then take a proof in plaster, on which you draw and model the nude figure more correctly. (Fig. 94.) When you have finished it, take a very hard and finely-sharpened lead-pencil

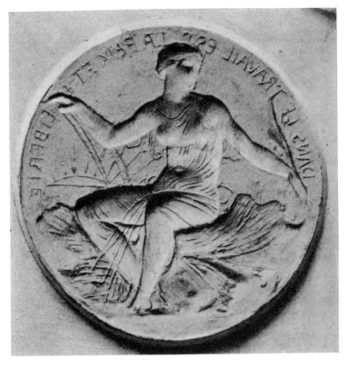

FIG. 96.—MOULD OF FIG. 95, HAVING OUTLINE OF DRAPERY IN PROJECTION.

and draw upon the nude figure the folds after the study from
nature, press gently on the pencil so that these directions
for folds will be slightly incised on the plaster (Fig. 95);
then make a second mould in which the fold indications will
appear slightly raised (Fig. 96); hollow or dig them out to
the depth that is necessary for the projection that you desire
in the proof. (Fig. 97.) Take from time to time a squeeze

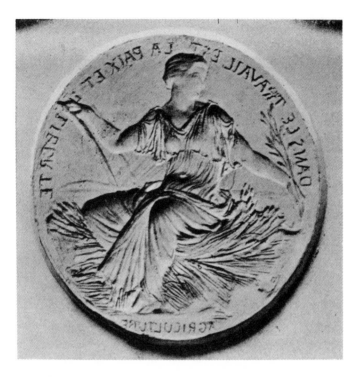

FIG. 97.—MOULD OF FIG. 95, WITH DRAPERY ENGRAVED AND FINISHED.

in wax to see how you are going on. If some part should have been graved too deep, you can easily work it down in the proof.

When you can no longer see in the mould what you are doing, draw a proof, on which you do all you possibly can by taking off (Fig. 98), drawing, and modelling, and if you find that in some part the relief is too flat, or the folds too

poor, you make a third, even a fourth mould, and go on working in the same way. Never be afraid of making several moulds—I have sometimes taken as many as twelve moulds

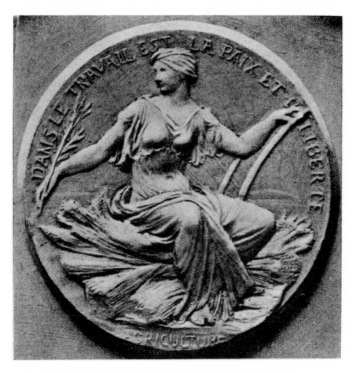

FIG. 98.—CAST OF FIG. 97 RETOUCHED.

for a medal of this style, and found that after all that was the quickest and surest way of advancing the work. After some practice you even arrive at engraving a medal or a figure hollow into the plaster without any previous modelling

in wax, I mean starting with making the mould. Although this is somewhat difficult, I hold it to be no more so than modelling a draped figure direct entirely in wax, and you get a very good result. An object of small dimensions can always be worked in this way with advantage.

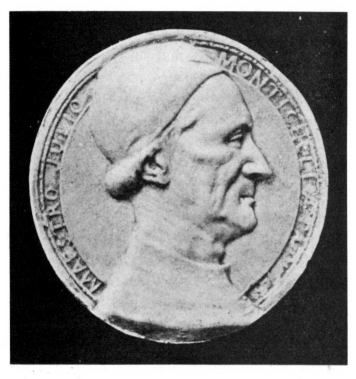

MEDAL BY THE AUTHOR.

COMPOSITION

OF all art-subjects the most difficult and delicate to treat is Composition, for it cannot, properly speaking, be taught. In approaching this subject the teacher must use special diplomacy towards the student in order to suggest, rather than to impose on him, those modifications which will make him advance.

Here, more than in anything else, the master should become the physician of his pupil by pointing out to him what is suitable for his particular temperament.

Before saying anything to the student about the correction of his composition the master should try to assimilate the ideas which the student seeks to express. He should put himself in his place and become one with his pupil, and then with his riper experience continue the work by developing it and strengthening it, but respecting as much as possible the original conception. For a master to impose on his pupil his own conception of a subject is entirely contrary to the rules of artistic teaching; in such a case the hand of the

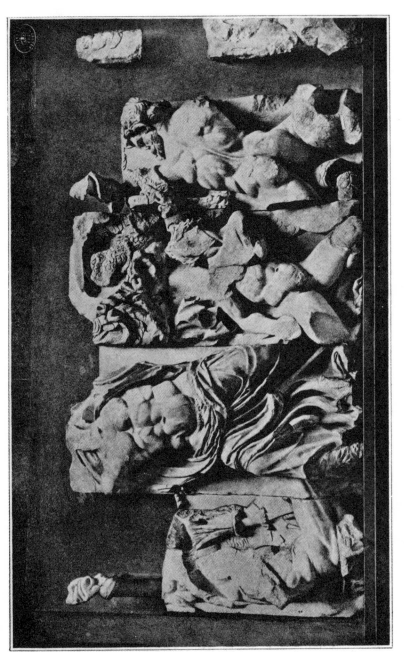

Fig. 99.—Zeus Group from the Large Frieze of the Altar of Pergamon.

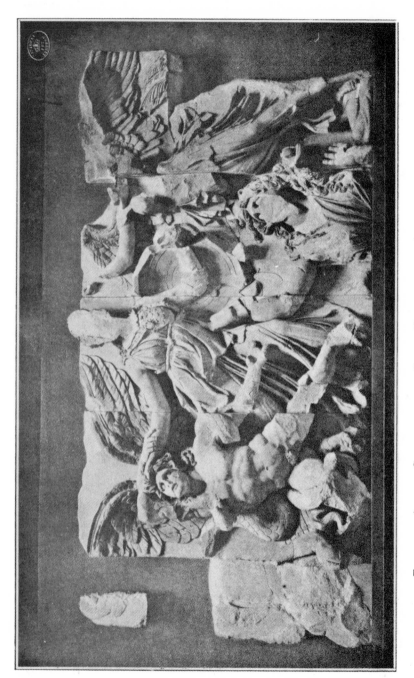

FIG. 100.—ATHENA GROUP FROM THE LARGE FRIEZE OF THE ALTAR OF PERGAMON.

student becomes merely the instrument of the master's brain, and he never acquires the needful strength of conviction to produce a work of individual quality. The only result is to make the student lose all interest in pursuing and perfecting his own conception. And yet this is just what the master ought to assist him in, by speaking to him of the masterpieces of old, and by using all possible means that will help him to give expression to his own thoughts and sentiments.

There is no positive law for composition ; still, there are some generally accepted "conventions" which the student will be glad to know without being put forward as absolute rules like the laws of the Medes and Persians.

These few rules are based on observations drawn from the works of various masters of different epochs ; but no master resembles another, nor one epoch of time another, and yet there are splendid works in almost all.

What would be the result if composition were taught like mathematics ? The training of people, who would all think and work in the same way, and who would have a ready prescription for every case. This is, perhaps, what one hears so often talked about as "a school." "This artist has founded a school by his teaching."

Is that a desirable result ? No, it is a most unfortunate result for Art, as by subjecting it to a fixed routine it kills the artistic germ which each individual may possess.

That is why positive lectures on composition are very dangerous; I mean those which lay down absolute laws, for, strange to say, the most interesting works of art are always those which have escaped and avoided those laws. Imagine a lecture (and I have often had the misfortune to be present at such an one) before fifty students, where it is affirmed that "in order to fill the space . . . " or "in order to make a composition" you "divide the panel in two horizontally and then divide it vertically. In the centre you put a large mass, and by lines (always the same, mind) you connect the sides with the central mass." Or you are told to divide any space into small squares, and in these squares find a combination of lines which will repeat, and so on.

Will this develop the artistic intelligence? No, certainly not. In order to develop this you must work from nature with the greatest sincerity, copy flowers or leaves, or whatsoever it be, but with the most scrupulous analysis of their character and forms, for nature only reveals herself to him who studies her with a loving eye. In this way the student will find the essence of the spirit of composition—for there is nothing more harmonious, nothing more symmetrical than a flower, a leaf, and above all the human form—notwithstanding all appearance of irregularity. Here are found all the laws of beauty in composition, and the student who

copies them sincerely assimilates these laws with his temperament and personality, and creates for himself an ideal, which later on he applies to his own compositions. It is only by obeying that the artist learns to master nature.

Of course, in a decorative composition there must be an interpretation; that is, there must be something more than an exact copy of nature. The grouping of masses, the arrangement of lines must be conceived according to the place which the composition is to occupy, according to the effect which will harmonise with its surroundings. But these lines cannot be taught; they are the personal gain which our conscientious studies from nature have developed and modified by our temperament (and, mind, everybody understands the spirit of nature in his own individual manner), for one thing is certain: you may set twenty students to copy the same model, and, notwithstanding their perfect sincerity, not one of their studies will resemble the others—unless the teacher has imposed on them his way of seeing it.

There is thus all the stronger reason for developing the individual spirit of observation when it is a question of composition, which is entirely the result of sentiment and character.

It follows that everybody has his own way of seeing, feeling, and reproducing, and this is what the master should

above all respect in the pupil, for it is this which makes the artist.

Do not let us forget that routine is the greatest enemy to art. And the teaching of composition in the same fashion to every student leads necessarily to routine, and consequently to the killing of all personality by making the student adopt ways and means which belong to the master.

There is nothing more unfortunate for students than a master who is a genius. The student, lost in admiration of this genius, no longer sees for himself, or belongs to himself; he imitates the master, and there results an exaggeration of his typical characteristics, pushed to caricature without his personal *finesse*, and when we see the works of this imitator, however skilful and clever they may appear, they produce on us the effect of an intelligent parrot and inspire us with a feeling of pity.

It is the duty of a genius to uphold the artistic standard, but he should above all abstain from teaching, for he has neither the requisite time nor the strength for the complete self-abnegation that is required of a teacher, and, I say, he must not have it either.

There is a fundamental difference between one who practises only and one who teaches art. The former may be exclusive, unjust in his opinions; he may, nay, he must, believe that he alone knows true art. That passionate

conviction will often be his strength. But imagine the teacher to be imbued with this strength and passion, and you will quickly realise how a young student, domineered over and subjugated, would lose all individuality of character and all the delicacy of his nature; he might perhaps acquire skill, but it would be a copy of the master's skill.

A true teacher must exclude the systematic spirit from his judgment. Far from seeming to keep exclusively to one conception of art only, he must understand all those conceptions which have been produced before and must be able to receive from his pupils all the new modes of expression which can still be brought forth; above all, he must never put his own example forward; he should be absolutely impersonal.

The genius teaches by his work, the professor by word and method. People rarely take into account all the qualities which a true teacher should unite in himself. Yet these are numerous and often of a high order; the consideration and the advantages granted to the man who instructs the young generation are, however, rarely in proportion to his services and merit.

The world is sometimes surprised to see such a small number of good teachers, particularly in the artistic branch. It ought rather to be surprised that men of value have allowed themselves by their aptitude for the vocation to be

entrapped into such an ungrateful and badly appreciated career.

If a professor gives himself up entirely to teaching, and sacrifices to it even his desire to produce for himself, he is nearly always looked on as an unsuccessful artist. The esteem accorded to a teacher is measured by his success outside teaching. A young master will be asked if he can draw or model a figure, but never if he can demonstrate to others how to do it. All such wrong and unjust views are calculated to drive the best qualified men out of the profession.[1]

Now to come back to our subject. How many minor Stevenses do we see? How many minor Burne-Joneses? The worst of it is that these good people by their bad imitations make us hate what we liked before; they almost make us regret that the artist had conceived an original idea, which was the personal result of his artistic intelligence, and that he brought forth this new note, of which all the lesser fry give us such imperfect imitations.

Therefore we must allow the student before and above

[1] The salaries also which are offered to young men, after having spent twelve years of their life in studying one branch of art, are more than ridiculous,—less than what a fourth-rate cook would earn, and the members of committees who are not ashamed to offer £120 per annum to a young master lack all respect for art and even self-respect. A great deal might be said on this subject, and I hope some day to have an opportunity of saying it.

everything to be himself. We must never impose on him our way of seeing, so that he may be made to believe, even for a minute, that there is none but our own way of composing. On the contrary, we must show him at every moment the different manners of the old and best masters, and the beauty which exists in each of their different styles. To sum up : we must open up his horizon and enlarge it, so that by means of this enlarged vista he may perceive that "Art is infinite," that it knows no limits, and that the experience of his teacher guides him towards developing his own aspirations and does not impose on him those of his master.

It is a great mistake, and unfortunately one too widely spread, to believe that Sculpture or Painting can be perfected by completely forsaking the ground of simple imitation of nature in order to seek exclusively an ideal type of the objects they represent; this is to ignore the resources of nature and the results of the infinite multiplicity of accidents which she brings about.

With regard to invention I should like to strike a note of warning : Every and any artist must persuade himself, that frequently what he takes for an invention is only a matter of memory, a souvenir. But however richly stored his memory may be, and however exact, it cannot make up for the constant observation of nature in its infinite variety, for every object

in nature and every view of the same object produce entirely new aspects, the study and close observation of which may lead to the discovery of a new beauty,—a discovery which everybody makes according to his light.

There is nothing more conducive to develop the power of composition than work from memory. The student should set himself the daily task of sketching from memory at night what he has done from nature during the day. And if he has seriously set himself this task, he will in his work from nature unconsciously study the characteristic side, the typical side of the action, the large lines, etc. He will no longer be inclined to look at details only, but at the essentials of all those things that go to make the typical.

Further, by combinations of lines which he will be obliged to create, he will see their relation to others and will apprehend their harmony ; in a word, he will develop his personal gift of observation, for the artist is nothing more nor less than an observer, and he is the greater or lesser artist according to the perfection or imperfection of this power of observation.

Begin this memory practice by at first only reproducing the principal lines of what you have done during the day, by reproducing what has appeared most striking to you in the individuality of the model which you had before your eyes, and as your study progresses you will also pass on to

the details in your drawing from memory. You should thus reproduce not only your daily studies, but anything which has struck your attention during the day: a typical head, a group of persons in the street, an incident, an accident. And if you make a mental resolve: "To-night I will reproduce this scene," your mind will at once take note of the chief lines of a group, of the division of the masses, down to the movements of each individual and his or her contribution to the elucidation of the subject or incident. Thus unconsciously you will do the work of composition, and you will have done it in your own individual way, for when you sit down at night to reproduce the scene, you will probably only indicate the essential part of the composition as expressed by the large lines, and you will complete it with the details that your own artistic feeling suggests.

In this way, by observing nature, you will get your best teaching, your brain will be stocked with notes which will have become your own property, for they will be assimilated to your temperament and will be a fruitful store to draw upon in the future.

And moreover, having to practise drawing from memory, you will be compelled to observe quickly, and this will help you in the studies from nature to see quickly what is typical in the model or in any subject.

You ought to begin these memory exercises with simple

things, and gradually take up more complicated subjects. You will be surprised at first to find how very little you do remember, but you will rapidly develop your memory power and will note what a resource it may become for an artist. I have practised this work from memory very much, and I well remember how at first I found it impossible to remember anything whatever, but when I closed my eyes and concentrated all my energy and will-power to see again the scene I wanted to reproduce, it would appear to my mental eye in every detail. As soon as I opened my eyes it disappeared, and nothing but white paper lay in front of me; but by repeating the same process several times, I would succeed in fixing the picture on my mental retina, and after having rapidly indicated the principal action of the scene in a few lines, I would close my eyes again to see the details and fill them in. This was my way of proceeding, which I give you for what it is worth. There are probably other ways of arriving at the same result.

In any case it is an excellent practice which makes us study not only the model in the studio in a set pose, but the movements and actions of different beings, all of them contributing to the expression and development of the scene passing before them. And I maintain that it is the best preparation for original composition, for things and scenes we have seen have naturally a greater force than those we

invent. It remains our task, in full freedom to idealise, amplify, and to accentuate the scene, and thus to add our personal note to that of nature, and I may go so far as to say, that involuntarily we strike an individual note in everything we reproduce sincerely, as everything which we have seen and which we draw must have passed through our brain, and must thereby have been modified by our own mental point of view.

I do not hold with absolute rules on Composition. Let your compositions be the result of your own mental tendencies, of your feelings and emotion about those things you love best in Nature, and which attract you unconsciously. By these means only can you have the strength of conviction in your work.

It is a difficult question which each one must put to himself some day : What do I love best in Nature ? What characters appeal most to me ? What moves and excites me most ? It seems very simple at first sight, but not so on closer observation. For we see so many works of art, we read so many criticisms — mostly written by very ignorant persons, but written in fine pompous language, in sonorous phraseology which dazzles us,—that we are every minute distracted from our own road, and occasionally it becomes impossible to find ourselves again.

Lucky he who discovers himself, that is, his own bent,

early; he has the chance of becoming a great artist if he is strong enough to resist the direction and advice of others, who, not being able to enter into his identity, would like to see him after their pattern. He who has the strength to avoid this rock, he who has conviction and faith, and along with them an unlimited love for his art, has the gates of fame open to him; he will do good original work, and not develop into an intelligent parrot.

Although composition is an advanced branch of study and of an entirely different order to the work from Nature, you must not think that it is necessary to defer its practice until you have reached an advanced degree of execution; no, rather from the beginning try it, set yourself subjects and try to do them as well as possible, or if not set subjects, try at least things you have seen which have left an impression.

Do such compositions by yourself, but it will be well to show them all some day to your master. In those naïve compositions which are quite your own idea and work, he will see the bent of your mind and the talent which guided you in them; he will derive from them a clue to your temperament, and understand in what direction he will have to guide you, and he will often in the very faults and repetitions find an indication of quality.

I have frequently had such examples before my eyes;

such faults are sometimes only exaggerations of an innate feeling, and if the master perceives that they are often recurring, he ought to strive to detect the personal quality, and he should make the student see and feel gradually that he is exaggerating unduly and that modification will improve without destroying his individuality.

The teacher should prove a physician to his student; he should auscultate him carefully and frequently; he should learn to know his temperament and ideas, and prescribe him the needful remedy: two doses of Michel Angelo to this one, three doses of Phidias to that one, and so on; and he should give the doses in a well gilt and sugared coating, so that the student could never scent the direction which the teacher tries to give to the execution of his ideas: thus he will digest the correction and profit by it.

Would it not be ridiculous if a hospital doctor were one day to order an emetic to all the inmates of his ward without taking into account their varied, perhaps opposite, ailments and wants? It would be just as absurd if a master were to correct the compositions of all his students in the same fashion, after an invariable method, however different they might be.

The study from the human figure is very different; it is based on invariable principles of construction, on anatomy, in fact, on positive laws; and from the beginning these laws

must be taught to all in the same way, because this know-
ledge ranks almost as a science. But when the student has
well grasped it, loosen the reins and let him show his own
power and accentuate what he has learned.

If a student more or less appropriates the characteristics
of another artist, I should like to tell him of a correction
which years ago my old master dealt me. I had one day,
in very bad taste, introduced a figure group which I had
seen in a bad artist's work. My professor, who easily de-
tected the theft, told me : " In art one must never steal
except from the richest and best. This is very good and
true, but it is still better not to steal at all. We should
instruct ourselves from good works of art, admire without
restriction what appeals most to us in them and draw all the
lessons we can from them, but that does not mean that we
should copy them ; we assimilate their qualities, and they
get transformed in us by our character which, on the other
hand, becomes modified as our study advances, as we progress,
and as we overcome the difficulties."

Beginners are easily satisfied with themselves, particularly
amateurs, who see no further than what is just before them,
who will only study enough to emerge from the state of
knowing nothing, and yet want to go in directly for "ideal"
work. They see in their slightest efforts the realisation of
their dream, and are surprised that others do not see an

equal amount of beauty. I shall not waste words on them beyond saying that they are wanting in respect for art and true artists.

Discouragement, if we are fortunate enough to be discouraged, is always a sign of progress; every time we are discouraged, it means that we have caught fresh glimpses of the beauty of Nature. Let that be a consolation to you and, on the other hand, be wary of satisfaction.

An artist who is satisfied with his work is, artistically speaking, nearing his end, for he will no longer strive to advance and rise; and in Art, when we do not go forward, we go backward. Nature keeps the artist up in the striving after progress, but, unfortunately, when he has attained to a certain celebrity orders crowd in and the temptation is great to scamp the work in order to begin another commission. His work will then rest solely on what he previously learnt, he will repeat himself and sometimes see and feel how inferior his present work is to his earlier productions, but he will not understand that, if he would only go to Nature, she would give him new inspirations; for Nature is as generous as she is beautiful, and does not abandon those who love her. By working from Nature one never runs the risk of absolutely commonplace work.

So let it again be said that the observation of Nature is the fountain whence the artist derives courage, and which

gives to his work the character and variety in which she abounds, so that unconsciously, by adding his own interpretation, his work will bear the stamp of individuality.

––––––––––

Before speaking of composition in relief, I shall say a few words about the different treatment which is demanded for the different places the relief may have to occupy.

There are three distinct divisions of relief : high-relief, half-relief, and low-relief, and of course a variety of degrees between these. And it is not a matter of indifference which of the varied reliefs should be applied to the decoration of a building.

HIGH-RELIEF

The first fact to be realised is, that every projection casts shadows, and that every flat surface attracts and reflects light.

Hence it follows that high-relief is proper for work which will be exposed to full daylight, and which, being placed in the highest part of an architectural monument, can only be seen from a distance.

The Greeks in their best time used relief almost as high as the round for the sculptures adorning the Pediments of their temples (Fig. 99 and Fig. 100), the Metopes in their Doric architecture and the external Friezes. Had these

reliefs been less prominent, these wonderful works of sculpture would have been killed by the diffused light, that is, they would have become quite indistinct.

HALF-RELIEF

In half-relief the objects and figures are only presented in half their natural projection. For works placed outside and at a considerable height, this is not suitable and satisfactory. The figures have not sufficient prominence to give them the appearance of roundness; at least, the spectator is not able to make out at a glance which parts stand out and which retreat. The forms and outlines become indistinct at a distance, because the shades of the figures lose themselves in the cast shadows and their light parts hardly stand out against the light on the wall.

Sculpture in half-relief is therefore suitable for interior decoration, or for easily accessible places. The Ancients made a very happy use of half-relief in applying it to objects of round form, such as vases, the shaft of a column (columnæ celatæ), as in the temple of Diana at Ephesus, or the balustrade of a sacred well. It is easily understood, that in these cases figures modelled in the round would not only destroy the convexity and thus injure the graceful form of the object, but would also render the parts indistinguishable from a distance.

Low-Relief

Low-relief, or bas-relief as it is called, to designate its little depth, is particularly adapted to work which is placed in rather dark situations. Its most famous example in antique art is the Frieze of the Parthenon. This was executed in low-relief, because it received no direct light. Being placed within the Colonnade and on the upper part of the wall, it received nothing but reflected light, and could only be seen distinctly when the marble pavement reflected the sunlight on to it.

It stands to reason that a higher and more accentuated relief would have multiplied the shadows in the shade and rendered the work indistinct. In order to make this frieze in its high place more distinct, the outlines are very neatly and sharply cut into the background, forming almost a right angle to the projection, so that the masses of the figures are strongly detached and the flatness of the relief is enhanced by the shadow of its contours, and the eye can easily follow these outlines containing the relieved figures of the composition of the frieze.

In the cases of superposed forms, as, for instance, where an arm crosses the torso, or when the leg of a rider projects on the side of his horse, the part most in projection is quite flat in order that its shadow should not cut up the form

behind it and thus take away from its projection, nor interfere with the more essential shadows which outline the movement of the composition.

Composition in low-relief presents relatively less difficulty than composition in the round. As it is always executed on a background, and consequently has only one aspect, all our efforts are concentrated on the arrangement of this aspect. On the other hand, in a composition in the round, whether it be a single figure or a group of several, you have to consider and express the subject from every aspect, and to make your lines harmonise and be interesting from every point of view. Again, as relief approaches painting you can allow yourself any number of figures in it, all of which will contribute to explain the subject.

Other difficulties, which I shall enlarge upon as we go deeper into the subject, compel me to advise you to begin your design studies in sculpture with compositions in relief, and not in the round as with the studies from the living model.

In your first attempts you should limit yourself to a subject which requires only one or two figures, such as " Music," " Poetry," and so on. Later on, when you have acquired practice in the harmonizing of lines, the effects of shadows, half-tints and light, you should take mythological subjects requiring more figures.

When you arrange in relief a subject of one figure, the first question is to find a pose which will best express the idea you wish to represent; next the contrasts of planes and lines, of which this pose is capable; then the arrangement of drapery (if the subject admits of drapery) which will best agree with the lines of the figure, and whose folds shall contribute to enhance the action; and lastly the accessories which will explain the subject to the spectator.

The proportions of these attributes or emblems are highly important; if they are made too big, they risk destroying the scale of the figure, and if too small, they will appear petty; your taste must guide you in the choice of their proportions.

In a sketch, as well as in the execution in large proportions, every figure that is to be draped afterwards must be modelled in the nude first. Yet at the very first it is necessary to sketch in the complete subject, with figure, drapery, and accessories, so as to have an idea of the general effect. (See Fig. 101.)

When you have made up your mind, that is, when you believe you have conceived the best expression of the subject, the arrangement of lines and places, and fixed the space of every accessory, you should make a sketch of the whole; afterwards scrape off everything that is in your way, viz. drapery and accessories, and proceed to model the nude of the figure in its large lines, paying special attention to settling the proportions

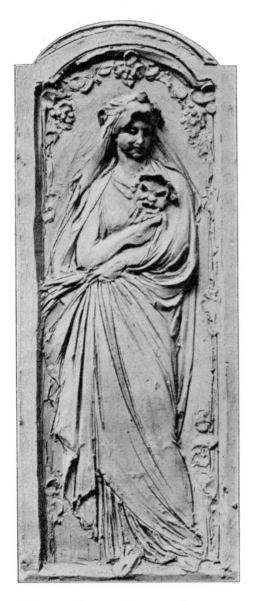

FIG. 101.—GENERAL EFFECT OF COMPOSITION.

FIG. 102.—COMPOSITION IN LOW RELIEF,
NUDE PREPARATION.

as exactly as possible in the nude (Fig. 102); for it might easily happen in the first hasty sketch that drapery hides the true proportion of an arm, of the leg, or the torso, and when you come to the execution of the design in large size, where the proportions are attended to more carefully, it would be impossible to obtain the same pleasing effect which you accidentally obtained in the sketch.

I know, you cannot always have a living model in front of you, which would at once show you what is possible or impossible in a movement, but what you can and ought to do is—as I have already recommended in my notes on the posing of the living model—to try the pose and movement yourself, to give the expression required for the subject, to observe the place and action of the hands, their relation to the act and the place of the head; for in the relation of these points you will find the mimic expression of the pose. You should in reality play and act the part represented by the figure you are designing, for you can hardly expect a professional model to evolve out of his or her inner consciousness the feeling and expression which you require, if you have not given him or her an exact rendering of it yourself. It is only on those conditions that you can obtain from the model, if not the exact expression, at least the leading lines, the points of vigour and of rest of the pose.

When you have finished modelling your figure in the

nude, see to the arrangement of the draperies as you had pre-
viously indicated them in your small sketch, in its principal
lines and masses. I always advise the student before begin-
ning the drapery, to make in clay a replica of his figure in
exactly the same pose as the sketch, but in higher projection
(Fig. 103)—even in the round, if you like—and to drape it
with a piece of muslin or other material. (This will, by the
way, be an excellent practice in learning how to manage and
arrange drapery on a lay-figure.) Thus you will have a
model, which, even if you do not copy it exactly, can suggest
to you combinations of lines such as you always find in
nature. It remains for you to leave out some folds, or enlarge
others, in your sketch ; in fact, to utilise whatever can further
your design and improve its quality.

If your sketch is of small proportions, it is desirable to
damp the drapery which you put on the self-made lay-figure.
It will thus better follow the movement of the pose, and
take of its own accord a better scale of proportions towards
the nude (see Fig. 104); if you put the material on dry,
the folds are inclined to become too large, and to hide the
chief lines of the figure.

I repeat, that you must take from such an arrangement
of drapery only what is absolutely useful to your sketch, for
if you copied every detail the result would be confusion and
the destruction of the unity of the design. (Fig. 105.)

FIG. 103.—NUDE FIGURE IN HIGH RELIEF FOR ARRANGE-
MENT OF DRAPERY.

FIG. 104.—DRAPERY ARRANGED ON NUDE FIGURE.

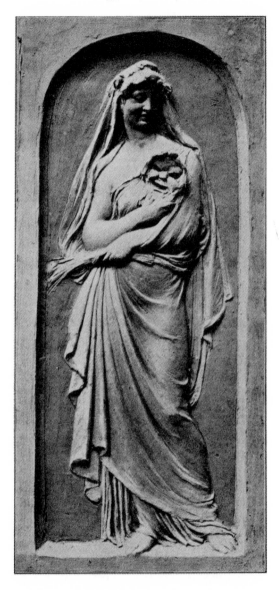

Fig. 105.—Sketch Completed—"Comedy."

You will do well to repeat the exercise of relief composition with one or two figures several times before you try more complicated subjects.

Composition in Relief with Several Figures

In an historical composition there are other things to be considered than in an arrangement of one or two allegorical figures, where, apart from the style and character, it is only a question of arrangement of lines and distribution of shadow and light.

When you want to compose the representation of a precise scene, you should first prepare yourself for it by reading about the manners, morals, and customs of the epoch in which it took place; by studying the individual character of each of the persons taking part in it; further, by conjuring up before your mental eye the types of figures and faces which will best depict these persons and their different age. Then there are the costumes which subject and scene demand, and which play such an important part in the movement of the figures, for it is evident that a man clad in a heavy cuirass cannot move as lightly as another covered by a simple chlamis; and lastly, the archæology and architecture of the period—its correctness will at once give an authentic look to the composition. To sum up, you must

try to transpose yourself in thought to the period in which the scene passes that you mean to describe. It would be ridiculous to seat a Greek general on a fifteenth century chair, or to drape with the peplos a thirteenth century queen. Yet similar mistakes are often seen in the work of students, who fancy that the only thing needful for a sculptor is to learn how to handle clay.

By getting a subject up in the way I have indicated, the student is compelled to read largely, and if he chooses his subjects from various epochs he will learn to understand and be imbued with the spirit and character of the different periods of history.

Many young art students start on their art career without any previous literary education and culture. The teacher must with all his might induce them to make up for this lack of culture whilst there is time, else it will be fatal to their future artistic creations.

By studying attentively the authors who treat of our subject, we make our study in composition all the more interesting and characteristic, and at the same time, we acquire historical and archæological knowledge.

Having become familiar with the personages in your design, you must begin to play or act their part. You have to ask yourself: in what way, by what change of posture, would this man express such or such a sentiment? It is

obvious that a person with a cool, deliberate disposition will not gesticulate in the same way as another with an enthusiastic temperament. Sly Ulysses will not reveal his emotions in the manner of impetuous Achilles, nor will Helena act like Iphigenia. The gestures of any of these personages must be different in whatever situation they may be. The difference of natural gesture is consequently well worth studying, for gesture is not only different in individuals, that is, modified by each person's disposition, it varies also in character according to manners and ideas pertaining to different climates, and every nation stamps it with her individual genius. Picture to yourself, for instance, the reserve of an Englishman as opposed to the laughing gesticulation of a Neapolitan. What a difference between the two! And yet notwithstanding all variety, the origin and root of gesture lies in the human heart, in which you may find every shade between the extremes, and by observing the gesticulation of each nation and race the artist will acquire a good scale of gradations. But in reproducing these, his taste will have to decide where to emphasise without becoming vulgar.

You must try then to reveal by the gestures the character of each person—make it, as it were, a biography. Having thus well imagined the scene to be represented and tried to play the part of each actor in turn, begin to group your personages in such a way that they all contribute, according

to their importance, to explain the subject. Do not put in any unnecessary figures which would only lead to confusion, but try to get contrasts of age and height, that is, of course, if the subject will allow of it; introduce an old man, an adult, a child, a woman, a young girl, etc., to help towards obtaining variety of form, and thus rendering the design more interesting.

It is sometimes a good plan, and we have striking examples of it in Egyptian and Assyrian reliefs, to have a repetition of movement among the personages of secondary importance; but this should be done with great tact, else the composition would become monotonous. For instance, if the principal *motif* of the subject is in the centre of the composition, and the arm-movements of the secondary figures tend towards that centre, the eyes of the spectator will be guided towards it and his attention will be attracted, so that he will easily see what you mean to express.

You will start the actual blocking-in of your composition with the general grouping of the figures in principal and secondary masses. (See Figs. 106 and 106A.) If the figures should be too far from each other, you may take advantage of drapery to unite them and render the masses more compact, or the same result may be achieved by accessories, arms, furniture, architecture, etc.

In a subject where the attention of the spectator is to

FIG. 106.—OUTLINE SKETCH OF COMPOSITION : "ARTEMIS AND ENDYMION."

Fig. 106a.—Rough Sketch of Composition.

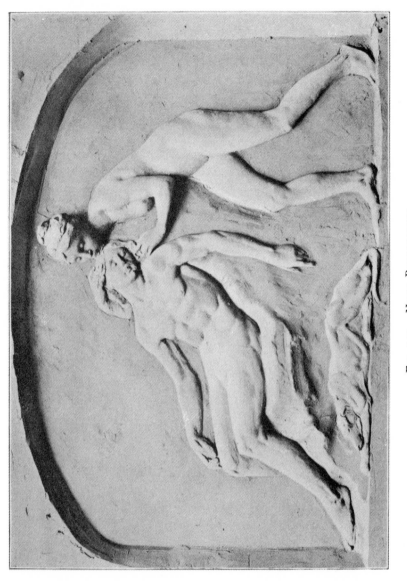

FIG. 107.—NUDE PREPARATION.

be concentrated on one point, the figures must not be separated as they may be in a frieze representing a procession : as, for instance, the Panathenaean procession in the Parthenon frieze, which is conceived with the decorative purpose of ornamenting an architectural part. On the other hand, an historical relief is generally conceived as a picture. Although this does not prevent its being applicable to architecture, it is so in a different way, for the subject must be concentrated. A frieze may almost be considered as an animated moulding, a band of enrichment that may go all round the building, whilst an historical composition occupies only one part of it. The moral is : the grouping of the figures must be compact.

After having blocked-in the composition in general, you proceed in the same manner as with a single-figure design, that is, you sketch in the nude of all the figures in their large lines and proportions, etc. (see Fig. 107), and if there are draperies you make again lay-figures in clay ; but instead of making them as separate figures, I should advise you to model the figures of the whole composition on a somewhat larger scale than your sketch, and above all in much higher projection (Fig. 108), and then to drape all these figures (see Fig. 109). This will enable you to obtain more harmony of lines in the draperies than if you had arranged each figure separately.

From this drapery arrangement you take, of course, only what is needed for your design, and suppress all the details which might cause confusion and hamper the unity of the design. And *unity* is the true secret of the success of any work. Perhaps you will ask what unity means in a composition? It means a certain general concurrence in the character and choice of the important lines, and the existence of a dominant part in the arrangement to which all the other parts tend.

You must pay great attention to the value of the masses, and avoid having several of the same volume. These latter may pass in a purely decorative allegory, or be even occasionally necessary there to preserve the equilibrium and balance of the architectural feature of which it forms part. But an historical relief applied to an architectural structure is always framed by a moulding, so that the design is already separated from the building by the frame and becomes a sculptural picture, and we may therefore contrast the masses as much as good taste will allow.

Sometimes you will get into difficulties by your masses looking too round or too pyramidal in their contours, and giving to the general design a want of strength and stability. I advise you then to try a few straight lines, either vertical or horizontal, which you may bring in under the plea of an architectural feature. These will assist you

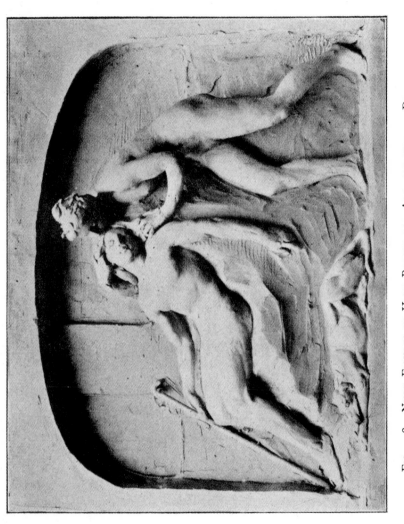

Fig. 108.—Nude Figures in High Relief for Arrangement of Drapery.

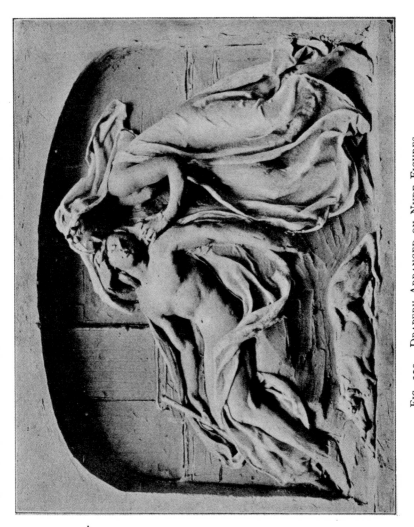

FIG. 109.—DRAPERY ARRANGED ON NUDE FIGURES.

materially in rectifying the balance and unity of the whole. You will observe in Fig. 110, where two masses or groups form an unpleasant angle, a horizontal line unites them and gives simple strength to the composition.

If, on the other hand, the masses in your design are filled with violent gestures in horizontal directions, a vertical

FIG. 110.—SHOWING THE EFFECT OF TWO MASSES HAVING A VERTICAL TENDENCY.

FIG. 110A.—TWO MASSES HAVING A VERTICAL TENDENCY CORRECTED BY HORIZONTAL LINES.

line introduced will not only restore the balance, but also, by contrasting with the accentuated movement of the persons, will heighten the contrast and give more forcible expression to the action (see Fig. 111). The dominant lines which enclose the scene and the movement of each personage may be interrupted by parts which disappear more or less on the background according to the distance or plane on which the figure is to be ; but they should never vanish

altogether, or the masses will get weakened and confused, so that the result would be a lack of unity and clearness, for in a relief, seen from a certain distance, what strikes us first is the silhouette of its contours, and these ought to give by their drawing a general idea of the movement and sentiment enacted within their frame.

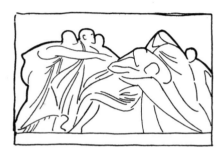

FIG. 111.—SHOWING THE EFFECT OF TWO MASSES HAVING A HORIZONTAL TENDENCY.

FIG. 111A.—TWO MASSES HAVING A HORIZONTAL TENDENCY CORRECTED BY VERTICAL LINES.

If you wish to shift the mass forward or push it back, or make it more or less projecting, you may with advantage use the following means :—Slice it off by means of a thread, take it carefully off the background, and then lay it on to the right or left of its original place until you have found the most suitable spot, when you fix it by pressing it lightly down in the centre and blending the clay in its outline with the background.

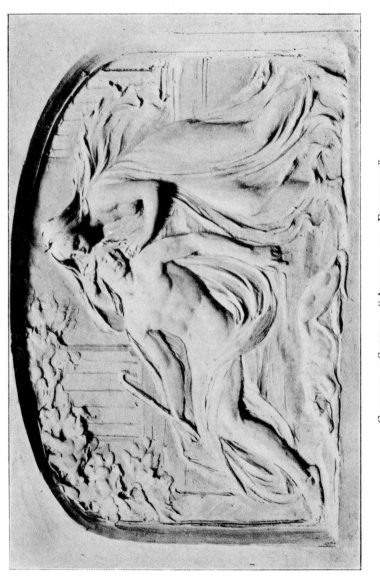

Completed Sketch: "Artemis and Endymion."

Should you wish to have it in higher relief after having cut it off and removed it, lay some clay on the background in its place until you have the desired projection, and then stick your mass of figures on to this added clay.

If you desire to diminish the projection, proceed in the opposite fashion, that is, after having cut off the mass, scrape some clay off the background and then stick your group on again. By this means you avoid having to remodel entirely what you had already done, and you can judge more quickly of the advantage of the change.

I must now deal with a question which has given rise to endless discussions, namely, the introduction of perspective in low-relief sculpture.

The Greek sculptors have always looked at the background of their reliefs as at a solid plane and not as representing air or sky, and everything justifies their point of view. To begin with, the shadows which a relief casts on the surface from which it rises proclaim very clearly the solidity of this surface, whether it be a wall, a vase, or the shaft of a column, for if the marble background should stand for the sky, it would be absurd to let shadows be projected on to it. Secondly, if the sculptor wishes to represent the appearance of a painting, he must progressively

diminish the size of the figures which he means to be in the background ; but he will be contradicted by the light, which will strike these figures as strongly as those in the foreground.

It was, therefore, not ignorance which made the Athenians avoid optical effects in sculpture, but rather perfected taste which forbade them to break the gravity of architecture by imitations of paintings which would seem to pierce the wall, and which would be still more unbecoming on a vase or on a column.

Is there in effect anything more offensive to an educated eye and mind than to simulate a concavity on the surface of a convex object, and to alter by an appearance of perspective the integrity of a column or a beautiful vase ?

Surely nobody will imagine that the simple laws of perspective were unknown to the architect Apollodorus, of Damascus, who erected the Column of Trajan? And yet this lofty column, the spiral of which carried up to the clouds the colossal statue of Trajan and the representation in relief of his battles and sieges in the Dacian war, shows in the background of the relief buildings which do not retreat according to the strict laws of geometrical perspective. The artist has preferred a skilful mistake which respected the roundness of the monument to an awkward observation of graduated planes and vanishing lines, which, hollowed

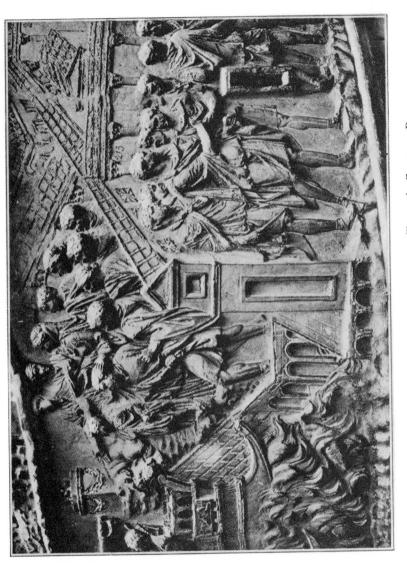

FIG. 112.—PORTION OF THE RELIEF ROUND TRAJAN'S COLUMN, ROME.

FIG. 113.—PORTION OF THE FRIEZE OF THE PARTHENON.

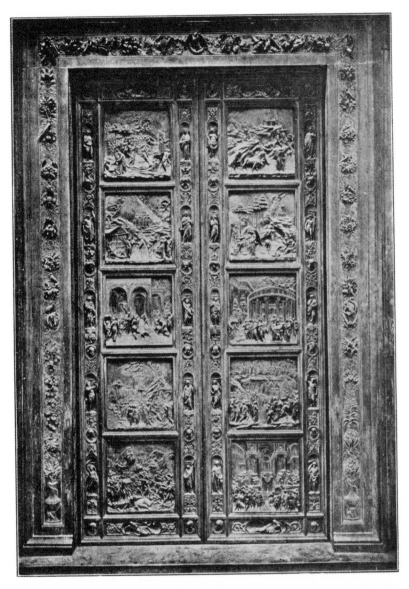

FIG. 114.—EASTERN GATE OF THE BAPTISTERY, FLORENCE, BY LORENZO GHIBERTI.

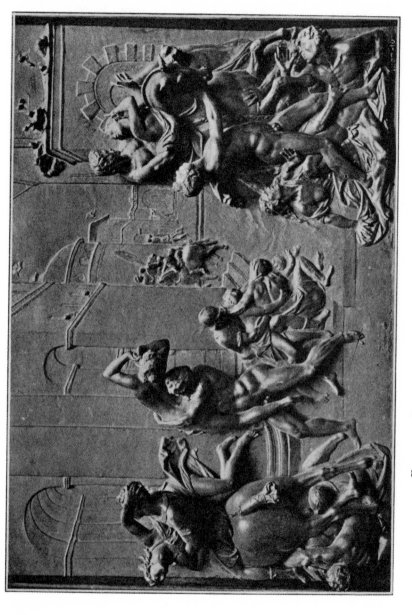

Fig. 115.—Rape of the Sabines, by Giovanni da Bologna.

out into the drum of the column, would have produced the illusion of a piercing where it was necessary to sustain the idea of indestructible solidity (see Fig. 112).

Phidias avoided the effects of perspective in the frieze of the Parthenon, but was not afraid of introducing in some places an apparent confusion, as, for instance, where he projected equestrian figures on other similar ones. But the repetition of limbs and the superposition of horses turn out to be excellently calculated by the greatest of masters for imitating the embroiled movement of cavalry in motion, and contrasting it with the isolation of the other figures and the quiet dignity of their solemn march (see Fig. 113).

Modern low relief, alas! is very far from Greek art. It has been subjected to the influence of painting, and to realise this you need only compare a specimen of the frieze by Phidias with the doors of the baptistery of St. John at Florence by Lorenzo Ghiberti (see Fig. 114, and Fig. 115 by G. Bologna). Ghiberti has brought in aërial and lineal perspective for the treatment of distance ; he represents mountains, trees, sky and clouds, and fancies thereby to have achieved a great progress over antique simplicity. But the brazen solidity of the background belies too clearly the vanishing lines and the illusory distance.

Unfortunately, the Italian and French sculptors of the following century went on in this style of ultra-picturesque

sculpture. They wasted all their energy and enthusiasm in piling figure on figure, plane on plane, cutting the marble away from full relief to the lowest half-tone in the background.

You will understand how this childish striving after an impossible illusion injured the purity of form and grandeur of style, how the essential qualities of art were forgotten in carving out unequal dark spots in order to provide the needed half-tones; in short, how effect was put in the place of beauty. See Fig. 116, Alexander and Diogenes.

I do not mean to imply that all colours should be interdicted in low-relief sculpture, but I want you to understand that it is the significance of the subject which prescribes the general effect of colour in the relief.

Let me conclude by impressing on you that for the principles of modelling in relief you cannot have a better guide and adviser than the models of Greek art, whether you find them in the ornamentation of vases, in tombs or altars, whether they give life to a frieze or to the pediment of a building, or whether they inscribe on the base of a statue those episodes and familiar scenes which go towards explaining the history of the period.

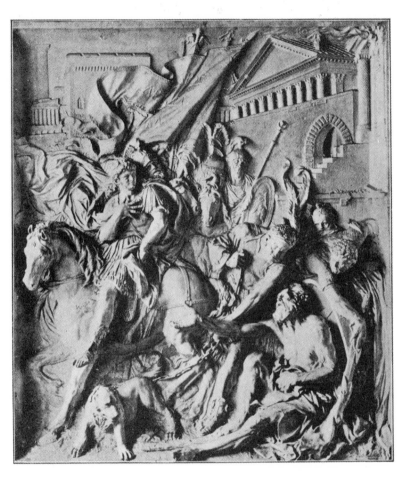

FIG. 116.—ALEXANDER AND DIOGENES, BY PUGET.

COMPOSITION IN THE ROUND

In figure composition we must as carefully as in relief composition strive to render the subject well, the harmony of lines, the contrast of planes, &c. ; and in addition to this—and that is the greatest difficulty—we must take care to make our subject clear from every side of the composition. It happens frequently that one or two views are interesting and the others insignificant, and then, in order to invest these latter sides with interest, one is obliged to change the arrangement entirely. On this account composition in the round is a much more complicated work than composition in relief, where all efforts are concentrated on one point of view only. On the other hand, the definite execution of a relief as a study from nature is in its turn more difficult than the execution in the round, in which there is less interpretation, because it comes so near to nature, that it is almost absolute.

When the work in the round consists of a single figure, the difficulty of composition is lessened because one can easily see and understand its action from all sides, but as soon as there are two or three figures, the difficulty begins—perhaps one of the figures may be completely hidden from one point of view, or there may be parts which have the appearance of relief, and yet it is essential that every figure should

preserve its roundness, its proportions, and, above all, be interesting from every side.

When for a single figure you have fixed on the action which expresses your subject best, the living model can give you—apart from style—all the qualities you wish to add, and if you have the good fortune to find a suitable model, with the characteristics that your subject requires, you have nothing more to do than to copy it faithfully, amplifying here, accentuating there, its character and type.

Simple poses are always preferable for a single-figure subject, and what is more, are more proper to sculpture, for the first condition of a statue is that it should stand well, should have a solid and firm position, and be so well balanced that the looker-on shall not be alarmed about its equilibrium and durability. It therefore behoves the sculptor to choose a simple action without complications, and to prefer an enduring action to an exceptional fleeting act.

It is painful to look at a statue which wriggles and writhes in violent efforts ; such a statue may impress you for a moment, but if you have it longer before your eyes its contortions tire and trouble you, and you feel inclined to say : " Please, take a little rest."

It is also very annoying to see a head which is laughing outright—it looks so very insipid.

A single figure ought to give us the sensation of stability,

FIG. 117.—FIGHTING GLADIATOR.

Fig. 118.—Venus de Milo.

and in this respect it comes near to an architectural work, for which one also requires apparent as well as real solidity. The pose of a single figure ought to be such that it can at least be kept without fatigue for a little while.

In a relief or in a painting, when you see one gladiator throwing himself upon another to vanquish him, you feel that his violent action is justified by the presence of the other personage towards whom he hurries. On the other hand, to see a figure in the round rush violently into space without an apparent object is simply ridiculous.

You will understand from this that the sculpture in the round, especially if it is a single figure, is less suited than relief or painting to represent a lively movement; the very material which we employ forbids us to think of representing the illusion of a violent movement as immovable.

The antique statue of the Fighting Gladiator (Fig. 117), an admirable, much admired work, shows deep knowledge of anatomy, and may serve as model in the art of expressing with energy and vivacity the play of the muscles, and elasticity of limbs trembling with life; its forms are wonderful in drawing and expression—and yet, notwithstanding all these qualities, it is incomplete and fatiguing. If we compare this splendidly executed work with the Venus of Milo (Fig. 118), or, better still, with the group of the Three Fates by Phidias, you understand at once the difference which exists

in the quiet grandeur, nobility, and dignity of the latter works and the annoyance or impatience which we feel before the former—notwithstanding our admiration for its technical excellence.

Michel Angelo, who was fond of highly accentuated poses, well understood how to imply a feeling of rest in his sculptural works. If you look at the figures on the Medici tomb (Fig. 119) you cannot fail to admire their stability, notwithstanding their highly accentuated attitudes.

There exist many life-size dancing figures, where the whole weight of the body rests on the point of one toe, and although many of them are perfect in execution, yet they cause a feeling of uneasiness, and are all the more fatiguing to look at, as they are of large proportions. Such subjects for single figures are only excusable on a small scale, and not in marble either, but in bronze.

EXECUTION OF A SINGLE-FIGURE SKETCH

To make a sketch in the round for a single figure, you can make an armature or skeleton frame-work after the pattern which I have already described for the study from Nature ; the support should be of iron, the rest of lead-piping fastened with copper-wire, and everything in correct proportion to the size of the sketch you are going to make. These sketches

FIG. 119.—FIGURE FROM THE TOMB OF GIULIANO DEI MEDICI, SACRISTY OF ST. LORENZO, FLORENCE.

can be made in clay, modelling paste, or wax. The advantage
in using the two latter materials consists in their not being
liable to drying, which is with
difficulty avoided when you use
clay in a work of small dimen-
sions. In a figure of only ten
inches in height you can re-
place lead-piping by two or
three threads of twisted copper-
wire (Fig. 120); they will oc-
cupy less space than the limbs,
and are of a sufficient resistance
to support the material; and
they are also very malleable
or easy to bend. The frame
must be twisted and bent into
the desired action (see Fig. 121),
and then be slightly covered
with whatever material you have
selected to work in, the same as
in a life study, and the correct
proportions should from the be-
ginning be adhered to, otherwise
it will be difficult to ascertain if the movement is possible;
at this stage it will be easy to turn and twist the figure

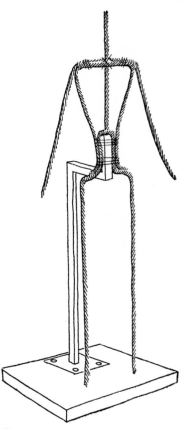

FIG. 120.—ARMATURE IN TWISTED
COPPER WIRE.

until the pose is quite as you wish it to be. (See Figs. 122 and 123.)

You might twist and turn an informal mass of clay or

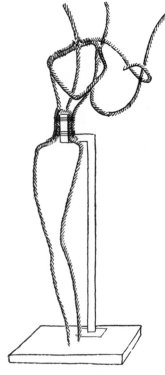

FIG. 121.—COPPER WIRE (TWISTED) ARMATURE IN ACTION.

wax in all directions, it would never convey to you the spirit of the fineness of the action, therefore the greatest neatness is desirable, and is encouraging at the same time, as it will help considerably to draw and reveal the idea which underlies your composition.

I always advise my students to try the contrary of what I say, so that they may become convinced by their own experience. It is even desirable to let students, who doubt the master's directions, proceed in their own fashion, so that, if it is contrary to practical rule, they should find themselves,

figuratively speaking, in a morass. After having allowed them to flounder and struggle hopelessly for some time, lead them back into the right way. That will convince them, and

Fig. 122.—Armature Covered with Clay.

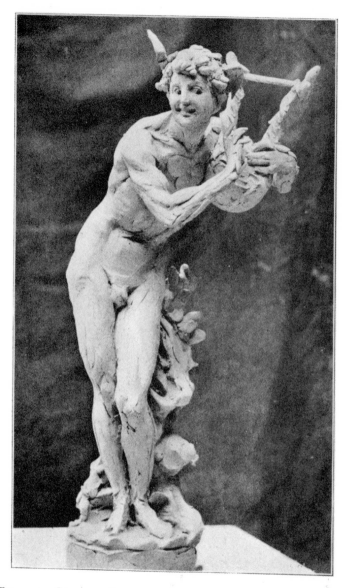

FIG. 123.—COMPLETE SKETCH OF SINGLE FIGURE. THE FIRST SOUND
OF THE LYRE.

give them confidence and faith in the advice of their teacher, which is necessary for their progress.

And here I may as well put in a word for neatness and cleanliness in the modeller's work. It does sometimes appear to me as if students believed that a sculptor ought to look dirty and be covered with clay, and not only have the clay on his garments, but also lying about his modelling-table and on the floor, have his tools and sponge muddy, the linen rags (used to keep his work damp) lying dirty on the floor, with puddles of water about—in fact, the studio to look as disgustingly dirty as certain famous stables of antiquity, which Heracles was set to clean ; and I must reluctantly say that lady-students are the greatest offenders in this direction. Now this proves to me a want of respect for your work, and a want of care and carefulness which is inexcusable. It shows that the student does not take sufficient interest in his study, else he would not surround himself with dirty disorder, which must distract his thoughts from his work.

It is on the other hand necessary to surround yourself and your work with cleanliness and tidiness, to put out of sight everything unnecessary which might unconsciously attract your eye, and to make your work as attractive as possible, so as to enable you to see its faults distinctly and to spend all your care and attention on correcting them.

However childish these details may appear to you, they

are of enormous importance, as I dare say you will find out
for yourself by comparing the work of a tidy, methodical
student with that of another lacking these qualities.

When you have obtained the action of your figure-sketch
to your satisfaction, and the correct proportions, you must
try to invest its forms with the character of the person you
are to represent, for it is clear that the forms of Heracles
will not be suitable for Apollo or Hermes. After that you
have to think of the head and the arrangement of the hair
—a subject which plays a great part in the style of a statue ;
there is nothing which will change the character of a head
more than the arrangement of the hair ; if it is done in bad
taste, it will invest the whole statue—however good it may
in other respects be—with vulgarity. On the other hand,
you may often see a nude statue of rather ordinary execution,
but where the hair and all the details introduced about it
have been done with such taste and care, that the otherwise
commonplace statue seems to have style and distinction.
The plinth is also of great importance ; its size should never
be more than necessary for the statue to rest on, the smaller
the plinth, the taller and more elegant the statue will appear ;
but if it is unnecessarily large it will detract from the appear-
ance of the statue, just as any other details on too big a
scale would do.

If a statue is to be draped, you can employ the same

means as for the relief study, *i.e.*, make on another armature
a copy of the nude sketch of the same size, or even some-
what larger, and then drape it with damp drapery. It is
more difficult to obtain a satisfactory arrangement of drapery
for a statue than for a relief, because it has to look well
all round, and the folds on one side must be as carefully
attended to as those on the other side; the chief lines of
the folds from the front, profile, and back have to be joined,
the principal masses have to be settled from every view,
and lastly the details.

If you proceed thus carefully in arranging the drapery,
there will be harmony and intelligence in the folds, because
one set of folds will spring from the other. But if you do
not trouble about the whole to begin with, and, having
found a pleasing arrangement for the front view, if you copy
that by itself and then proceed to make another arrange-
ment for the back and sides, your drapery will lack that
feeling of continuity which makes for harmony; there will
only be different sets of more or less pleasing folds, which
cannot have the clearness of expression that you obtain by
the other methods.

Another thing you have to avoid in making a statue is,
stretching out the limbs in equal movements, so that they
make angles of the same degree, especially right angles;
such geometrical figures round the body cannot lend elegance

to the composition, for they make the outline hard and take
away from its harmony and homogeneity. (See Fig. 124.)

In a kneeling figure you must
take care that it should not from
one point of view look like a
cripple without legs, see Fig. 125.
You have rather to contrive the
lines of your pose in such a way
that the spectator sees sufficient
of the legs from
every side to
prevent such an
idea rising in
his mind.

If your figure
should be posed
sitting or climb-
ing on a rock,

FIG. 124.—DIAGRAM SHOWING
ANGULAR POSE OF THE LIMBS.

you must not give too much importance
to the rock by making it too big, see Fig.
126, else your figure would look like a toy
on the rock and lose its sculptural aspect ;
you must rather reduce the rock to the
minimum of what is necessary to give the figure a solid
footing or seat. In short, everything about a statue in the

FIG. 125.—DIAGRAM
OF A KNEELING
FIGURE, GIVING
THE APPEARANCE
OF A CRIPPLE.

round which is not the figure itself should be considered as a detail and not to be made much of, but should nevertheless be executed in good taste.

The action for a single figure as well as for a group in sculpture is suggested to the artist, or perhaps I should say limited, by the purely material necessities of his art; he has to vary them with the different materials employed in sculpture.

Before I start on the subject of composition of groups, I must say a few words on these different materials and on the action and gesture they permit.

There are four materials principally employed in sculpture: Wood, Marble, Bronze, and Terracotta.

Fig. 126.—Diagram showing an Exaggerated Proportion of the Rock to the Figure.

Wood

Sculpture in wood is more suitable for gesture than in stone and marble. A fibrous, compact, and comparatively light substance, wood has more power of bearing than stone and

marble, and consequently it can be projected further. The limbs of a figure carved in oak, cedar, or walnut, when stretched out from the body, do not run the risk of breaking with their own weight. A lively and expanded gesture, which would be impossible in marble, is quite possible and tolerable in wood-carving, where it will cause no uneasy feeling to mind and eye.

Although wood-carving has been and is still applied to large figures, it is really more suitable for work of smaller dimensions which can be carved out of one piece. In any case it is for interior decoration, sheltered from the inclemency of the weather, that one should employ a material which is liable to split. Besides being liable to the risk of being consumed by fire and eaten by worms, wood cannot promise the artist a long duration, that is, a duration in proportion to the time, patience, and skill spent on and required by the material, for the practice of wood-carving is not learnt as quickly as that of marble-carving, it requires much greater skill in the handling of tools.

MARBLE

Of all the materials employed in sculpture, marble is the least suitable for violent action, and the simple, almost solemn, attitudes which the Greek sculptors gave to their statues were advised by the weight of the material.

For this very reason marble is very well suited for sculpture, as it compels the artist to observe a tranquillity of line and severity of outline favourable to the grand style, by rendering bold action and violent gesture impossible.

Thus it is needful for a sculptor to be quiet and grave when he works for marble, but this restraint imposed on his genius will turn out an advantage.

Sculpture in marble, on account of its robust and masculine simplicity, might be called the Doric order of Statuary. Its movement should be concentric, not eccentric.

BRONZE

Before speaking of what is permissible in bronze, I will try to give you a summary sketch of bronze-casting, which may make it easier for you to understand its possibilities as a medium for the expression of your ideas.

The art of bronze-casting, which goes back to very ancient times, as bronze was known before iron, was brought to high perfection by the Greeks.

Within recent years the method of casting bronze in sand-moulds, which had been used for a century, has largely given way to the older so-called " à cire perdue " process, where the wax model is melted out of the complete mould, and which is now even applied to colossal statues.

The sculptor who wishes to have his clay model repro-

duced in bronze must first cast it in plaster of Paris. From the plaster statue a new mould must be taken, either a piece-mould in plaster of Paris or a gelatine-mould. The latter process saves to a large extent the retouching on the wax cast, as there is but one seam instead of the numerous seams of a piece-mould. The new mould is then, by means of a brush, covered with layers of a liquid wax composition until the desired thickness has been obtained, for you must bear in mind that the place ot the wax will afterwards be taken by the bronze. When the pieces of the mould covered with wax have been joined, they are tied round with iron strips, and through an opening left at the bottom a liquid mixture, consisting of powdered brick and plaster, is poured into the mould to fill it completely and form the core for the bronze. In larger work it is necessary to have an iron armature inside the core to give support to the bronze. This core will adhere closely to the wax when hardened, so that when the iron bands, the plaster-shell, and the gelatine-mould are taken off, the statue sup-ported by the core stands before you in wax. This is the moment when the sculptor has to repair any damage wrought in places during the casting process, especially where the mould has left seams at the joints.

When the wax model has been touched up, it becomes necessary to insert small rods of bronze through the wax

into the core, and to let them stand out in order to join the outer mould to the core and to sustain the latter in place when the wax form has been melted. The bronze-caster also puts in a few ducts for the outflow of the wax which does not get absorbed by the mould and core, and in various places vents or ducts for the escape of air during the casting process, and lastly the "ingates" through which the liquid metal is to flow into the mould. Then the figure is covered by a carefully prepared liquid mixture of clay, pounded brick, and plaster, laid on in several layers so as to form a strong outer shell. It is a process that takes time and cannot be hurried, as any air-bubbles or any hidden place left uncovered will prove damaging to the work. When thoroughly dry the whole is placed in the casting-pit, and through the application of continuous heat the wax is melted and driven out through the prepared canals, but part of it gets absorbed by the mould and core, and helps to strengthen them. I believe the bronze-caster can calculate the proportion that ought to flow out, and thus be quite sure that every particle of wax has left the space which is to be filled with bronze.

When everything has been prepared and the precautions that practice suggests have been taken, the liquid metal is poured into the mould, and, if no accidents happen, it will rise gradually and fill every space of the mould.

How exciting and what anxious work the casting itself is has been most dramatically described by Benvenuto Cellini when he cast his statue of Perseus.

When the metal has been cooled the outer shell is carefully broken off, the core is raked out, and the pieces of metal representing the ducts and any other unevennesses are removed. Then the sculptor sees his work transformed into an enduring material before him.

Do not imagine that this superficial description is meant to instruct you in bronze-casting or to invite you to try it yourself. My only object in sketching the process is to explain to you how the laws governing movement in sculpture are modified by the nature of the material. A bronze statue is, indeed, comparatively light, although modern bronze-casters do not economise the material in the same degree as the ancients did, and this possibility of lightness permits the artist to have figures with outstretched limbs and flowing draperies which could not be done in marble. It permits him to lighten the weight in these overhanging parts by having a thinner coat of wax in their place in the mould, and, again, to increase the weight at the bottom to better support the superstructure. Bold poses and actions may be attempted in bronze without exciting anxiety so long as the laws of gravity and the dignity of art are respected.

TERRACOTTA

The word means fired clay, but it is also applied to the unburnt clay. The use of burnt clay has not been restricted to the potters of antiquity, but was well known to the sculptor in very ancient times, and works which have been found in Egyptian tombs of the earliest times in Etruscan and Greek excavations prove that this branch of art is as old as that of the potter.

In the middle ages terracotta was not much used; large statues that were not executed in stone or metal were formed in stucco and painted, but from the fifteenth century downwards great artists have not disdained to leave us their work in terracotta. I only mention here the beautiful portrait busts of which you find examples in the South Kensington Museum and the enamelled terracottas of the della Robbias. Though the art declined in the seventeenth and eighteenth centuries, the latter half of the nineteenth century saw a revival of it, and it is much to be hoped that terracotta will gradually take the place of the much less durable plaster in architectural decoration.

Terracotta statues are generally produced in the following manner. The clay model is cast in plaster in the same way as for reproduction in marble or bronze, and on this plaster-cast a piece-mould is made, consisting of numerous pieces

which can be drawn out of the deep and under-cut parts
of the model without damaging it or each other, and which
are one and a half to two inches thick. At the back of
each piece a mark is made by gouging out a hole about
half an inch deep, and when the front of the statue has been
covered with pieces, they are brushed over with soap or
clay-water and covered by a uniform layer of plaster about
two inches thick strengthened with pieces of iron. Having
thus moulded the front part, you go on to the moulding of
the back of your statue, and proceed in the same way, only
instead of enclosing the back pieces in one large shell of
plaster you make four or five of them. Then take the outer
shell off the front, and draw all the small pieces off the
statue, beginning with the last piece, and putting them care-
fully in their places in the shell, which you will easily find
owing to the gouged-out holes, which represent raised points
in the shell. You do the same with the other pieces at the
back, and put each small piece in place in the outer shell.
This constitutes a piece-mould.

The mould is then dusted over with French chalk to
prevent the clay from adhering, and then carefully prepared
clay, rather harder than it is used for modelling purposes,
is pressed or squeezed into the piece-mould, beginning
with the front of the statue. Care is taken to make this
layer of clay of an even thickness, so that in drying the

shrinkage shall be everywhere the same and no cracks occur.

The front half being finished you go on to the back, and begin with the part containing the head ; when that is finished you join it at once to the front, and put your hand inside to press the clay of the front and back pieces carefully together so that they form one mass. In the same way the succeeding pieces are treated, and when all the parts are joined, strong cords are put round the outer shell, and the clay is left to settle and get firm in the mould for a day or longer. After that the mould, which was hitherto in a horizontal position, is raised to the vertical, the cords undone, the outer shell of the front is taken off, and the pieces of the mould are carefully drawn off and at once replaced in the shell for further use. The back is treated in the same way, but a few pieces at the base are left as support, in case the clay should not be firm enough to support the weight of the upper portion. Where the mould has been taken off the work must be retouched, the seams must be taken off, and a touch here and there will give freshness to the work. Of course this ought to be done at once before the clay gets too hard, for it is not advisable to damp the surface again, as the moisture would run down and impair its solidity at the base. The work of taking a piece-mould from a relief is the same,

but much simpler, as one shell is sufficient to enclose all the pieces.

A good number of proofs may be taken out of the same piece-mould, and the proofs are put carefully away for months to dry before they are committed to the kiln for firing. Through the action of firing they become as hard as marble, and better fitted than marble to withstand the damaging influence of our treacherous climate.

The shrinkage during drying and firing is about one in thirteen, which explains to you why work intended for firing cannot be supported by an iron or wooden framework inside; the latter would remain rigidly the same, and would cause the clay to crack and break when it shrinks.

Apart from this process, sculptors occasionally venture to have small sketches fired without having recourse to the above rather expensive process. There is a charm in the idea of preserving an original clay-sketch, inspired and worked with feverish haste, being quite spontaneous in design and execution. But even such sketches must submit to the laws of gravity and the fragility of the material. You will occasionally find it advisable to cut off an outstretched arm or a flowing drapery, to mould and squeeze it separately, and fix it after firing by means of plaster and inserted wires.

I have given you only a very general description of the process of making terracotta reproductions, in order to enable

you to understand what is permissible in the material. There
are a great number of details which no description of mine
could teach you, and into which only practice under a skilled
moulder and caster can initiate you.

COMPOSITION OF GROUPS

A group in the terms of sculpture means an assemblage
of figures united by a common motive or a common action,
and so close together that the eye can take them in all at
once, and thus perceive the effect which the artist has
intended.

It is action which gives life to Art; its object is the
representation of the human passions and the action of the
human will, so as to appeal to the eye and the emotion of
the spectator.

But the passions and actions of men do not usually reveal
themselves in remote solitude. A forced action in a single
figure borders on madness, and is as rare as its representation
in sculpture would be insipid.

Laocōon as a single figure dying in the terrible coils of
the snake would not call forth our pity to the same extent
as the group where his young children are joined with their
father in the death-struggle with the monsters.

In the conception of a group the sculptor takes a step

which brings him nearer to low-relief. In whatever material the group is to be executed, the artist is allowed to depict more movement than in a single figure ; not only because, by the arrangement of the figures he can find combinations of lines and poses which may serve as points of support to the figure whose action is more developed, but also because a violent action will be justified by the presence of another figure of the group.

A group of two, if both figures are to be standing, is certainly one of the most difficult tasks in sculpture. If the subject, to be clearly understood, demands that both personages shall face the spectator, the back view of the group cannot be very interesting, being without the two principal factors of expression, the faces ; there will only be two backs to be seen, and the front must necessarily show the only interesting view. This is only one of the rocks to be avoided, but there are a good many others, for the law which rules the single-figure composition, namely, that it should be interesting from every side, obtains also for the group of two or more figures, and therefore it is obvious that you must avoid evident repetition of forms and lines.

A difference between the two figures in sex, age, or height is a great help towards this, and the contrast between the nude and drapery may also help to break the monotony ; the placing of the figures at different heights at the base

will supply another *motif* of outline and happier grouping, than if both figures were placed on the same level. If the subject permits it, an accentuated movement will contrast with a quieter, more dignified one ; in short, more than anywhere

FIG. 127.—DIAGRAM SHOWING APPARENT CUTTING OFF
OF THE BACK FIGURE.

else, this is the occasion where contrast must be used to avoid the monotony to which a group of two is liable.

The difficulty will be lessened if one of the figures is seated or reclining, and then again, it may not be possible to see from the front view the legs of the figure that is behind the reclining one (see Fig. 127), and from the back the sitting figure may not be visible. In short, there are endless

difficulties, and I have just mentioned a few because "fore-warned is forearmed."

There is plenty of scope here for your individual taste to try and find combinations which will avoid these pitfalls. My own opinion about groups of two figures is that they should be placed in front of a wall, in fact, that they should form part of its decoration, so that all the sculptor's energy could be spent on the front view, and that it might be composed as a high-relief.

It is easier to give to the composition an aspect of roundness when you have to make a group of three figures in which there are differences of age or height. If they are placed at different heights on the plinth the composition of lines is less constrained, and there is less risk of repetition in the views. Still, here also you must avoid concentrating in one point of view what will explain the subject : the latter must be comprehensible from all sides.

When the general conception of a group of several figures is ready in your brain and imagination, make a first small sketch from about six to eight inches high. Throw a lump of clay on your stand, and knock it into the general shape that you have conceived, without first troubling much about the movement of each figure (as a composer would hum the melody and not trouble about the orchestration in his first sketch). Look out rather for the planes of contrast of

FIG. 128A.—THE SAME, A LITTLE MORE
ADVANCED.

FIG. 128.—PREPARATORY SKETCH FOR A COMPOSITION
CARVED OUT OF A BLOCK OF CLAY.

which your first plan is capable; then mark with small balls of clay the position of the heads of the various figures to indicate the places whence the movement may develop. Draw this by its chief lines in the planes which you have discovered first, then the arms and legs will find their place. (See Figs. 128 and 128A.)

By thus evolving your composition out of a lump of clay the group becomes more compact, it has a sculptural quality which it would not have if the figures were modelled separately and then grouped. The latter proceeding does not give brilliant results, and I have seen groups of three figures, where the six legs looked like six posts supporting three unhappy torsos. You will at least avoid that by starting your sketch with a solid mass of clay and avoiding unnecessary perforations. Michel Angelo has laid down the rule that a group should be so compactly composed that, if it is rolled down a hill, none of the limbs would break off, and he was certainly right in principle, although the formula sounds daring.

When the indication of planes and their combinations suggests the movement, you must examine how far this agrees with the feeling that each of the personages is to express. It is here even more necessary than in a relief that unity should prevail, not only in the *ensemble* of the composition, but also in the expression and gesture of the figures. The

famous actor Garrick, in commenting on the acting of a friend, who played the part of a drunken man, reproved him by saying that his head was completely drunk, but that his arms and legs were quite capable—thus insisting on unity in gesture. In fact, an enraged man, who is ready to fight, will not simply express his fury in his face : his whole body will show the preparation for the fight, his tendons will be strained for attack or resistance, his muscles will quiver with excitement, his attitude will correspond with the emotion that possesses him. A despairing man, on the other hand, who has lost courage, will appear as if all vital force had left him, his pose, his limbs will seem uncontrolled, his muscles slack, in short, everything will express his state of mind. So you must observe it is not the head alone which expresses this or that feeling, but the whole figure.

You should always be thoroughly imbued with the feeling you want to express and to excite in the spectator, and I repeat what I have insisted on before, you should try conscientiously to act the part of the man you want to represent, to make yourself well acquainted with him by reading, and to try to realise with your mental eye the scenes you read of in poetry.

When you are satisfied with the general effect of your small sketch, with its outline, its movement, and planes, it will be necessary to begin a second sketch in larger proportions,

Fig. 129.—Example of a Composition in the Round for a Garden.

EXAMPLE OF A COMPOSITION IN THE ROUND FOR A GARDEN.

EXAMPLE OF A COMPOSITION IN THE ROUND FOR A GARDEN.

in which you will in a more definite way fix the movement of each personage, trying at the same time to preserve the compact mass of the first sketch. When the movement is settled, the exact proportioning of the limbs will follow, and then you will proceed to the execution of the work in the way I have already described for composition in general.

I hope that these instructions will help you to overcome some of the innumerable difficulties which our Art presents to the beginner.

I intend to complete the series by another volume in which I shall treat of the modelling of animals, and of the different methods of enlargement of statues from small sketches, and of different armatures for colossal work, for equestrian statues, etc.

FINIS.

A CATALOG OF SELECTED
DOVER BOOKS
IN ALL FIELDS OF INTEREST

A CATALOG OF SELECTED DOVER BOOKS IN ALL FIELDS OF INTEREST

DRAWINGS OF REMBRANDT, edited by Seymour Slive. Updated Lippmann, Hofstede de Groot edition, with definitive scholarly apparatus. All portraits, biblical sketches, landscapes, nudes. Oriental figures, classical studies, together with selection of work by followers. 550 illustrations. Total of 630pp. 9⅜ × 12¼.
21485-0, 21486-9 Pa., Two-vol. set $25.00

GHOST AND HORROR STORIES OF AMBROSE BIERCE, Ambrose Bierce. 24 tales vividly imagined, strangely prophetic, and decades ahead of their time in technical skill: "The Damned Thing," "An Inhabitant of Carcosa," "The Eyes of the Panther," "Moxon's Master," and 20 more. 199pp. 5⅜ × 8½. 20767-6 Pa. $3.95

ETHICAL WRITINGS OF MAIMONIDES, Maimonides. Most significant ethical works of great medieval sage, newly translated for utmost precision, readability. Laws Concerning Character Traits, Eight Chapters, more. 192pp. 5⅜ × 8½.
24522-5 Pa. $4.50

THE EXPLORATION OF THE COLORADO RIVER AND ITS CANYONS, J. W. Powell. Full text of Powell's 1,000-mile expedition down the fabled Colorado in 1869. Superb account of terrain, geology, vegetation, Indians, famine, mutiny, treacherous rapids, mighty canyons, during exploration of last unknown part of continental U.S. 400pp. 5⅜ × 8½. 20094-9 Pa. $6.95

HISTORY OF PHILOSOPHY, Julián Marías. Clearest one-volume history on the market. Every major philosopher and dozens of others, to Existentialism and later. 505pp. 5⅜ × 8½. 21739-6 Pa. $9.95

ALL ABOUT LIGHTNING, Martin A. Uman. Highly readable non-technical survey of nature and causes of lightning, thunderstorms, ball lightning, St. Elmo's Fire, much more. Illustrated. 192pp. 5⅜ × 8½. 25237-X Pa. $5.95

SAILING ALONE AROUND THE WORLD, Captain Joshua Slocum. First man to sail around the world, alone, in small boat. One of great feats of seamanship told in delightful manner. 67 illustrations. 294pp. 5⅜ × 8½. 20326-3 Pa. $4.95

LETTERS AND NOTES ON THE MANNERS, CUSTOMS AND CONDITIONS OF THE NORTH AMERICAN INDIANS, George Catlin. Classic account of life among Plains Indians: ceremonies, hunt, warfare, etc. 312 plates. 572pp. of text. 6⅝ × 9¼. 22118-0, 22119-9 Pa. Two-vol. set $15.90

ALASKA: The Harriman Expedition, 1899, John Burroughs, John Muir, et al. Informative, engrossing accounts of two-month, 9,000-mile expedition. Native peoples, wildlife, forests, geography, salmon industry, glaciers, more. Profusely illustrated. 240 black-and-white line drawings. 124 black-and-white photographs. 3 maps. Index. 576pp. 5⅜ × 8½. 25109-8 Pa. $11.95

THE BOOK OF BEASTS: Being a Translation from a Latin Bestiary of the Twelfth Century, T. H. White. Wonderful catalog real and fanciful beasts: manticore, griffin, phoenix, amphivius, jaculus, many more. White's witty erudite commentary on scientific, historical aspects. Fascinating glimpse of medieval mind. Illustrated. 296pp. 5⅜ × 8¼. (Available in U.S. only)
24609-4 Pa. $5.95

FRANK LLOYD WRIGHT: ARCHITECTURE AND NATURE With 160 Illustrations, Donald Hoffmann. Profusely illustrated study of influence of nature—especially prairie—on Wright's designs for Fallingwater, Robie House, Guggenheim Museum, other masterpieces. 96pp. 9¼ × 10¾.
25098-6 Pa. $7.95

FRANK LLOYD WRIGHT'S FALLINGWATER, Donald Hoffmann. Wright's famous waterfall house: planning and construction of organic idea. History of site, owners, Wright's personal involvement. Photographs of various stages of building. Preface by Edgar Kaufmann, Jr. 100 illustrations. 112pp. 9¼ × 10.
23671-4 Pa. $7.95

YEARS WITH FRANK LLOYD WRIGHT: Apprentice to Genius, Edgar Tafel. Insightful memoir by a former apprentice presents a revealing portrait of Wright the man, the inspired teacher, the greatest American architect. 372 black-and-white illustrations. Preface. Index. vi + 228pp. 8¼ × 11.
24801-1 Pa. $9.95

THE STORY OF KING ARTHUR AND HIS KNIGHTS, Howard Pyle. Enchanting version of King Arthur fable has delighted generations with imaginative narratives of exciting adventures and unforgettable illustrations by the author. 41 illustrations. xviii + 313pp. 6⅛ × 9¼.
21445-1 Pa. $6.50

THE GODS OF THE EGYPTIANS, E. A. Wallis Budge. Thorough coverage of numerous gods of ancient Egypt by foremost Egyptologist. Information on evolution of cults, rites and gods; the cult of Osiris; the Book of the Dead and its rites; the sacred animals and birds; Heaven and Hell; and more. 956pp. 6⅝ × 9¼.
22055-9, 22056-7 Pa. Two-vol. set $21.90

A THEOLOGICO-POLITICAL TREATISE, Benedict Spinoza. Also contains unfinished *Political Treatise*. Great classic on religious liberty, theory of government on common consent. R. Elwes translation. Total of 421pp. 5⅜ × 8½.
20249-6 Pa. $6.95

INCIDENTS OF TRAVEL IN CENTRAL AMERICA, CHIAPAS, AND YU-CATAN, John L. Stephens. Almost single-handed discovery of Maya culture; exploration of ruined cities, monuments, temples; customs of Indians. 115 drawings. 892pp. 5⅜ × 8½.
22404-X, 22405-8 Pa. Two-vol. set $15.90

LOS CAPRICHOS, Francisco Goya. 80 plates of wild, grotesque monsters and caricatures. Prado manuscript included. 183pp. 6⅜ × 9⅜.
22384-1 Pa. $4.95

AUTOBIOGRAPHY: The Story of My Experiments with Truth, Mohandas K. Gandhi. Not hagiography, but Gandhi in his own words. Boyhood, legal studies, purification, the growth of the Satyagraha (nonviolent protest) movement. Critical, inspiring work of the man who freed India. 480pp. 5⅜ × 8½. (Available in U.S. only)
24593-4 Pa. $6.95

ILLUSTRATED DICTIONARY OF HISTORIC ARCHITECTURE, edited by Cyril M. Harris. Extraordinary compendium of clear, concise definitions for over 5,000 important architectural terms complemented by over 2,000 line drawings. Covers full spectrum of architecture from ancient ruins to 20th-century Modernism. Preface. 592pp. 7½ × 9¾. 24444-X Pa. $15.95

THE NIGHT BEFORE CHRISTMAS, Clement Moore. Full text, and woodcuts from original 1848 book. Also critical, historical material. 19 illustrations. 40pp. 4⅝ × 6. 22797-9 Pa. $2.50

THE LESSON OF JAPANESE ARCHITECTURE: 165 Photographs, Jiro Harada. Memorable gallery of 165 photographs taken in the 1930's of exquisite Japanese homes of the well-to-do and historic buildings. 13 line diagrams. 192pp. 8⅞ × 11¼. 24778-3 Pa. $8.95

THE AUTOBIOGRAPHY OF CHARLES DARWIN AND SELECTED LET-TERS, edited by Francis Darwin. The fascinating life of eccentric genius composed of an intimate memoir by Darwin (intended for his children); commentary by his son, Francis; hundreds of fragments from notebooks, journals, papers; and letters to and from Lyell, Hooker, Huxley, Wallace and Henslow. xi + 365pp. 5⅜ × 8. 20479-0 Pa. $6.95

WONDERS OF THE SKY: Observing Rainbows, Comets, Eclipses, the Stars and Other Phenomena, Fred Schaaf. Charming, easy-to-read poetic guide to all manner of celestial events visible to the naked eye. Mock suns, glories, Belt of Venus, more. Illustrated. 299pp. 5¼ × 8¼. 24402-4 Pa. $7.95

BURNHAM'S CELESTIAL HANDBOOK, Robert Burnham, Jr. Thorough guide to the stars beyond our solar system. Exhaustive treatment. Alphabetical by constellation: Andromeda to Cetus in Vol. 1; Chamaeleon to Orion in Vol. 2; and Pavo to Vulpecula in Vol. 3. Hundreds of illustrations. Index in Vol. 3. 2,000pp. 6⅛ × 9¼. 23567-X, 23568-8, 23673-0 Pa., Three-vol. set $38.85

STAR NAMES: Their Lore and Meaning, Richard Hinckley Allen. Fascinating history of names various cultures have given to constellations and literary and folkloristic uses that have been made of stars. Indexes to subjects. Arabic and Greek names. Biblical references. Bibliography. 563pp. 5⅜ × 8¼. 21079-0 Pa. $7.95

THIRTY YEARS THAT SHOOK PHYSICS: The Story of Quantum Theory, George Gamow. Lucid, accessible introduction to influential theory of energy and matter. Careful explanations of Dirac's anti-particles, Bohr's model of the atom, much more. 12 plates. Numerous drawings. 240pp. 5⅜ × 8¼. 24895-X Pa. $5.95

CHINESE DOMESTIC FURNITURE IN PHOTOGRAPHS AND MEASURED DRAWINGS, Gustav Ecke. A rare volume, now affordably priced for antique collectors, furniture buffs and art historians. Detailed review of styles ranging from early Shang to late Ming. Unabridged republication. 161 black-and-white draw-ings, photos. Total of 224pp. 8⅞ × 11¼. (Available in U.S. only) 25171-3 Pa. $12.95

VINCENT VAN GOGH: A Biography, Julius Meier-Graefe. Dynamic, penetrat-ing study of artist's life, relationship with brother, Theo, painting techniques, travels, more. Readable, engrossing. 160pp. 5⅜ × 8¼. (Available in U.S. only) 25253-1 Pa. $3.95

HOW TO WRITE, Gertrude Stein. Gertrude Stein claimed anyone could understand her unconventional writing—here are clues to help. Fascinating improvisations, language experiments, explanations illuminate Stein's craft and the art of writing. Total of 414pp. 4⅜ × 6¼. 23144-5 Pa. $5.95

ADVENTURES AT SEA IN THE GREAT AGE OF SAIL: Five Firsthand Narratives, edited by Elliot Snow. Rare true accounts of exploration, whaling, shipwreck, fierce natives, trade, shipboard life, more. 33 illustrations. Introduction. 353pp. 5⅜ × 8½. 25177-2 Pa. $7.95

THE HERBAL OR GENERAL HISTORY OF PLANTS, John Gerard. Classic descriptions of about 2,850 plants—with over 2,700 illustrations—includes Latin and English names, physical descriptions, varieties, time and place of growth, more. 2,706 illustrations. xiv + 1,678pp. 8½ × 12¼. 23147-X Cloth. $75.00

DOROTHY AND THE WIZARD IN OZ, L. Frank Baum. Dorothy and the Wizard visit the center of the Earth, where people are vegetables, glass houses grow and Oz characters reappear. Classic sequel to *Wizard of Oz.* 256pp. 5⅜ × 8. 24714-7 Pa. $4.95

SONGS OF EXPERIENCE: Facsimile Reproduction with 26 Plates in Full Color, William Blake. This facsimile of Blake's original ''Illuminated Book'' reproduces 26 full-color plates from a rare 1826 edition. Includes ''The Tyger,'' ''London,'' ''Holy Thursday,'' and other immortal poems. 26 color plates. Printed text of poems. 48pp. 5¼ × 7. 24636-1 Pa. $3.50

SONGS OF INNOCENCE, William Blake. The first and most popular of Blake's famous ''Illuminated Books,'' in a facsimile edition reproducing all 31 brightly colored plates. Additional printed text of each poem. 64pp. 5¼ × 7. 22764-2 Pa. $3.50

PRECIOUS STONES, Max Bauer. Classic, thorough study of diamonds, rubies, emeralds, garnets, etc.: physical character, occurrence, properties, use, similar topics. 20 plates, 8 in color. 94 figures. 659pp. 6⅛ × 9¼. 21910-0, 21911-9 Pa., Two-vol. set $15.90

ENCYCLOPEDIA OF VICTORIAN NEEDLEWORK, S. F. A. Caulfeild and Blanche Saward. Full, precise descriptions of stitches, techniques for dozens of needlecrafts—most exhaustive reference of its kind. Over 800 figures. Total of 679pp. 8¾ × 11. Two volumes.
Vol. 1 22800-2 Pa. $11.95
Vol. 2 22801-0 Pa. $11.95

THE MARVELOUS LAND OF OZ, L. Frank Baum. Second Oz book, the Scarecrow and Tin Woodman are back with hero named Tip, Oz magic. 136 illustrations. 287pp. 5⅜ × 8½. 20692-0 Pa. $5.95

WILD FOWL DECOYS, Joel Barber. Basic book on the subject, by foremost authority and collector. Reveals history of decoy making and rigging, place in American culture, different kinds of decoys, how to make them, and how to use them. 140 plates. 156pp. 7⅞ × 10¾. 20011-6 Pa. $8.95

HISTORY OF LACE, Mrs. Bury Palliser. Definitive, profusely illustrated chronicle of lace from earliest times to late 19th century. Laces of Italy, Greece, England, France, Belgium, etc. Landmark of needlework scholarship. 266 illustrations. 672pp. 6⅛ × 9¼. 24742-2 Pa. $14.95

ILLUSTRATED GUIDE TO SHAKER FURNITURE, Robert Meader. All furniture and appurtenances, with much on unknown local styles. 235 photos. 146pp. 9 × 12. 22819-3 Pa. $7.95

WHALE SHIPS AND WHALING: A Pictorial Survey, George Francis Dow. Over 200 vintage engravings, drawings, photographs of barks, brigs, cutters, other vessels. Also harpoons, lances, whaling guns, many other artifacts. Comprehensive text by foremost authority. 207 black-and-white illustrations. 288pp. 6 × 9. 24808-9 Pa. $8.95

THE BERTRAMS, Anthony Trollope. Powerful portrayal of blind self-will and thwarted ambition includes one of Trollope's most heartrending love stories. 497pp. 5⅜ × 8½. 25119-5 Pa. $9.95

ADVENTURES WITH A HAND LENS, Richard Headstrom. Clearly written guide to observing and studying flowers and grasses, fish scales, moth and insect wings, egg cases, buds, feathers, seeds, leaf scars, moss, molds, ferns, common crystals, etc.—all with an ordinary, inexpensive magnifying glass. 209 exact line drawings aid in your discoveries. 220pp. 5⅜ × 8½. 23330-8 Pa. $4.95

RODIN ON ART AND ARTISTS, Auguste Rodin. Great sculptor's candid, wide-ranging comments on meaning of art, great artists; relation of sculpture to poetry, painting, music; philosophy of life, more. 76 superb black-and-white illustrations of Rodin's sculpture, drawings and prints. 119pp. 8⅜ × 11¼. 24487-3 Pa. $6.95

FIFTY CLASSIC FRENCH FILMS, 1912–1982: A Pictorial Record, Anthony Slide. Memorable stills from Grand Illusion, Beauty and the Beast, Hiroshima, Mon Amour, many more. Credits, plot synopses, reviews, etc. 160pp. 8⅜ × 11. 25256-6 Pa. $11.95

THE PRINCIPLES OF PSYCHOLOGY, William James. Famous long course complete, unabridged. Stream of thought, time perception, memory, experimental methods; great work decades ahead of its time. 94 figures. 1,391pp. 5⅜ × 8½. 20381-6, 20382-4 Pa., Two-vol. set $23.90

BODIES IN A BOOKSHOP, R. T. Campbell. Challenging mystery of blackmail and murder with ingenious plot and superbly drawn characters. In the best tradition of British suspense fiction. 192pp. 5⅜ × 8½. 24720-1 Pa. $3.95

CALLAS: PORTRAIT OF A PRIMA DONNA, George Jellinek. Renowned commentator on the musical scene chronicles incredible career and life of the most controversial, fascinating, influential operatic personality of our time. 64 black-and-white photographs. 416pp. 5⅜ × 8½. 25047-4 Pa. $8.95

GEOMETRY, RELATIVITY AND THE FOURTH DIMENSION, Rudolph Rucker. Exposition of fourth dimension, concepts of relativity as Flatland characters continue adventures. Popular, easily followed yet accurate, profound. 141 illustrations. 133pp. 5⅜ × 8½. 23400-2 Pa. $3.95

HOUSEHOLD STORIES BY THE BROTHERS GRIMM, with pictures by Walter Crane. 53 classic stories—Rumpelstilskin, Rapunzel, Hansel and Gretel, the Fisherman and his Wife, Snow White, Tom Thumb, Sleeping Beauty, Cinderella, and so much more—lavishly illustrated with original 19th century drawings. 114 illustrations. x + 269pp. 5⅜ × 8½. 21080-4 Pa. $4.95

SUNDIALS, Albert Waugh. Far and away the best, most thorough coverage of ideas, mathematics concerned, types, construction, adjusting anywhere. Over 100 illustrations. 230pp. 5⅜ × 8½. 22947-5 Pa. $4.95

PICTURE HISTORY OF THE NORMANDIE: With 190 Illustrations, Frank O. Braynard. Full story of legendary French ocean liner: Art Deco interiors, design innovations, furnishings, celebrities, maiden voyage, tragic fire, much more. Extensive text. 144pp. 8⅜ × 11¼. 25257-4 Pa. $9.95

THE FIRST AMERICAN COOKBOOK: A Facsimile of "American Cookery," 1796, Amelia Simmons. Facsimile of the first American-written cookbook published in the United States contains authentic recipes for colonial favorites—pumpkin pudding, winter squash pudding, spruce beer, Indian slapjacks, and more. Introductory Essay and Glossary of colonial cooking terms. 80pp. 5⅜ × 8½. 24710-4 Pa. $3.50

101 PUZZLES IN THOUGHT AND LOGIC, C. R. Wylie, Jr. Solve murders and robberies, find out which fishermen are liars, how a blind man could possibly identify a color—purely by your own reasoning! 107pp. 5⅜ × 8½. 20367-0 Pa. $2.50

THE BOOK OF WORLD-FAMOUS MUSIC—CLASSICAL, POPULAR AND FOLK, James J. Fuld. Revised and enlarged republication of landmark work in musico-bibliography. Full information about nearly 1,000 songs and compositions including first lines of music and lyrics. New supplement. Index. 800pp. 5⅜ × 8½. 24857-7 Pa. $14.95

ANTHROPOLOGY AND MODERN LIFE, Franz Boas. Great anthropologist's classic treatise on race and culture. Introduction by Ruth Bunzel. Only inexpensive paperback edition. 255pp. 5⅜ × 8½. 25245-0 Pa. $5.95

THE TALE OF PETER RABBIT, Beatrix Potter. The inimitable Peter's terrifying adventure in Mr. McGregor's garden, with all 27 wonderful, full-color Potter illustrations. 55pp. 4¼ × 5½. (Available in U.S. only) 22827-4 Pa. $1.75

THREE PROPHETIC SCIENCE FICTION NOVELS, H. G. Wells. *When the Sleeper Wakes, A Story of the Days to Come* and *The Time Machine* (full version). 335pp. 5⅜ × 8½. (Available in U.S. only) 20605-X Pa. $6.95

APICIUS COOKERY AND DINING IN IMPERIAL ROME, edited and translated by Joseph Dommers Vehling. Oldest known cookbook in existence offers readers a clear picture of what foods Romans ate, how they prepared them, etc. 49 illustrations. 301pp. 6⅝ × 9¼. 23563-7 Pa. $7.95

SHAKESPEARE LEXICON AND QUOTATION DICTIONARY, Alexander Schmidt. Full definitions, locations, shades of meaning of every word in plays and poems. More than 50,000 exact quotations. 1,485pp. 6½ × 9¼. 22726-X, 22727-8 Pa., Two-vol. set $29.90

THE WORLD'S GREAT SPEECHES, edited by Lewis Copeland and Lawrence W. Lamm. Vast collection of 278 speeches from Greeks to 1970. Powerful and effective models; unique look at history. 842pp. 5⅜ × 8½. 20468-5 Pa. $11.95

THE BLUE FAIRY BOOK, Andrew Lang. The first, most famous collection, with many familiar tales: Little Red Riding Hood, Aladdin and the Wonderful Lamp, Puss in Boots, Sleeping Beauty, Hansel and Gretel, Rumpelstiltskin; 37 in all. 138 illustrations. 390pp. 5⅜ × 8½. 21437-0 Pa. $6.95

THE STORY OF THE CHAMPIONS OF THE ROUND TABLE, Howard Pyle. Sir Launcelot, Sir Tristram and Sir Percival in spirited adventures of love and triumph retold in Pyle's inimitable style. 50 drawings, 31 full-page. xviii + 329pp. 6½ × 9¼. 21883-X Pa. $6.95

AUDUBON AND HIS JOURNALS, Maria Audubon. Unmatched two-volume portrait of the great artist, naturalist and author contains his journals, an excellent biography by his granddaughter, expert annotations by the noted ornithologist, Dr. Elliott Coues, and 37 superb illustrations. Total of 1,200pp. 5⅜ × 8.

Vol. I 25143-8 Pa. $8.95
Vol. II 25144-6 Pa. $8.95

GREAT DINOSAUR HUNTERS AND THEIR DISCOVERIES, Edwin H. Colbert. Fascinating, lavishly illustrated chronicle of dinosaur research, 1820's to 1960. Achievements of Cope, Marsh, Brown, Buckland, Mantell, Huxley, many others. 384pp. 5⅜ × 8½. 24701-5 Pa. $7.95

THE TASTEMAKERS, Russell Lynes. Informal, illustrated social history of American taste 1850's-1950's. First popularized categories Highbrow, Lowbrow, Middlebrow. 129 illustrations. New (1979) afterword. 384pp. 6 × 9. 23993-4 Pa. $8.95

DOUBLE CROSS PURPOSES, Ronald A. Knox. A treasure hunt in the Scottish Highlands, an old map, unidentified corpse, surprise discoveries keep reader guessing in this cleverly intricate tale of financial skullduggery. 2 black-and-white maps. 320pp. 5⅜ × 8½. (Available in U.S. only) 25032-6 Pa. $5.95

AUTHENTIC VICTORIAN DECORATION AND ORNAMENTATION IN FULL COLOR: 46 Plates from "Studies in Design," Christopher Dresser. Superb full-color lithographs reproduced from rare original portfolio of a major Victorian designer. 48pp. 9¼ × 12¼. 25083-0 Pa. $7.95

PRIMITIVE ART, Franz Boas. Remains the best text ever prepared on subject, thoroughly discussing Indian, African, Asian, Australian and, especially, Northern American primitive art. Over 950 illustrations show ceramics, masks, totem poles, weapons, textiles, paintings, much more. 376pp. 5⅜ × 8. 20025-6 Pa. $6.95

SIDELIGHTS ON RELATIVITY, Albert Einstein. Unabridged republication of two lectures delivered by the great physicist in 1920-21. *Ether and Relativity* and *Geometry and Experience*. Elegant ideas in non-mathematical form, accessible to intelligent layman. vi + 56pp. 5⅜ × 8½. 24511-X Pa. $2.95

THE WIT AND HUMOR OF OSCAR WILDE, edited by Alvin Redman. More than 1,000 ripostes, paradoxes, wisecracks: Work is the curse of the drinking classes, I can resist everything except temptation, etc. 258pp. 5⅜ × 8½. 20602-5 Pa. $4.50

ADVENTURES WITH A MICROSCOPE, Richard Headstrom. 59 adventures with clothing fibers, protozoa, ferns and lichens, roots and leaves, much more. 142 illustrations. 232pp. 5⅜ × 8½. 23471-1 Pa. $3.95

PLANTS OF THE BIBLE, Harold N. Moldenke and Alma L. Moldenke. Standard reference to all 230 plants mentioned in Scriptures. Latin name, biblical reference, uses, modern identity, much more. Unsurpassed encyclopedic resource for scholars, botanists, nature lovers, students of Bible. Bibliography. Indexes. 123 black-and-white illustrations. 384pp. 6 × 9. 25069-5 Pa. $8.95

FAMOUS AMERICAN WOMEN: A Biographical Dictionary from Colonial Times to the Present, Robert McHenry, ed. From Pocahontas to Rosa Parks, 1,035 distinguished American women documented in separate biographical entries. Accurate, up-to-date data, numerous categories, spans 400 years. Indices. 493pp. 6¼ × 9. 24523-3 Pa. $9.95

THE FABULOUS INTERIORS OF THE GREAT OCEAN LINERS IN HIS-TORIC PHOTOGRAPHS, William H. Miller, Jr. Some 200 superb photographs capture exquisite interiors of world's great "floating palaces"—1890's to 1980's: *Titanic, Ile de France, Queen Elizabeth, United States, Europa,* more. Approx. 200 black-and-white photographs. Captions. Text. Introduction. 160pp. 8⅜ × 11¼. 24756-2 Pa. $9.95

THE GREAT LUXURY LINERS, 1927-1954: A Photographic Record, William H. Miller, Jr. Nostalgic tribute to heyday of ocean liners. 186 photos of Ile de France, Normandie, Leviathan, Queen Elizabeth, United States, many others. Interior and exterior views. Introduction. Captions. 160pp. 9 × 12. 24056-8 Pa. $10.95

A NATURAL HISTORY OF THE DUCKS, John Charles Phillips. Great landmark of ornithology offers complete detailed coverage of nearly 200 species and subspecies of ducks: gadwall, sheldrake, merganser, pintail, many more. 74 full-color plates, 102 black-and-white. Bibliography. Total of 1,920pp. 8⅜ × 11¼. 25141-1, 25142-X Cloth. Two-vol. set $100.00

THE SEAWEED HANDBOOK: An Illustrated Guide to Seaweeds from North Carolina to Canada, Thomas F. Lee. Concise reference covers 78 species. Scientific and common names, habitat, distribution, more. Finding keys for easy identification. 224pp. 5⅜ × 8½. 25215-9 Pa. $5.95

THE TEN BOOKS OF ARCHITECTURE: The 1755 Leoni Edition, Leon Battista Alberti. Rare classic helped introduce the glories of ancient architecture to the Renaissance. 68 black-and-white plates. 336pp. 8⅜ × 11¼. 25239-6 Pa. $14.95

MISS MACKENZIE, Anthony Trollope. Minor masterpieces by Victorian master unmasks many truths about life in 19th-century England. First inexpensive edition in years. 392pp. 5⅜ × 8½. 25201-9 Pa. $7.95

THE RIME OF THE ANCIENT MARINER, Gustave Doré, Samuel Taylor Coleridge. Dramatic engravings considered by many to be his greatest work. The terrifying space of the open sea, the storms and whirlpools of an unknown ocean, the ice of Antarctica, more—all rendered in a powerful, chilling manner. Full text. 38 plates. 77pp. 9¼ × 12. 22305-1 Pa. $4.95

THE EXPEDITIONS OF ZEBULON MONTGOMERY PIKE, Zebulon Montgomery Pike. Fascinating first-hand accounts (1805-6) of exploration of Mississippi River, Indian wars, capture by Spanish dragoons, much more. 1,088pp. 5⅜ × 8½. 25254-X, 25255-8 Pa. Two-vol. set $23.90

A CONCISE HISTORY OF PHOTOGRAPHY: Third Revised Edition, Helmut Gernsheim. Best one-volume history—camera obscura, photochemistry, daguer-reotypes, evolution of cameras, film, more. Also artistic aspects—landscape, portraits, fine art, etc. 281 black-and-white photographs. 26 in color. 176pp. 8⅜ × 11¼. 25128-4 Pa. $13.95

THE DORÉ BIBLE ILLUSTRATIONS, Gustave Doré. 241 detailed plates from the Bible: the Creation scenes, Adam and Eve, Flood, Babylon, battle sequences, life of Jesus, etc. Each plate is accompanied by the verses from the King James version of the Bible. 241pp. 9 × 12. 23004-X Pa. $8.95

HUGGER-MUGGER IN THE LOUVRE, Elliot Paul. Second Homer Evans mystery-comedy. Theft at the Louvre involves sleuth in hilarious, madcap caper. "A knockout."—Books. 336pp. 5⅜ × 8½. 25185-3 Pa. $5.95

FLATLAND, E. A. Abbott. Intriguing and enormously popular science-fiction classic explores the complexities of trying to survive as a two-dimensional being in a three-dimensional world. Amusingly illustrated by the author. 16 illustrations. 103pp. 5⅜ × 8½. 20001-9 Pa. $2.25

THE HISTORY OF THE LEWIS AND CLARK EXPEDITION, Meriwether Lewis and William Clark, edited by Elliot Coues. Classic edition of Lewis and Clark's day-by-day journals that later became the basis for U.S. claims to Oregon and the West. Accurate and invaluable geographical, botanical, biological, meteorological and anthropological material. Total of 1,508pp. 5⅜ × 8½. 21268-8, 21269-6, 21270-X Pa. Three-vol. set $26.85

LANGUAGE, TRUTH AND LOGIC, Alfred J. Ayer. Famous, clear introduction to Vienna, Cambridge schools of Logical Positivism. Role of philosophy, elimination of metaphysics, nature of analysis, etc. 160pp. 5⅜ × 8½. (Available in U.S. and Canada only) 20010-8 Pa. $2.95

MATHEMATICS FOR THE NONMATHEMATICIAN, Morris Kline. Detailed, college-level treatment of mathematics in cultural and historical context, with numerous exercises. For liberal arts students. Preface. Recommended Reading Lists. Tables. Index. Numerous black-and-white figures. xvi + 641pp. 5⅜ × 8½. 24823-2 Pa. $11.95

28 SCIENCE FICTION STORIES, H. G. Wells. Novels, *Star Begotten* and *Men Like Gods*, plus 26 short stories: "Empire of the Ants," "A Story of the Stone Age," "The Stolen Bacillus," "In the Abyss," etc. 915pp. 5⅜ × 8½. (Available in U.S. only) 20265-8 Cloth. $10.95

HANDBOOK OF PICTORIAL SYMBOLS, Rudolph Modley. 3,250 signs and symbols, many systems in full: official or heavy commercial use. Arranged by subject. Most in Pictorial Archive series. 143pp. 8⅜ × 11. 23357-X Pa. $6.95

INCIDENTS OF TRAVEL IN YUCATAN, John L. Stephens. Classic (1843) exploration of jungles of Yucatan, looking for evidences of Maya civilization. Travel adventures, Mexican and Indian culture, etc. Total of 669pp. 5⅜ × 8½. 20926-1, 20927-X Pa. Two-vol. set $9.90

CATALOG OF DOVER BOOKS

DEGAS: An Intimate Portrait, Ambroise Vollard. Charming, anecdotal memoir by famous art dealer of one of the greatest 19th-century French painters. 14 black-and-white illustrations. Introduction by Harold L. Van Doren. 96pp. 5⅜ x 8½.
25131-4 Pa. $3.95

PERSONAL NARRATIVE OF A PILGRIMAGE TO ALMADINAH AND MECCAH, Richard Burton. Great travel classic by remarkably colorful personality. Burton, disguised as a Moroccan, visited sacred shrines of Islam, narrowly escaping death. 47 illustrations. 959pp. 5⅜ x 8½. 21217-3, 21218-1 Pa., Two-vol. set $19.90

PHRASE AND WORD ORIGINS, A. H. Holt. Entertaining, reliable, modern study of more than 1,200 colorful words, phrases, origins and histories. Much unexpected information. 254pp. 5⅜ x 8½. 20758-7 Pa. $5.95

THE RED THUMB MARK, R. Austin Freeman. In this first Dr. Thorndyke case, the great scientific detective draws fascinating conclusions from the nature of a single fingerprint. Exciting story, authentic science. 320pp. 5⅜ x 8½. (Available in U.S. only) 25210-8 Pa. $5.95

AN EGYPTIAN HIEROGLYPHIC DICTIONARY, E. A. Wallis Budge. Monumental work containing about 25,000 words or terms that occur in texts ranging from 3000 B.C. to 600 A.D. Each entry consists of a transliteration of the word, the word in hieroglyphs, and the meaning in English. 1,314pp. 6⅜ x 10. 23615-3, 23616-1 Pa., Two-vol. set $31.90

THE COMPLEAT STRATEGYST: Being a Primer on the Theory of Games of Strategy, J. D. Williams. Highly entertaining classic describes, with many illustrated examples, how to select best strategies in conflict situations. Prefaces. Appendices. xvi + 268pp. 5⅜ x 8½. 25101-2 Pa. $5.95

THE ROAD TO OZ, L. Frank Baum. Dorothy meets the Shaggy Man, little Button-Bright and the Rainbow's beautiful daughter in this delightful trip to the magical Land of Oz. 272pp. 5⅜ x 8. 25208-6 Pa. $4.95

POINT AND LINE TO PLANE, Wassily Kandinsky. Seminal exposition of role of point, line, other elements in non-objective painting. Essential to understanding 20th-century art. 127 illustrations. 192pp. 6½ x 9¼. 23808-3 Pa. $4.95

LADY ANNA, Anthony Trollope. Moving chronicle of Countess Lovel's bitter struggle to win for herself and daughter Anna their rightful rank and fortune—perhaps at cost of sanity itself. 384pp. 5⅜ x 8½. 24669-8 Pa. $8.95

EGYPTIAN MAGIC, E. A. Wallis Budge. Sums up all that is known about magic in Ancient Egypt: the role of magic in controlling the gods, powerful amulets that warded off evil spirits, scarabs of immortality, use of wax images, formulas and spells, the secret name, much more. 253pp. 5⅜ x 8½. 22681-6 Pa. $4.50

THE DANCE OF SIVA, Ananda Coomaraswamy. Preeminent authority unfolds the vast metaphysic of India: the revelation of her art, conception of the universe, social organization, etc. 27 reproductions of art masterpieces. 192pp. 5⅜ x 8½. 24817-8 Pa. $5.95

CHRISTMAS CUSTOMS AND TRADITIONS, Clement A. Miles. Origin, evolution, significance of religious, secular practices. Caroling, gifts, yule logs, much more. Full, scholarly yet fascinating; non-sectarian. 400pp. 5⅜ × 8½.
23354-5 Pa. $6.50

THE HUMAN FIGURE IN MOTION, Eadweard Muybridge. More than 4,500 stopped-action photos, in action series, showing undraped men, women, children jumping, lying down, throwing, sitting, wrestling, carrying, etc. 390pp. 7⅞ × 10⅜.
20204-6 Cloth. $21.95

THE MAN WHO WAS THURSDAY, Gilbert Keith Chesterton. Witty, fast-paced novel about a club of anarchists in turn-of-the-century London. Brilliant social, religious, philosophical speculations. 128pp. 5⅜ × 8½.
25121-7 Pa. $3.95

A CEZANNE SKETCHBOOK: Figures, Portraits, Landscapes and Still Lifes, Paul Cezanne. Great artist experiments with tonal effects, light, mass, other qualities in over 100 drawings. A revealing view of developing master painter, precursor of Cubism. 102 black-and-white illustrations. 144pp. 8⅜ × 6⅞.
24790-2 Pa. $5.95

AN ENCYCLOPEDIA OF BATTLES: Accounts of Over 1,560 Battles from 1479 b.c. to the Present, David Eggenberger. Presents essential details of every major battle in recorded history, from the first battle of Megiddo in 1479 b.c. to Grenada in 1984. List of Battle Maps. New Appendix covering the years 1967–1984. Index. 99 illustrations. 544pp. 6½ × 9¼.
24913-1 Pa. $14.95

AN ETYMOLOGICAL DICTIONARY OF MODERN ENGLISH, Ernest Weekley. Richest, fullest work, by foremost British lexicographer. Detailed word histories. Inexhaustible. Total of 856pp. 6½ × 9¼.
21873-2, 21874-0 Pa., Two-vol. set $17.00

WEBSTER'S AMERICAN MILITARY BIOGRAPHIES, edited by Robert McHenry. Over 1,000 figures who shaped 3 centuries of American military history. Detailed biographies of Nathan Hale, Douglas MacArthur, Mary Hallaren, others. Chronologies of engagements, more. Introduction. Addenda. 1,033 entries in alphabetical order. xi + 548pp. 6½ × 9¼. (Available in U.S. only)
24758-9 Pa. $11.95

LIFE IN ANCIENT EGYPT, Adolf Erman. Detailed older account, with much not in more recent books: domestic life, religion, magic, medicine, commerce, and whatever else needed for complete picture. Many illustrations. 597pp. 5⅜ × 8¼.
22632-8 Pa. $8.95

HISTORIC COSTUME IN PICTURES, Braun & Schneider. Over 1,450 costumed figures shown, covering a wide variety of peoples: kings, emperors, nobles, priests, servants, soldiers, scholars, townsfolk, peasants, merchants, courtiers, cavaliers, and more. 256pp. 8⅜ × 11¼.
23150-X Pa. $8.95

THE NOTEBOOKS OF LEONARDO DA VINCI, edited by J. P. Richter. Extracts from manuscripts reveal great genius; on painting, sculpture, anatomy, sciences, geography, etc. Both Italian and English. 186 ms. pages reproduced, plus 500 additional drawings, including studies for *Last Supper*, *Sforza* monument, etc. 860pp. 7⅞ × 10¾. (Available in U.S. only) 22572-0, 22573-9 Pa., Two-vol. set $29.90

THE ART NOUVEAU STYLE BOOK OF ALPHONSE MUCHA. All 72 Plates from "Documents Decoratifs" in Original Color. Alphonse Mucha. Rare copyright-free design portfolio by high priest of Art Nouveau. Jewelry, wallpaper, stained glass, furniture, figure studies, plant and animal motifs, etc. Only complete one-volume edition. 80pp. 9¾ × 12¼. 24044-4 Pa. $8.95

ANIMALS: 1,419 COPYRIGHT-FREE ILLUSTRATIONS OF MAMMALS, BIRDS, FISH, INSECTS, ETC., edited by Jim Harter. Clear wood engravings present, in extremely lifelike poses, over 1,000 species of animals. One of the most extensive pictorial sourcebooks of its kind. Captions. Index. 284pp. 9 × 12. 23766-4 Pa. $9.95

OBELISTS FLY HIGH, C. Daly King. Masterpiece of American detective fiction, long out of print, involves murder on a 1935 transcontinental flight—"a very thrilling story"—NY Times. Unabridged and unaltered republication of the edition published by William Collins Sons & Co. Ltd., London, 1935. 288pp. 5⅜ × 8½. (Available in U.S. only) 25036-9 Pa. $4.95

VICTORIAN AND EDWARDIAN FASHION: A Photographic Survey, Alison Gernsheim. First fashion history completely illustrated by contemporary photographs. Full text plus 235 photos, 1840-1914, in which many celebrities appear. 240pp. 6⅜ × 9¼. 24205-6 Pa. $6.95

THE ART OF THE FRENCH ILLUSTRATED BOOK, 1700-1914, Gordon N. Ray. Over 630 superb book illustrations by Fragonard, Delacroix, Daumier, Doré, Grandville, Manet, Mucha, Steinlen, Toulouse-Lautrec and many others. Preface. Introduction. 633 halftones. Indices of artists, authors & titles, binders and provenances. Appendices. Bibliography. 608pp. 8⅜ × 11¼. 25086-5 Pa. $24.95

THE WONDERFUL WIZARD OF OZ, L. Frank Baum. Facsimile in full color of America's finest children's classic. 143 illustrations by W. W. Denslow. 267pp. 5⅜ × 8½. 20691-2 Pa. $5.95

FRONTIERS OF MODERN PHYSICS: New Perspectives on Cosmology, Relativity, Black Holes and Extraterrestrial Intelligence, Tony Rothman, et al. For the intelligent layman. Subjects include: cosmological models of the universe; black holes; the neutrino; the search for extraterrestrial intelligence. Introduction. 46 black-and-white illustrations. 192pp. 5⅜ × 8½. 24587-X Pa. $6.95

THE FRIENDLY STARS, Martha Evans Martin & Donald Howard Menzel. Classic text marshalls the stars together in an engaging, non-technical survey, presenting them as sources of beauty in night sky. 23 illustrations. Foreword. 2 star charts. Index. 147pp. 5⅜ × 8½. 21099-5 Pa. $3.50

FADS AND FALLACIES IN THE NAME OF SCIENCE, Martin Gardner. Fair, witty appraisal of cranks, quacks, and quackeries of science and pseudoscience: hollow earth, Velikovsky, orgone energy, Dianetics, flying saucers, Bridey Murphy, food and medical fads, etc. Revised, expanded In the Name of Science. "A very able and even-tempered presentation."—The New Yorker. 363pp. 5⅜ × 8. 20394-8 Pa. $6.50

ANCIENT EGYPT: ITS CULTURE AND HISTORY, J. E Manchip White. From pre-dynastics through Ptolemies: society, history, political structure, religion, daily life, literature, cultural heritage. 48 plates. 217pp. 5⅜ × 8¼. 22548-8 Pa. $5.95

SIR HARRY HOTSPUR OF HUMBLETHWAITE, Anthony Trollope. Incisive, unconventional psychological study of a conflict between a wealthy baronet, his idealistic daughter, and their scapegrace cousin. The 1870 novel in its first inexpensive edition in years. 250pp. 5⅜ × 8½. 24953-0 Pa. $5.95

LASERS AND HOLOGRAPHY, Winston E. Kock. Sound introduction to burgeoning field, expanded (1981) for second edition. Wave patterns, coherence, lasers, diffraction, zone plates, properties of holograms, recent advances. 84 illustrations. 160pp. 5⅜ × 8½. (Except in United Kingdom) 24041-X Pa. $3.50

INTRODUCTION TO ARTIFICIAL INTELLIGENCE: SECOND, EN-LARGED EDITION, Philip C. Jackson, Jr. Comprehensive survey of artificial intelligence—the study of how machines (computers) can be made to act intelligently. Includes introductory and advanced material. Extensive notes updating the main text. 132 black-and-white illustrations. 512pp. 5⅜ × 8½. 24864-X Pa. $8.95

HISTORY OF INDIAN AND INDONESIAN ART, Ananda K. Coomaraswamy. Over 400 illustrations illuminate classic study of Indian art from earliest Harappa finds to early 20th century. Provides philosophical, religious and social insights. 304pp. 6⅝ × 9⅜. 25005-9 Pa. $8.95

THE GOLEM, Gustav Meyrink. Most famous supernatural novel in modern European literature, set in Ghetto of Old Prague around 1890. Compelling story of mystical experiences, strange transformations, profound terror. 13 black-and-white illustrations. 224pp. 5⅜ × 8½. (Available in U.S. only) 25025-3 Pa. $6.95

ARMADALE, Wilkie Collins. Third great mystery novel by the author of *The Woman in White* and *The Moonstone.* Original magazine version with 40 illustrations. 597pp. 5⅜ × 8½. 23429-0 Pa. $9.95

PICTORIAL ENCYCLOPEDIA OF HISTORIC ARCHITECTURAL PLANS, DETAILS AND ELEMENTS: With 1,880 Line Drawings of Arches, Domes, Doorways, Facades, Gables, Windows, etc., John Theodore Haneman. Sourcebook of inspiration for architects, designers, others. Bibliography. Captions. 141pp. 9 × 12. 24605-1 Pa. $6.95

BENCHLEY LOST AND FOUND, Robert Benchley. Finest humor from early 30's, about pet peeves, child psychologists, post office and others. Mostly unavailable elsewhere. 73 illustrations by Peter Arno and others. 183pp. 5⅜ × 8½. 22410-4 Pa. $3.95

ERTÉ GRAPHICS, Erté. Collection of striking color graphics: *Seasons, Alphabet, Numerals, Aces* and *Precious Stones.* 50 plates, including 4 on covers. 48pp. 9⅜ × 12¼. 23580-7 Pa. $6.95

THE JOURNAL OF HENRY D. THOREAU, edited by Bradford Torrey, F. H. Allen. Complete reprinting of 14 volumes, 1837–61, over two million words; the sourcebooks for *Walden,* etc. Definitive. All original sketches, plus 75 photographs. 1,804pp. 8⅜ × 12¼. 20312-3, 20313-1 Cloth., Two-vol. set $80.00

CASTLES: THEIR CONSTRUCTION AND HISTORY, Sidney Toy. Traces castle development from ancient roots. Nearly 200 photographs and drawings illustrate moats, keeps, baileys, many other features. Caernarvon, Dover Castles, Hadrian's Wall, Tower of London, dozens more. 256pp. 5⅜ × 8½. 24898-4 Pa. $5.95

AMERICAN CLIPPER SHIPS: 1833-1858, Octavius T. Howe & Frederick C. Matthews. Fully-illustrated, encyclopedic review of 352 clipper ships from the period of America's greatest maritime supremacy. Introduction. 109 halftones. 5 black-and-white line illustrations. Index. Total of 928pp. 5⅜ × 8½.
25115-2, 25116-0 Pa., Two-vol. set $17.90

TOWARDS A NEW ARCHITECTURE, Le Corbusier. Pioneering manifesto by great architect, near legendary founder of "International School." Technical and aesthetic theories, views on industry, economics, relation of form to function, "mass-production spirit," much more. Profusely illustrated. Unabridged transla-tion of 13th French edition. Introduction by Frederick Etchells. 320pp. 6⅛ × 9¼. (Available in U.S. only)
25023-7 Pa. $8.95

THE BOOK OF KELLS, edited by Blanche Cirker. Inexpensive collection of 32 full-color, full-page plates from the greatest illuminated manuscript of the Middle Ages, painstakingly reproduced from rare facsimile edition. Publisher's Note. Captions. 32pp. 9⅜ × 12¼.
24345-1 Pa. $4.95

BEST SCIENCE FICTION STORIES OF H. G. WELLS, H. G. Wells. Full novel *The Invisible Man*, plus 17 short stories: "The Crystal Egg," "Aepyornis Island," "The Strange Orchid," etc. 303pp. 5⅜ × 8½. (Available in U.S. only)
21531-8 Pa. $6.95

AMERICAN SAILING SHIPS: Their Plans and History, Charles G. Davis. Photos, construction details of schooners, frigates, clippers, other sailcraft of 18th to early 20th centuries—plus entertaining discourse on design, rigging, nautical lore, much more. 137 black-and-white illustrations. 240pp. 6⅜ × 9¼.
24658-2 Pa. $6.95

ENTERTAINING MATHEMATICAL PUZZLES, Martin Gardner. Selection of author's favorite conundrums involving arithmetic, money, speed, etc., with lively commentary. Complete solutions. 112pp. 5⅜ × 8½.
25211-6 Pa. $2.95

THE WILL TO BELIEVE, HUMAN IMMORTALITY, William James. Two books bound together. Effect of irrational on logical, and arguments for human immortality. 402pp. 5⅜ × 8½.
20291-7 Pa. $7.50

THE HAUNTED MONASTERY and THE CHINESE MAZE MURDERS, Robert Van Gulik. 2 full novels by Van Gulik continue adventures of Judge Dee and his companions. An evil Taoist monastery, seemingly supernatural events; overgrown topiary maze that hides strange crimes. Set in 7th-century China. 27 illustrations. 328pp. 5⅜ × 8½.
23502-5 Pa. $5.95

CELEBRATED CASES OF JUDGE DEE (DEE GOONG AN), translated by Robert Van Gulik. Authentic 18th-century Chinese detective novel; Dee and associates solve three interlocked cases. Led to Van Gulik's own stories with same characters. Extensive introduction. 9 illustrations. 237pp. 5⅜ × 8½.
23337-5 Pa. $4.95

Prices subject to change without notice.

Available at your book dealer or write for free catalog to Dept. GI, Dover Publications, Inc., 31 East 2nd St., Mineola, N.Y. 11501. Dover publishes more than 175 books each year on science, elementary and advanced mathematics, biology, music, art, literary history, social sciences and other areas.